KEEPING AN EYE OPEN

KEEPING AN EYE OPEN

ESSAYS ON ART

Julian Barnes

JONATHAN CAPE

LONDON

Published by Jonathan Cape 2015

6 8 10 9 7 5

Copyright © Julian Barnes 2015

First published in Great Britain in 2015 by
Jonathan Cape
20 Vauxhall Bridge Road,
London SW1V 2SA

www.vintage-books.co.uk

global.penguinrandomhouse.com

A CIP catalogue record for this book is
available from the British Library

ISBN 9780224102018

Penguin Random House is committed to a sustainable future
for our business, our readers and our planet.
This book is made from Forest Stewardship Council® certified paper.
Our paper procurement policy can be found at:
www.randomhouse.co.uk/environment
Printed and bound in Italy by L.E.G.O. S.p.A.

CONTENTS

FOR PAT

Introduction

Some years ago, a journalist friend, posted to Paris by his magazine, became in quick succession the father of two children. As soon as their eyes were able to focus properly, he would take them round the Louvre, tenderly pointing their infant retinas at some of the world's greatest paintings. I don't know if he also played classical music to them while they were in their mother's womb, as some prospective parents do; but I have occasionally found myself wondering how those children will turn out: as potential directors of MOMA – or, perhaps, as adults with no visual sense at all, and a horror of art galleries.

My own parents never tried feeding me culture at an early (or any other) age; neither did they seek to dissuade me from it. They were both schoolteachers, and so the arts – or perhaps, more precisely, the idea of the arts – were respected in the house. There were proper books on the shelves; and there was even a piano in the sitting-room – though at no point in my childhood was it actually played. My mother had been given it by her doting father when she was a young, capable and hopeful pianist. Her playing, however, came to a halt in her early twenties when she found herself faced with a difficult piece of Scriabin. She realised, as she repeatedly failed to master it, that she had reached a certain level, which she could never go beyond. She stopped playing, abruptly and finally. Even so, the piano could not be got rid of; it moved house with her, following her loyally into marriage, and maternity, and old age and widowhood. On its regularly dusted

top was a pile of sheet music, including that Scriabin piece she had abandoned decades previously.

As for art, there were three oil paintings in the house. Two were of country scenes in Finistère, painted by one of my father's French *assistants*. They were, in a way, as misleading as the piano, since 'Uncle Paul', as he was known, hadn't exactly painted them *en plein air*; rather, he had copied – and aggrandised – them from picture postcards. I still have the originals he worked from (one smeared with real paint) on my desk. The third picture, which hung in our hall, was somewhat more authentic. An oil of a female nude, in a gilt frame, it was probably an obscure nineteenth-century copy of an equally obscure original. My parents had bought it at an auction sale in the outer London suburb where we lived. I remember it mainly because I found it completely unerotic. This seemed very strange, because most other depictions of unclad women had what felt like a healthy effect on me. Perhaps this was what art did: by being solemn, it took the excitement out of life.

There was further evidence that this might be art's purpose and effect: the boring amateur dramatics my parents would take my brother and me to once a year; and the dreary discussion programmes about the arts they used to listen to on the wireless. By the age of twelve or thirteen, I was a healthy little philistine of the kind the British are so good at producing, keen on sports and comics. I couldn't carry a tune, didn't learn a musical instrument, never studied art at school, and never acted after my cameo (non-speaking) appearance as Third Wise Man at the age of about seven. Though I was introduced to literature as part of my schoolwork, and was beginning to see how it might have connections to real life, I thought of it mainly as a subject on which I would have to pass examinations.

I was once taken by my parents to the Wallace Collection in London: more gilt frames, and more unerotic nudes. We stood for a while in

Quimperlé (Finistère): Le Pont fleuri

front of one of the museum's most famous pictures: *The Laughing Cavalier* by Frans Hals. I couldn't for the life of me see what the man with the silly moustache was smirking at, or why it might be an interesting picture. I was probably taken to the National Gallery as well, but have no memory of the event. It wasn't until the summer of 1964, when I was staying in Paris for a few weeks between school and university, that I started looking at pictures of my own volition. And though I must have gone to the Louvre, it was a large, dark, unfashionable museum that made the most impression on me – perhaps because there was no-one else there, so I felt no emulative pressure to respond in a particular way. The Musée Gustave Moreau, near the Gare Saint-Lazare, had been left to the French state on the painter's death in 1898, and – from its gloom and grubbiness – seemed to have been rather grudgingly kept up thereafter. Upstairs was Moreau's huge, high barn of a studio, underheated by a chunky black stove which had probably been going since the artist's time. Badly lit paintings were hung from floor to ceiling, while large wooden chests contained thin drawers you could pull out to examine hundreds of preliminary drawings. I had never knowingly seen a picture by Moreau before, and knew nothing about him (let alone that he was the only contemporary painter wholeheartedly admired by Flaubert). I was uncertain what to make of such work: exotic, bejewelled and darkly glittering, with an odd mixture of private and public symbolism, little of which I could unscramble. Perhaps it was this mysteriousness that attracted me; and perhaps I admired Moreau the more because nobody told me to do so. But it was certainly here that I remember myself for the first time consciously looking at pictures, rather than being passively and obediently in their presence.

And I also liked Moreau because he was so odd. At this early stage of my looking, I was attracted to art that was as transformative as possible: indeed, I thought this was what art *was*. You took life and

turned it, by some charismatic, secret process, into something else: related to life, but stronger, more intense and, preferably, weirder. Among the painters of the past, I was drawn to the likes of El Greco and Tintoretto for their liquid elongations of form, Bosch and Brueghel for their fantastical imaginings, Arcimboldo for his witty emblematic constructions. And among the painters of the twentieth century – the Modernists, anyway – I was pretty much thrilled by all of them, as long as they turned dull reality into cubes and slicings, into visceral whirls, intense sploshings, brainy grids and enigmatic constructions. Had I known Apollinaire as more than a (Modernist, therefore admirable) poet, I would have approved his praise of Cubism for being a 'noble' and 'necessary' reaction against 'contemporary frivolity'. As for the wider, longer history of painting, of course I could see that Dürer and Memling and Mantegna were brilliant, but I tended to feel that Realism was a kind of default setting for art.

This was a normal, and normally romantic, approach. It took me a lot of looking before I understood that Realism, far from being just the base camp for high-altitude adventure by others, could be just as truthful, and even just as strange – that it too involved choice, organisation and imagination, so in its own way might be equally transformative. I was also, slowly, to learn that there were painters whom you grew out of (like the Pre-Raphaelites); painters you grew into (Chardin); painters towards whom you had a lifelong, sighing indifference (Greuze); painters you suddenly became aware of after years of unnoticing (Liotard, Hammershoi, Cassatt, Vallotton); painters assuredly great but to whom your response was always a bit negligent (Rubens); and painters who would, whatever age you were, remain persistently, indomitably great (Piero, Rembrandt, Degas). And then – perhaps the slowest advance of all – I permitted myself to believe, or rather see, that not all Modernism was entirely wonderful. That some parts of it were better than others; that maybe Picasso could

be vainglorious, Miró and Klee could be twee, Léger could be repetitive, and so on. I eventually came to realise that Modernism had strengths and weaknesses and a built-in obsolescence, just like all other art movements. Which, as it happens, made it more rather than less interesting.

But still, in 1964, I knew that it was 'my' movement. And I felt lucky that some of the great Modernists were still alive. Braque had died the previous year, but Picasso, the great competitor (in life as in art), was around; so was that suave bamboozler Salvador Dalí, as well as Magritte and Miró (and Giacometti and Calder and Kokoschka). As long as some of its exponents continued to practise, Modernism could not yet be given over to the museums and the academics. This was true of the other arts as well: in 1964 T.S. Eliot and Ezra Pound were alive; so was Stravinsky, whom I once saw conduct half a concert at London's Royal Festival Hall. This sense of my life (just) overlapping with theirs was important in a way I didn't fully recognise at the time, because I had no notion as yet that I would become a writer. But anyone setting out to practise any of the arts in the second half of the twentieth century had to take on Modernism: to understand it, digest it, work out why and how it had changed things, and decide where that left you, as a potential artist after Modernism. You might (and should) choose to go your own way, but it was not an option simply to ignore the movement, to pretend that it had never happened. Besides, by the Sixties the next generation and more had been at work – there was Postmodernism, and later post-Postmodernism, and so on until eventually the labels ran out. A literary critic in New York was later to call me a 'pre-Postmodernist', a moniker I am still working on.

Though I wasn't aware of it back then, I see now that the way in which I processed – and enjoyed, and was thrilled by – Modernism was less through literature than through art. The journey out of

Realism seemed easier to follow in paint than it was in print. In a museum you went from one gallery to the next, reading what appeared to be a clear narrative: from Courbet to Manet and Monet and Degas to Cézanne and then to Braque and Picasso – and you were there! With fiction, it all seemed more complicated and less linear, with more backtracking. If the first great European novel was *Don Quixote*, its strange happenings, tricksiness and narrative self-consciousness also made it Modern, Postmodern, Magical Realist – all things at once. Similarly, if the first great Modernist novel was *Ulysses,* how come its best sections were the most realistic, the ones that most truly render ordinary life? I didn't realise – couldn't yet see – how in all the arts there are usually two things going on at the same time: the desire to make it new, and a continuing conversation with the past. All the great innovators look to previous innovators, to the ones who gave them permission to go and do otherwise, and painted homages to predecessors are a frequent trope.

At the same time, there *is* progress, often awkward, always required. In 2000 the Royal Academy put on an exhibition called '1900 – Art at the Crossroads'. It displayed, without preferential hanging or curatorial nudge, a cross-section of what was being admired and bought as the previous century had turned, regardless of school, affiliation or subsequent critical judgement. Bouguereau and Lord Leighton were hung alongside Degas and Munch; inert academicism and tedious story-telling next to the airy freedoms of Impressionism; diligent and didactic Realism beside fervent Expressionism; sleek porniness and naively unaware erotic musings next to the newest thick-brushed attempts to render the body truthfully. If such an exhibition had been organised in 1900 itself, you could imagine visitors feeling baffled and affronted by the enormous aesthetic squabble in front of them. Here was the cacophonous, overlapping, irreconcilable actuality that would later be argued and flattened into art history, with virtue and vice

attributed, victory and defeat calculated, false taste rebuked. By deliberately not seeking to instruct, this exhibition taught one thing clearly: the 'noble necessity' of Modernism.

Flaubert believed that it was impossible to explain one art form in terms of another, and that great paintings required no words of explanation. Braque thought the ideal state would be reached when we said nothing at all in front of a painting. But we are very far from reaching that state. We remain incorrigibly verbal creatures who love to explain things, to form opinions, to argue. Put us in front of a picture and we chatter, each in our different way. Proust, when going round an art gallery, liked to comment on who the people in the pictures reminded him of in real life; which might have been a deft way of avoiding the direct aesethetic confrontation. But it is a rare picture that stuns, or argues, us into silence. And if one does, it is only a short time before we want to explain and understand the very silence into which we have been plunged.

In 2014, I went back to the Musée Gustave Moreau for the first time in half a century. It was much as memory had continued to picture it: cavernous, gloomy and densely hung. That old cast-iron stove had been pensioned off and reduced to decorative status; and I had forgotten that Moreau, when planning his house, had awarded himself not one but two gigantic studios, one on top of the other, linked by a circular cast-iron staircase. The Musée remains doggedly in the lower tier of Parisian tourist attractions. And in the meantime I had come across Degas's opinion of the place. He had been planning a posthumous museum of his own, but a visit to the rue de la Rochefoucauld dissuaded him. As he came out, he remarked, 'How truly sinister . . . it might be a family vault . . . All those pictures crammed together look to me like a *Thesaurus* or a *Gradus ad Parnassum*.'

This time, part of me was impressed by my younger self – that it hadn't turned tail and fled. I tried to insist that my fifty years of extra

looking now allowed me to appreciate Moreau better than I had at first. But I saw again the same CinemaScope scale and dull-Technicolor hues; the same high-mindedness, thematic repetition, and the solemn purposefulness of the sexuality. (Moreau once said to Degas, 'Are you really proposing to revive painting by means of the dance?' Degas replied, 'And you – are you proposing to renovate it with jewellery?') While I could admire some of the technique – especially Moreau's innovation of adding black-ink outlining and decoration over the painted surface – by the end of a couple of hours I was still trying and still failing. The Flaubert who admired Gustave Moreau was the Flaubert of *Salammbô* rather than of *Madame Bovary*. This was and remained bookish art: it came out of academic study, and has now become a worthy subject of academic study itself, without ever seeming to have gone through a middle period of being charged with life and fire and excitement. And whereas before I had found it interestingly odd, now I found it not odd enough.

I first began writing about art with a chapter on Géricault's *Raft of the Medusa* in my novel *A History of the World in 10½ Chapters* (1989). Since then, I have never followed any particular plan. But I found, when assembling these pieces, that I had unwittingly been retracing that story I tentatively started to read back in the 1960s: the story of how art (mainly French art) made its way from Romanticism to Realism and into Modernism. The central section of this period – approximately 1850 to 1920 – continues to fascinate me, as a time of great truth-speaking combined with a fundamental re-examination of the forms of art. I think we still have a lot to learn from that time. And if I was right as a boy about the dullness of that nude we had at home, I was wrong in my deductions about art's solemnity. Art doesn't just capture and convey the excitement, the thrill of life. Sometimes, it does even more: it *is* that thrill.

Géricault: Catastrophe into Art

<p style="text-align:center">I</p>

It began with a portent.

They had doubled Cape Finisterre and were sailing south before a fresh wind when a school of porpoises surrounded the frigate. Those on board crowded the poop and the breastwork, marvelling at the animals' ability to circle a vessel already gaily proceeding at nine or ten knots. But as they watched the sporting of the porpoises, a cry was raised. A cabin boy had fallen through one of the fore portholes on the larboard side. A signal gun was fired, a life-raft thrown out, and the vessel hove to. But these manoeuvres were cumbrously done, and by the time the six-oared barge was let down, it was in vain. They could not find the raft, let alone the boy. He was only fifteen years old, and those who knew him maintained that he was a strong swimmer; they conjectured that he would most probably have reached the raft. If so, he doubtless perished upon it, after having experienced the most cruel sufferings.

The expedition for Senegal consisted of four vessels: a frigate, a corvette, a flute and a brig. It had set sail from the Island of Aix on 17th June 1816 with 365 people on board. Now it continued south with its complement reduced by one. They provisioned at Tenerife, taking on precious wines, oranges, lemons, banian figs and vegetables of all kinds. Here they noted the depravity of the local inhabitants: the

women of Saint Croix stood at their doors and urged the Frenchmen to enter, confident that their husbands' jealousies would be cured by the monks of the Inquisition who would speak disapprovingly of conjugal mania as the blinding gift of Satan. Reflective passengers ascribed such behaviour to the southern sun, whose power, it is known, weakens both natural and moral bonds.

From Tenerife they sailed south-south-west. Fresh winds and navigational ineptitude scattered the flotilla. Alone, the frigate passed the tropic and rounded Cape Barbas. It was running close to the shore, at times no more than half a cannon shot away. The sea was strewn with rocks; brigantines could not frequent these seas at low water. They had doubled Cape Blanco, or so they believed, when they found themselves in shallows; the lead was cast every half-hour. At daybreak Mr Maudet, ensign of the watch, made out the reckoning upon a chicken coop, and judged that they were on the edge of the Arguin reef. His advice was discounted. But even those unschooled in the sea could observe that the water had changed colour; weed was apparent at the ship's side, and a great many fish were being taken. In calm seas and clear weather, they were running aground. The lead announced eighteen fathoms, then shortly afterwards six fathoms. The frigate, luffing, almost immediately gave a heel; a second and third, then stopped. The sounding line showed a depth of five metres and sixty centimetres.

By misfortune, they had struck the reef at high tide; and the seas growing violent, attempts to free the ship failed. The frigate was assuredly lost. Since the boats it carried were not capacious enough to contain the whole personnel, it was decided to build a raft and embark upon it those who could not be put into the boats. The raft would then be towed to the shore and all would be saved. This plan was perfectly well laid; but as two of the company were later to affirm, it was traced upon loose sand, which was dispersed by the breath of egotism.

The raft was made, and well made, places in the boats allotted, provisions made ready. At daybreak, with two metres and seventy centimetres of water in the hold and the pumps failing, the order was given to abandon ship. Yet disorder quickly embraced the well-laid plan. The allotment of places was ignored, and the provisions were carelessly handled, forgotten or lost in the waters. One hundred and fifty was to be the complement of the raft: 120 soldiers, including officers, twenty-nine sailors and male passengers, one woman. But scarcely had fifty men got on board this machine – whose extent was twenty metres in length and seven in breadth – than it sank under the water to a depth of at least seventy centimetres. They cast off the barrels of flour which had been embarked, whereupon the level of the raft rose; the remaining people descended upon it, and it sank again. When the machine was fully laden, it was a metre beneath the surface, and those on board so crowded they could not take a single step; at the back and front, they were in water up to the waist. Loose flour barrels were cast against them by the waves; a twenty-five-pound bag of biscuit was thrown down to them, which the water converted at once into a paste.

It had been intended that one of the naval officers should take command of the raft; but this officer declined to come on board. At seven o'clock in the morning the signal for departure was given, and the little flotilla pulled away from the abandoned frigate. Seventeen persons had refused to leave the vessel, or had concealed themselves away, and thus remained on board to discover their fate.

The raft was towed by four boats in line astern, preceded by a pinnace, which made soundings. As the boats took up their positions, cries of *Vive le roi!* arose from the men on the raft, and a small white flag was raised upon the end of a musket. But it was at this instant of greatest hope and expectation for those upon the raft that the breath of egotism was added to the normal winds of the sea. One

by one, whether for reason of self-interest, incompetence, misfortune or seeming necessity, the tow-ropes were cast aside.

The raft was barely two leagues from the frigate when it was abandoned. Those on board had wine, a little brandy, some water and a small portion of sodden biscuit. They had been given no compass or chart. With neither oars nor rudder, there was no means of controlling the raft, and little means either of controlling those upon it, who were constantly flung against one another as the waters rolled over them. In the first night, a storm got up and threw the machine with great violence; the cries of those on board mingled with the roaring of the billows. Some attached ropes to the timbers of the craft, and held fast to these; all were buffeted without mercy. By daybreak the air was filled with lamentable cries; vows which could never be fulfilled were offered up to Heaven, and all prepared themselves for imminent death. It was impossible to form an idea of that first night which was not below the truth.

The next day the seas were calm, and for many hope was rekindled. Nevertheless, two young lads and a baker, convinced that there was no escape from death, bade farewell to their companions and willingly embraced the sea. It was during this day that those on the raft began to experience their first delusions. Some fancied that they saw land, others espied vessels come to save them, and the dashing of these deceptive hopes upon the rocks provoked greater despondency.

The second night was more terrible than the first. The seas were mountainous and the raft constantly near to being overthrown; the officers, clustered by the short mast, ordered the soldiery from one side of the machine to the other to counterbalance the energy of the waves. A group of men, certain that they were lost, broke open a cask of wine and resolved to soothe their last moments by abandoning the power of reason; in which they succeeded, until the sea water coming in through the hole they had made in the cask spoiled the wine. Thus

doubly maddened, these disordered men determined to send all to a common destruction, and to this end attacked the ropes that bound the raft together. The mutineers being resisted, a pitched battle took place amid the waves and the darkness of the night. Order was restored, and there was an hour of tranquillity upon that fatal machine. But at midnight the soldiery rose again and attacked their superiors with knives and sabres; those without weapons were so deranged that they attempted to tear at the officers with their teeth, and many bites were endured. Men were thrown into the sea, bludgeoned, stabbed; two barrels of wine were thrown overboard and the last of the water. By the time the villains were subdued, the raft was laden with corpses.

During the first uprising, a workman by the name of Dominique, who had joined the mutineers, was cast into the sea. On hearing the piteous cries of this treacherous underling, the engineer in charge of the workmen threw himself into the water and, taking the villain by the hair, succeeded in dragging him back on board. Dominique's head had been split open by a sabre. In the darkness the wound was bound up and the wretch restored to life. But no sooner was he so revived than ingratitude overtook him; he joined the mutineers and rose with them again. This time he found less fortune and less mercy; he perished that night.

Delirium now menaced the unhappy survivors. Some threw themselves into the sea; some fell into torpor; some unfortunate wretches rushed at their comrades with sabres drawn, demanding to be given *the wing of a chicken*. The engineer whose bravery had saved the workman Dominique pictured himself travelling the fine plains of Italy, and one of the officers saying to him, 'I remember that we have been deserted by the boats; but fear nothing; I have just written to the governor, and in a few hours we will be saved.' The engineer, calm in his delirium, responded thus: 'Have you a pigeon to carry your orders with as much celerity?'

Only one cask of wine remained for the sixty still on board the raft. They collected tags from the soldiers and fashioned them into fish-hooks; they took a bayonet and bent it into such shape as to catch a shark. Whereupon a shark arrived, and seized the bayonet, and with a savage twist of its jaw straightened it fully out again, and swam away.

An extreme resource proved necessary to prolong their miserable existence. Some of those who had survived the night of the mutiny fell upon the corpses and hacked pieces from them, devouring the flesh upon the instant. Most of the officers refused this meat; though one proposed that it should first be dried to make it more palatable. Some tried chewing sword-belts and cartouche boxes, and the leather trimmings to their hats, with little benefit. One sailor attempted to eat his own excrement, but he could not succeed.

The third day was calm and fine. They took repose, but cruel dreams added to the horrors already inflicted by hunger and thirst. The raft, which now carried less than one half its original comple-ment, had risen up in the water, an unforeseen benefit of the night's mutinies. Yet those on board remained in water to the knees, and could only repose standing up, pressed against one another in a solid mass. On the fourth morning they perceived that a dozen of their fellows had died in the night; the bodies were given to the sea, except for one that was reserved against their hunger. At four o'clock that afternoon a shoal of flying fish passed over the raft, and many became ensnared in the extremities of the machine. That night they dressed the fish, but their hunger was so great and each portion so exiguous that many of them added human flesh to the fish, and the flesh being dressed was found less repugnant. Even the officers began to eat it when presented in this form.

It was from this day onwards that all learned to consume human flesh. The next night was to bring a fresh supply. Some Spaniards,

Italians and Negroes, who had remained neutral during the first muti-nies, conspired together with the plan of throwing their superiors overboard and escaping to the shore, which they believed to be at hand, with those valuables and possessions that had been placed into a bag and hung upon the mast. Once more, a terrible combat ensued, and blood washed over the fatal raft. When this third mutiny was finally suppressed, there remained no more than thirty on board, and the raft had risen yet again in the water. Barely a man lay without wounds, into which salt water constantly flowed, and piercing cries were heard.

On the seventh day two soldiers concealed themselves behind the last barrel of wine. They struck a hole in it and began to drink the wine through a straw. On being discovered, the two trespassers were instantly cast into the water, in accordance with the necessary law that had been promulgated.

It was now that the most terrible decision came to be taken. On counting their numbers, it was found that they were twenty-seven. Fifteen of these were likely to live for some days; the rest, suffering from large wounds and many of them delirious, had but the smallest chance of survival. In the time that might elapse before their deaths, however, they would surely diminish further the limited supply of provisions. It was calculated that they could well drink between them as many as thirty or forty bottles of wine. To put the sick on half-allowance was to kill them by degrees. And thus, after a debate in which the most dreadful despair presided, it was agreed among the fifteen healthy persons that their sick comrades must, for the common good of those who might yet survive, be cast into the sea. Three sailors and a soldier, their hearts now hardened by the constant sight of death, performed these repugnant but necessary executions. The healthy were separated from the unhealthy like the clean from the unclean.

After this cruel sacrifice, the last fifteen survivors threw all their arms into the water, reserving only a sabre lest some rope or wood might need cutting. There was sustenance left for six days while they awaited death.

Then came a small event which each interpreted according to his nature. A white butterfly, of a species common in France, appeared over their heads fluttering, and settled upon the sail. To some, crazed with hunger, it seemed that even this could make a morsel. To others, the ease with which their visitor moved appeared a very mockery of those who lay exhausted and almost motionless beneath it. To yet others, this simple butterfly was a sign, a messenger from Heaven as white as Noah's dove. Even those sceptical ones who declined to recognise a divine instrument knew that butterflies travel little distance from the dry land, and were raised by cautious hope.

Yet no dry land appeared. Under the burning sun a raging thirst consumed them, until they began to moisten their lips with their own urine. They drank it from little tin cups, which they first placed in water to cool their inner liquid the more quickly. It happened that a man's cup might be stolen and restored to him later, but without the urine it had previously held. There was one who could not bring himself to swallow it, however thirsty he might be. A surgeon amongst them remarked that the urine of some men was more agreeable to swallow than that of others. He further remarked that the one immediate effect of drinking urine was an inclination to produce urine anew.

An officer of the army discovered a lemon, which he intended to reserve entirely for himself; violent entreaties persuaded him of the perils of selfishness. Thirty cloves of garlic were also found, from which arose further disputation; had all weapons but a sabre not been discarded, blood might have been shed once more. There were two phials filled with spirituous liquor for cleaning the teeth; one or two

drops of this liquor, dispensed with reluctance by its possessor, produced on the tongue a delightful sensation, which for a few seconds cast out thirst. Some pieces of pewter, on being placed in the mouth, effected a kind of coolness. An empty phial which had once contained essence of roses was passed among the survivors; they inhaled, and the remnants of perfume made a soothing impression.

On the tenth day several of the men, upon receiving their allotment of wine, conceived the plan of becoming intoxicated and then destroying themselves; they were with difficulty persuaded from this notion. Sharks now surrounded the raft, and some soldiers, in their derangement, openly bathed within sight of the great fish. Eight of the men, reckoning that land could not be far distant, constructed a second raft upon which to escape. They built a narrow machine with a low mast and a hammock cloth for a sail; but as they made a trial of it, the frailty of the craft proved to them the temerity of their enterprise, and they abandoned it.

On the thirteenth day of their ordeal, the sun rose entirely free from the clouds. The fifteen wretches had put up their prayers to the Almighty, and divided amongst them their portion of wine, when a captain of infantry, looking towards the horizon, descried a ship and announced it with an exclamation. All offered thanks to the Lord and gave way to transports of joy. They straightened barrel hoops and attached handkerchiefs to the end; one of their number mounted to the top of the mast and waved these little flags. All watched the vessel on the horizon and guessed at its progress. Some estimated that it was coming closer by the minute; others asserted that its course lay in a contrary direction. For half an hour they lay suspended between hope and fear. Then the ship disappeared from the sea.

From joy they fell into despondency and grief; they envied the fate of those who had died before them. Then, to find some consolation from their despair in sleep, they rigged a piece of cloth as shelter from

the sun, and lay down beneath it. They proposed to write an account of their adventures, which they would all sign, and nail it to the top of the mast, hoping that it might by some means reach their families and the government.

They had passed two hours among the most cruel reflections when the master gunner, wishing to go to the front of the raft, went out of the tent and saw the *Argus* half a league distant, carrying a full press of sail and bearing down upon them. He could scarcely breathe. His hands stretched towards the sea. 'Saved!' he cried. 'See the brig close upon us!' All rejoiced; even the wounded made to crawl towards the back part of the machine, the better to see their saviours approaching. They embraced one another, and their delight redoubled when they saw that they owed their deliverance to Frenchmen. They waved handkerchiefs and thanked Providence.

The *Argus* clewed up her sails and lay on to their starboard, half a pistol shot away. The fifteen survivors, the strongest of whom could not have lived beyond the next forty-eight hours, were taken up on board; the commander and officers of the brig, by their reiterated care, rekindled in them the flame of life. Two who later wrote their account of the ordeal concluded that the manner in which they were saved was truly miraculous, and that the finger of Heaven was conspic-uous in the event.

The voyage of the frigate had begun with a portent, and it ended with an echo. When the fatal raft, towed by its attendant vessels, had put to sea, there were seventeen persons left behind on the *Medusa*. Thus abandoned by their own choice, they straight away examined the ship for everything that the departing had not taken and the sea had not penetrated. They found biscuit, wine, brandy and bacon, enough to subsist for a while. At first tranquillity prevailed, for their comrades had promised to return to their rescue. But when forty-two days had passed without relief, twelve of the seventeen determined

to reach land. To this end they constructed a second raft from some of the frigate's remaining timbers, which they bound together with strong ropes, and they embarked upon it. Like their predecessors, they lacked oars and navigational equipment, and possessed no more than a rudimentary sail. They took with them a small supply of provisions and what hope there was remaining. But many days later some Moors who live beside the Saharan coast and are subjects of King Zaide discovered the vestiges of their craft, and came to Andar with this information. It was believed that the men on this second raft were doubtless the prey of those sea-monsters which are found in great numbers off the shores of Africa.

And then finally, as if in mockery, there came the echo of an echo. Five men remained upon the frigate. Several days after the second raft had departed, a sailor who had refused to go upon it also attempted to reach the shore. Unable to construct a third raft for himself, he put to sea in a chicken coop. Perhaps it was the very cage upon which Mr Maudet had verified the frigate's fatal course on that morning when they had struck the reef. But the chicken coop sank and the sailor perished when no more than half a cable's length from the *Medusa*.

<p style="text-align:center">II</p>

How do you turn catastrophe into art?

Nowadays the process is automatic. A nuclear plant explodes? We'll have a play on the London stage within a year. A president is assassinated? You can have a book or the film or the filmed book or the booked film. War? Send in the novelists. A series of gruesome murders? Listen for the tramp of the poets. We have to understand it, of course, this catastrophe; to understand it, we have to imagine it, so we need the imaginative arts. But we also need to justify it and forgive it, this

catastrophe, however minimally. Why did it happen, this mad act of Nature, this crazed human moment? Well, at least it produced art. Perhaps, in the end, that's what catastrophe is *for*.

He shaved his head before he started the picture, we all know that. Shaved his head so he wouldn't be able to see anyone, locked himself in his studio and came out when he'd finished his masterpiece. Is that what happened?

The expedition set off on 17th June 1816.

The *Medusa* struck the reef in the afternoon of 2nd July 1816.

The survivors were rescued from the raft on 17th July 1816.

Savigny and Corréard published their account of the voyage in November 1817.

The canvas for the painting was bought on 24th February 1818.

The canvas was transferred to a larger studio and restretched on 28th June 1818.

The painting was finished in July 1819.

On 28th August 1819, three days before the opening of the Salon, Louis XVIII examined the painting and addressed to the artist what the *Moniteur Universel* called 'one of those felicitous remarks which at the same time judge the work and encourage the artist'. The King said, 'Monsieur Géricault, your shipwreck is certainly no disaster.'

It begins with truth to life. The artist read Savigny and Corréard's account; he met them, interrogated them. He compiled a dossier of the case. He sought out the carpenter from the *Medusa*, who had survived, and got him to build a scale model of his original machine. On it he positioned wax models to represent the survivors. Around him in his studio he placed his own paintings of severed heads and dissected limbs, to infiltrate the air with mortality. Recognisable portraits of Savigny, Corréard and the carpenter are included in the final picture. (How did they feel about posing for this reprise of their sufferings?)

He was perfectly calm when painting, reported Antoine Alphonse Montfort, the pupil of Horace Vernet; there was little perceptible motion of the body or the arms, and only a slight flushing of the face to indicate his concentration. He worked directly onto the white canvas with only a rough outline to guide him. He painted for as long as there was light, with a remorselessness which was also rooted in technical necessity: the heavy, fast-drying oils he used meant that each section, once begun, had to be completed that day. His head, as we know, had been shaved of its reddish-blond curls, as a Do Not Disturb sign. But he was not solitary: models, pupils and friends continued coming to the house, which he shared with his young assistant Louis-Alexis Jamar. Among the models he used was the young Delacroix, who posed for the dead figure lying face down with his left arm extended.

Let us start with what he did not paint. He did not paint:

1) The *Medusa* striking the reef;

2) The moment when the tow-ropes were cast off and the raft was abandoned;

3) The mutinies in the night;

4) The necessary cannibalism;

5) The self-protective mass murder;

6) The arrival of the butterfly;

7) The survivors up to their waists, or calves, or ankles in water;

8) The actual moment of rescue.

In other words, his first concern was not to be: 1) political; 2) symbolic; 3) theatrical; 4) shocking; 5) thrilling; 6) sentimental; 7) documentational; or 8) unambiguous.

Notes

1) The *Medusa* was a shipwreck, a news story and a painting; it was also a cause. Bonapartists attacked Monarchists. The behaviour of the frigate's captain illuminated: a) the incompetence and corruption of the Royalist Navy; b) the general callousness of the ruling class towards those beneath them. Parallels with the ship of state running aground would have been both obvious and heavy-handed.

2) Savigny and Corréard, survivors and co-authors of the first account of the shipwreck, petitioned the government, seeking compensation for the victims and punishment for the guilty officers. Rebuffed by institutional justice, they applied to the wider courts of public opinion with their book. Corréard subsequently set up as a publisher and

pamphleteer with a shop called 'At the Wreck of the Medusa'; it became a meeting-place for political malcontents. We can imagine a painting of the moment when the tow-ropes are loosed: an axe, glittering in the sun, is being swung; an officer, turning his back on the raft, is casually slipping a knot . . . It would make an excellent painted pamphlet.

3) The Mutiny was the scene that Géricault most nearly painted. Several preliminary drawings survive. Night, tempest, heavy seas, riven sail, raised sabres, drowning, hand-to-hand combat, naked bodies. What's wrong with all this? Mainly that it would look like one of those saloon-bar fights in B-westerns where every single person is involved – throwing a punch, smashing a chair, breaking a bottle over an enemy's head, swinging heavy-booted from the chandelier. Too much is going on. You can tell more by showing less.

The sketches of the Mutiny that survive are held to resemble traditional sketches of the Last Judgement, with its separation of the innocent from the guilty, and with the fall of the mutinous into damnation. Such an allusion would have been misleading. On the raft, it was not virtue that triumphed, but strength; and there was little mercy to be had. The subtext of such a version might suggest that God was on the side of the officer class. Perhaps he used to be in those days.

4) There is very little cannibalism in Western art. Prudishness? This seems unlikely: Western art is not prudish about gouged eyes, severed heads in bags, sacrificial mastectomy, circumcision, crucifixion. What's more, cannibalism was a heathen practice, which could be usefully condemned in paint while

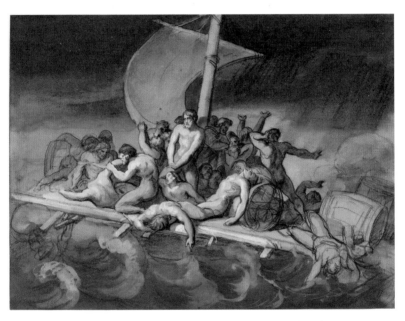

Scene of Cannibalism on the Raft of the Medusa by Géricault

also surreptitiously exciting the spectator. But some subjects just seem to get painted more than others.

Géricault made one sketch of cannibalism on the raft. The spotlit moment of anthropophagy shows a well-muscled survivor gnawing the elbow of a well-muscled cadaver. It is almost comic. Tone was always going to be a problem here.

5) A painting is a moment. What would we think was happening in a scene where three sailors and a soldier were throwing people off a raft into the sea? That the victims were already dead? Or if not, that they were being murdered for their jewellery? Cartoonists having trouble explaining the background to their jokes often show newsvendors standing by billboards on which some convenient headline is inscribed. With a painting, the equivalent information would have to be given in the title: A GRIEVOUS SCENE ABOARD THE RAFT OF THE MEDUSA IN WHICH DESPERATE SURVIVORS, WRACKED BY CONSCIENCE, REALISE THAT PROVISIONS ARE INSUFFICIENT AND TAKE THE TRAGIC BUT NECESSARY DECISION TO SACRIFICE THE WOUNDED IN ORDER THAT THEY THEMSELVES MIGHT HAVE A GREATER CHANCE OF SURVIVAL. That should just about do it.

The title of *The Raft of the Medusa*, incidentally, is not *The Raft of the Medusa*. The painting was listed in the Salon catalogue as *Scène de naufrage – Scene of Shipwreck*. A cautious political move? Perhaps. But it's equally a useful instruction to the spectator: this is a painting, not an opinion.

6) It's not hard to imagine the arrival of the butterfly as depicted by other painters. But it sounds fairly coarse in its emotional appeal, doesn't it? And even if the question of tone could

be overcome, there are two major difficulties. First, it wouldn't look like a true event, even though it was: what is true is not necessarily convincing. Second, a white butterfly six or seven centimetres across, alighting on a raft twenty metres long by seven metres broad, gives serious problems of scale.

7) If the raft is under water, you can't paint the raft. The figures would all be sprouting from the sea like a line-up of Venus Anadyomenes. Further, the lack of a raft presents formal problems: with everyone standing up because if they lay down they would drown, your painting is stiff with verticals; you would need to be extra-ingenious. Better to wait until more on board have died, the raft has risen out of the water, and the horizontal plane becomes fully available.

8) The boat from the *Argus* pulling alongside, the survivors holding out their arms and clambering in, the pathetic contrast between the condition of the rescued and that of the rescuers, a scene of exhaustion and joy – all very affecting, no doubt about it. Géricault made several sketches of this moment of rescue. It could make a strong image; but it's a bit . . . straightforward.

That's what he didn't paint.

What did he paint, then? Well, what does it look as if he painted? Let us reimagine our eye into ignorance. We scrutinise *Scene of Shipwreck* with no knowledge of French naval history. We see survivors on a raft hailing a tiny ship on the horizon (the distant vessel, we can't help noticing, is no bigger than that butterfly would have been). Our

initial presumption is that this is the moment of sighting which leads to rescue. This feeling comes partly from a tireless preference for happy endings, but also from asking ourselves, at some level of consciousness, the following question: how would we know about these people on the raft, if some or all of them had *not* been rescued?

What backs up this presumption? The ship is on the horizon; the sun is also on the horizon (though unseen), lightening it with yellow. Sunrise, we deduce, and the ship arriving with the sun, bringing a new day, hope and rescue; the black clouds overhead (very black) will soon disappear. However, what if it were sunset? Dawn and dusk are easily confused. What if it were sunset, with the ship about to vanish like the sun, and the castaways facing hopeless night as black as that cloud overhead? Puzzled, we might look at the raft's sail to see if the machine was being blown towards or away from its rescuer, and to judge if that baleful cloud is about to be dispelled; but we get little help – the wind is blowing not up and down the picture, but from right to left, and the frame cuts us off from further knowledge of the weather to our right. Then, still undecided, a third possibility occurs; it could be sunrise, yet even so the rescuing vessel is not coming towards the shipwrecked. This would be the plainest rebuff of all from fate: the sun is rising, *but not for you.*

The ignorant eye yields, with a certain testy reluctance, to the informed eye. Let's check *Scene of Shipwreck* against Savigny and Corréard's narrative. It's clear at once that Géricault hasn't painted the hailing which led to the final rescue: that happened differently, with the brig suddenly close upon the raft and everyone rejoicing. No, this is the first sighting, when the *Argus* appeared on the horizon for a tantalising half-hour. Comparing paint with print, we notice at once that Géricault has not represented the survivor up the mast holding straightened-out barrel-hoops with handkerchiefs attached to them. He has opted instead for a man being held up on top of a barrel

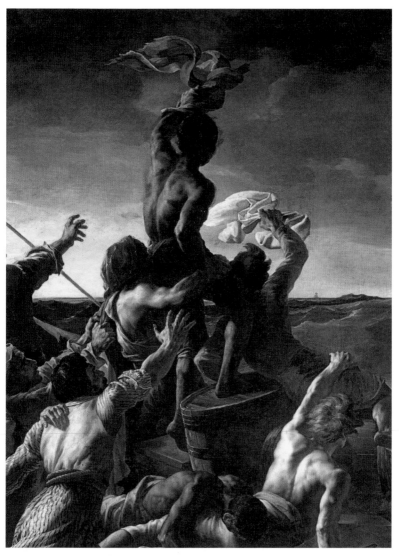

The Raft of the Medusa by Géricault
Detail showing men waving at the ship

and waving a large cloth. We pause over this change, then acknowledge its advantage: reality offered him a monkey-up-a-stick image; art suggested a more solid focus and an extra vertical.

But let us not inform ourselves too quickly. Return the question to the tetchy ignorant eye. Forget the weather; what can be deduced from the personnel on the raft itself? Why not start with a head-count. There are twenty figures on board. Two are actively waving, one actively pointing, two vigorously supplicating, plus one offering muscular support to the hailing figure on the barrel: six in favour of hope and rescue. Then there are five figures (two prone, three supine) who look either dead or dying, plus an old greybeard with his back to the sighted *Argus* in a posture of mourning: six against. In between (we measure space as well as mood) there are eight more figures: one half-supplicating, half-supporting; three watching the hailer with non-committal expressions; one watching the hailer agonisingly; two in profile examining, respectively, waves past and waves to come; plus one obscure figure in the darkest, most damaged part of the canvas, with head in hands (and clawing at his scalp?). Six, six and eight: no overall majority.

(Twenty? queries the informed eye. But Savigny and Corréard said there were only fifteen survivors. So all those five figures who might only be unconscious are definitely dead? Presumably. But then what about the culling that took place, when the last fifteen healthy survivors pitched their twelve wounded comrades into the sea? Géricault has dragged some of them back from the deep to help out with his composition. And should the dead lose their vote in the referendum over hope versus despair? Technically, yes; but not in assessing the mood of the picture.)

So the structure is balanced, six for, six against, eight don't knows. Our eyes, ignorant and informed, squintily roam. Increasingly, they are drawn back from the obvious focus of attention, the hailer on the

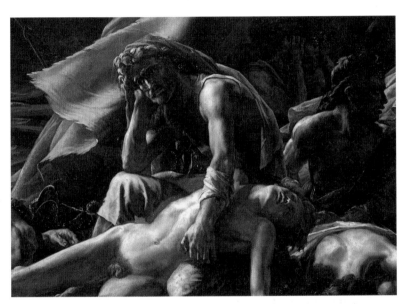

The Raft of the Medusa by Géricault
Detail of the man with the grey beard

barrel, towards the mourning figure front left, the only person looking out at us. He is supporting on his lap a younger fellow who is – we have done our sums – certainly dead. The old man's back is turned against every living person on the raft: his pose is one of resignation, sorrow, despair: he is further marked out by his grey hair and the red cloth worn as a neck-protector. He might have strayed in from a different period and genre – some Poussin elder who had got lost, perhaps. (Nonsense, snaps the informed eye. Poussin? Guérin and Gros, if you must know. And the dead 'Son'? A medley of Guérin, Girodet and Prud'hon.) What is this 'Father' doing? a) lamenting the dead man (his son? his chum?) on his lap; b) realising they will never be rescued; c) reflecting that even if they are rescued, it doesn't matter a damn because of the death he holds in his arms? (By the way, says the informed eye, there really are handicaps to being ignorant. You'd never, for instance, guess that the Father and Son are an attenuated cannibalistic motif, would you? As a group they first appear in Géricault's only surviving sketch of the Cannibalism scene; and any educated contemporary spectator would assuredly be reminded of Dante's description of Count Ugolino sorrowing in his Pisan tower among his dying children – whom he ate. Is that clear now?)

Whatever we decide that the old man is thinking, his presence becomes as powerful a force in the painting as that of the hailer. This counterbalance suggests the following deduction: that the picture represents the midpoint of that first sighting of the *Argus*. The vessel has been in view for a quarter of an hour and has another fifteen minutes to offer. Some believe it is still coming towards them; some are uncertain and waiting to see what happens; some – including the wisest head on board – know that it is heading away from them, and that they will not be saved. This figure incites us to read *Scene of Shipwreck* as an image of hope being mocked.

Those who saw Géricault's painting on the walls of the 1819 Salon knew, almost without exception, that they were looking at the survivors of the *Medusa*'s raft, knew that the ship on the horizon did pick them up (if not at the first attempt), and knew that what had happened on the expedition to Senegal was a major political scandal. But the painting which survives is the one that outlives its own story. Religion decays, the icon remains; a narrative is forgotten, yet its representation still magnetises (the ignorant eye triumphs – how galling for the informed eye). Nowadays, as we examine *Scene of Shipwreck*, it is hard to feel much indignation against Hugues Duroy de Chaumareys, captain of the expedition, or against the minister who appointed him captain, or the naval officer who refused to skipper the raft, or the sailors who loosed the tow-ropes, or the soldiery who mutinied. (Indeed, history democratises our sympathies. Had not the soldiers been brutalised by their wartime experiences? Was not the captain a victim of his own pampered upbringing? Would we bet on ourselves to behave heroically in similar circumstances?) Time dissolves the story into form, colour, emotion. Modern and ignorant, we reimagine the story; do we vote for the optimistic yellowing sky, or for the grieving greybeard? Or do we end up believing both versions? The eye can flick from one mood, and one interpretation, to the other: is this what was intended?

8a) He very nearly painted the following. Two oil studies of 1818, which in composition are closest of any preparatory sketches to the final image, show this significant difference: the vessel that is being hailed is much closer. We can see its outline, sails and masts. It is in profile, on the extreme right of the canvas, and has just begun a painful voyage across the painted horizon. It has clearly not yet seen the raft. The impact of these preliminary sketches is more active, kinetic: we feel as if the frantic waving by those on

the raft might have some effect over the next few minutes, and that the picture, instead of being an instant of time, propels itself into its own future, asking the question: Will the ship sail off the edge of the canvas without seeing the raft? In contrast, the final version of *Shipwreck* is less active, offers a less articulated question. The signalling seems more futile, and the hazard on which the survivors' fate depends more terrifying. What is their chance of rescue? A drop in the ocean.

He was eight months in his studio. Around this time he drew a self-portrait, from which he stares out at us with the sullen, rather suspicious gaze that painters often assume when faced by a mirror; guiltily, we imagine that the disapproval is aimed at us, whereas in fact it is mostly directed back at the sitter. His beard is short, and a tasselled Greek cap covers his shorn hair (we only hear of it being cropped when he began the picture, but hair grows a long way in eight months: how many extra trims did he need?). He strikes us as a piratical figure, determined and ferocious enough to take on, to board his enormous *Shipwreck*. The width of his brushes, by the way, is surprising. From the breadth of his manner, Montfort supposed that Géricault used very thick brushes; yet they were small compared to those of other artists. Small brushes, and heavy, fast-drying oils.

We must remember him at work. It is a normal temptation to schematise, reducing eight months to a finished picture and a series of preliminary sketches; but we must resist this. He is tallish, strong and slender, with admirable legs, which were compared to those of the ephebe restraining the horse in the centre of his *Barberi Race*. Standing before the *Shipwreck*, he works with an intensity of concentration and a need for absolute silence: the scratch of a chair is enough to break the invisible thread between eye and brush-tip. He is painting

his large figures directly onto the canvas with only an outline drawing for assistance. When the work is half-done it looks like a row of sculptures hanging on a white wall.

We must remember him in the confinement of his studio, at work, in motion, making mistakes. When we know the final result of his eight months, his progress towards it seems irresistible. We start with the masterpiece and work backwards through the discarded ideas and near-misses; but for him the discarded ideas began as excitements, and he saw only at the very end what we take for granted at the beginning. For us the conclusion was inevitable; not for him. We must try to allow for hazard, for lucky discovery, even for bluff. We can only explain it in words, yet we must also try to forget words. A painting may be represented as a series of decisions labelled 1) to 8a), but we should understand that these are just the annotations of feeling. We must remember nerves and emotions. The painter isn't carried fluently downstream towards the sunlit pool of that finished image, but is trying to hold a course in an open sea of contrary tides.

Truth to life, at the start, to be sure; yet once the progress gets under way, truth to art is the greater allegiance. The incident never took place as depicted; the numbers are inaccurate; the cannibalism is reduced to a literary reference; the Father and Son group has the thinnest documentary justification, the barrel group none at all. The raft has been cleaned up as if for the state visit of some queasy-stomached monarch: the strips of human flesh have been housewifed away, and everyone's hair is as sleek as a painter's new-bought brush.

As Géricault approaches his final image, questions of form predominate. He pulls the focus, crops, adjusts. The horizon is raised and lowered (if the hailing figure is below the horizon, the whole raft is gloomily engulfed by the sea; if he breaks the horizon, it is like the raising of hope). Géricault cuts down the surrounding areas of sea and sky, hurling us onto the raft whether we like it or not. He stretches

the distance from the shipwrecked to the rescuing vessel. He readjusts the positions of his figures. How often in a picture do so many of the chief participants have their backs to the spectator?

And what splendidly muscular backs they are. We feel embarrassed at this point, yet we shouldn't be. The naive question often proves to be a central one. So go on, let's ask. *Why do the survivors look so healthy?* We admire the way Géricault sought out the *Medusa's* carpenter and had him build a scale model of the raft . . . but . . . but if he bothered to get the raft right, why couldn't he do the same with its inhabitants? We can understand why he fiddled the hailing figure into a separate vertical, why he added some supernumerary corpses to assist the formal structure. But why does everyone – even the corpses – look so muscled, so . . . healthy? Where are the wounds, the scars, the haggardness, the disease? These are men who have drunk their own urine, gnawed the leather from their hats, consumed their own comrades. Five of the fifteen did not survive their rescue very long. So why do they look as if they have just come from a body-building class?

When television companies make drama-docs set in concentration camps, the eye – ignorant or informed – is always drawn to those pyjamaed extras. Their heads may be shaven, their shoulders hunched, and all nail varnish removed, yet subtly they throb with vigour. As we watch them queue onscreen for a bowl of gruel into which the camp guard contemptuously spits, we imagine them offscreen gorging themselves at the catering van. Does *Scene of Shipwreck* prefigure this anomaly? With some painters we might pause and wonder. But not with Géricault, the portrayer of madness, corpses and severed heads. He once stopped a friend in the street who was yellow with jaundice and told him how handsome he was looking. Such an artist would hardly shrink from flesh at the limit of its endurance.

So let's imagine something else he didn't paint – *Scene of Shipwreck* with the casting redistributed among the emaciated.

Shrivelled flesh, suppurating wounds, Belsen cheeks: such details would move us, without trouble, to pity. Salt water would gush from our eyes to match the salt water on the canvas. But this would be precipitate: the painting would be acting on us too directly. Withered castaways in tattered rags are in the same emotional register as that butterfly, the first impelling us to an easy desolation as the second impels us to an easy consolation. The trick is not hard to work.

Whereas the response Géricault seeks is one beyond mere pity and indignation, though these emotions might be picked up en route like hitch-hikers. For all its subject-matter, *Scene of Shipwreck* is full of muscle and dynamism. The figures on the raft are like the waves: beneath them, yet also through them, surges the energy of the ocean. Were they painted in lifelike exhaustion, they would be mere dribbles of spume rather than formal conduits. For the eye is washed – not eased, not persuaded, but tide-tugged – up to the peak of the hailing figure, down to the trough of the despairing elder, across to the recumbent corpse front right who links and leaks into the real tides. It is because the figures are sturdy enough to transmit such power that the canvas unlooses in us deeper, submarinous emotions, can shift us through currents of hope and despair, elation, panic and resignation.

What has happened? The painting has slipped history's anchor. This is no longer *Scene of Shipwreck*, let alone *The Raft of the Medusa*. We don't just imagine the ferocious miseries on that fatal machine; we don't just become the sufferers. They become us. And the picture's secret lies in the pattern of its energy. Look at it one more time: at the violent waterspout building up through those muscular backs as they reach for the speck of the rescuing vessel. All that straining – to what end? There is no formal response to the painting's main surge, just as there is no response to most human feelings. Not merely hope,

but any burdensome yearning: ambition, hatred, love (especially love) – how rarely do our emotions meet the object they seem to deserve? How hopelessly we signal; how dark the sky; how big the waves. We are all lost at sea, washed between hope and despair, hailing something that may never come to our rescue. Catastrophe has become art; but this is no reducing process. It is freeing, enlarging, explaining. Catastrophe has become art: that is, after all, what it is for.

Three reactions to *Scene of Shipwreck*:

a) Salon critics complained that while they might be familiar with the events the painting referred to, there was no internal evidence from which to ascertain the nationality of the victims, the skies under which the tragedy was taking place, or the date at which it was all happening. This was, of course, the point.

b) Delacroix in 1855 recalled his reactions nearly forty years earlier to his first sight of the emerging *Medusa*: 'The impression it gave me was so strong that as I left the studio I broke into a run, and kept running like a madman all the way back to the rue de la Planche where I then lived, at the far end of the faubourg Saint-Germain.'

c) Géricault, on his death-bed, in reply to someone who mentioned the painting: '*Bah, une vignette!*'

And there we have it – the moment of supreme agony on the raft, taken up, transformed, justified by art, turned into a sprung and weighted image, then varnished, framed, glazed, hung in a famous art gallery to illuminate our human condition, fixed, final, always

there. Is that what we have? Well, no. People die; rafts rot; and works of art are not exempt. The emotional structure of Géricault's work, the oscillation between hope and despair, is reinforced by the pigment: the raft contains areas of bright illumination violently contrasted with patches of the deepest darkness. To make the shadow as black as possible, Géricault used quantities of bitumen to give him the shimmering gloom he sought. Bitumen, however, is chemically unstable, and from the moment Louis XVIII examined the work, a slow, irreparable decay of the paint surface was inevitable. 'No sooner do we come into this world,' said Flaubert, 'than bits of us start to fall off.' The masterpiece, once completed, does not stop: it continues in motion, downhill. Our leading expert on Géricault confirms that the painting is 'now in part a ruin'. And perhaps if they examine the frame they will discover woodworm living there.

Delacroix: How Romantic?

In 1937, the American art critic Walter Pach edited and translated the first English-language version of Delacroix's *Journal*. In his introduction he recorded a story told him decades previously by Odilon Redon. In 1861, the young Redon, up from Bordeaux but yet to make his name, had gone to a Parisian ball with his musician brother Ernest. When presented to Delacroix, the two hardly dared speak, so instead followed him round the room 'from group to group in order to hear every word he had to say'. Famous men and women fell silent at the approach of the painter who, though not handsome, carried himself like 'a prince'. When Delacroix left the ball, the two Redons continued following him:

> We walked behind him through the streets. He went slowly and seemed to be meditating, so we kept at a distance in order not to disturb him. There had been rain, and I remember how he picked his steps to avoid the wet places. But when he reached the house on the Right Bank where he had lived for so many years, he seemed to realize that he had taken his way toward it out of habit, and he turned back and walked, still slowly and pensively, through the city and across the river, to the Rue de Furstenberg where he was to die, two years afterwards.

Redon himself, in his posthumous miscellany *À soi-même*, also left an account of the incident, which he dated to 1859. Though theoretically

more authentic, this version feels more written-up. Thus, instead of the young men simply being introduced to Delacroix, Ernest 'by instinct' points out the great painter. The two youngsters shuffle up to him, whereupon:

> He cast on us this blinking, unique glance that darted more sharply than the light of the chandelier. He was very distinguished. He had the *grand'croix* on his high stand-up collar and from time to time he looked down at it. He was accosted by Auber who introduced him to a very young Princesse Bonaparte, 'anxious', Auber said, 'to see a great artist.' He shivered, leaned over smiling, and said: 'You see, he is not very big.'

Redon's account makes Delacroix both the heroic myth that the younger man's imagination required and the ordinary human who engages our sympathy. Thus: 'When I saw Delacroix . . . he was magnificent as a tiger; same pride, same finesse, same power.' Yet at the same time he had 'sloping shoulders, bent posture' and 'was of medium height, thin and tense'. Crossing nocturnal Paris alone, the artist was 'walking like a cat on the most narrow sidewalks'. And then this moment, absent from the version Redon told Pach – perhaps because it sounds too good to be true:

> A poster, which read '*Tableaux*' ('Paintings') attracted his eye; he approached, read, and went away with his dream – I would say, with his obsession.

The story was clearly one of Redon's party pieces, and perhaps exists elsewhere in other variations. But for all that, it contains much of Delacroix: pride and self-doubt, social success and solitude, an intense presence and a dreaminess, a love of honours and a shrinkingness, a

feline ability to negotiate Paris and a lostness. And though fans might trail this great Romantic figure, the artist himself had few followers. He arrived, performed, and left to walk damp streets alone.

Delacroix was twenty-four when he began the *Journal* on 3rd September 1822. It opens with a simple declaration and an alluring promise:

> I am carrying out my plan, so often formulated, of keeping a journal. What I most keenly wish is not to forget that I am writing for myself alone. Thus I shall always tell the truth, I hope, and thus I shall improve myself. These pages will reproach me for my changes of mind. I am starting out in a good humour.

You can quite see why some believe that all private journals are at some level intended to be read by others. Despite the excludingness of that second sentence, the paragraph as a whole invites us in. If this were a novel, the narrative hook would have already been inserted: we want and need to know whether the diarist does indeed tell the truth, whether he improves himself as a result, whether he changes his mind, and whether or not his initial good humour dissipates. Furthermore, Delacroix has chosen a particularly auspicious day on which to begin writing, one which commands him, and allows us, to look to both the past – it is the anniversary of his mother's death – and the future: his first important painting, *Dante and Virgil*, has just been bought by the French government and hung at the Luxembourg. Further, his heart has recently been excited by a girl – somehow it is inevitable that she is called Lisette – who has 'a quality that Raphael understood so well: arms like bronze and a form both delicate and robust'. He has kissed her for the first time, in some dark passage of the house, after returning from the village by the garden. How can the *Journal* not turn out to be a Stendhalian tale of love and ambition,

the more so since the painter-hero's origins are novelistically myste-
rious? (There were rumours, even in his lifetime, that Delacroix was
the natural son of Talleyrand.)

But if Lisette's expectations were to be disappointed – her young
pursuer was already dreaming of looking back at her from the future
as 'a lovely flower on the road of life and in my memory' – so too
may be the diary-reader's. The *Journal* is one of the great art docu-
ments of the nineteenth century; but it is not at all what you might
expect – or what those who have dipped into the various shortened
versions of it might assume it to be. For a start, it contains an early,
huge gap from 1824 to 1847, so that the diarist leaps from his mid-
twenties to his late forties. Further, and more tellingly, that expected
Stendhalian narrative fails to unfold. The Romantic artist's life turns
out to be not especially Romantic. Much as Delacroix admired Byron,
he did not imitate the Englishman's passions or transgressions. Apart
from a formative trip to Morocco in 1832, he rarely left Paris; he did
not even go to Italy, as so many of his colleagues did, to admire the
originals of what he knew in reproduction. And though he had sexual
entanglements, there are no great *amours* to be anatomised and cele-
brated. He thought love was time-consuming, and despite briefly
deluding himself with the dream of a wife who might be his equal,
or even his superior, he soon settled into the complacency that 'a
woman is only a woman, always basically very like the next one'.
Delacroix well knew – and partly chose – 'this inevitable solitude to
which our hearts are condemned', but recognised its artistic advan-
tages: 'things you experience when alone are much stronger and more
virgin'. So he faced the world with an exquisite cold courtesy. Only
a year into his habit of diary-keeping, he writes of it as 'a way of
calming the emotions that have troubled me for so long'. The diary
was about self-mastery, and the purpose of self-mastery was the better
to become a great artist. The Lisettes of this world stood no chance

against that dominant passion. 'Neglect nothing that will serve to make you great,' was Stendhal's advice; while the painter himself noted down Voltaire's opinion that laziness is a sign of mediocrity.

So although the Diary of a Romantic Artist contains some of what we might expect, it also served as many other things: work journal, travel notebook, jotter for a proposed *Dictionnaire des Beaux-Arts*, aide-memoire, file of sent letters, chrestomathy, address book, and so on; there are train and omnibus timetables interspersed, along with press cuttings and receipts. Delacroix left no testamentary instructions about these *'écrits intimes'*. In 1853 he had allowed his friend Théophile Silvestre to see the manuscript and publish a few extracts from it; however, we know that he didn't want the *Journal* published in his lifetime (or in the lifetimes of those about whom he had written disobliging comments). Further, his long-time *femme de charge* Jenny Le Guillou claimed that the painter had tried to burn the manuscript a few days before his death, but that she had saved it from the flames. Michèle Hannoosh, introducing the first new French edition of the *Journal* since 1932, describes how a 'perfect ambiguity' hangs over Delacroix's intentions. Nor are the limits of the 'work' itself at all clear. Previous editors have chosen to prioritise certain volumes of notes over others, in order to make something that most resembles what we might call a Journal – though there is little evidence that Delacroix was more interested in the jottings that make up the main corpus than in those relegated to the appendix. Hannoosh calls it 'an extraordinarily complex, hybrid, chaotic and labyrinthine document'. The artist admitted that he wrote it 'on the run', using whatever piece of paper or notebook was at hand; so that narrative progression and even chronological order are often lacking. He returns to his text and corrects it, or adds to it; sometimes there are multiple entries assembled under the same nominal date. For stretches the text resembles less a diary than a rough working draft

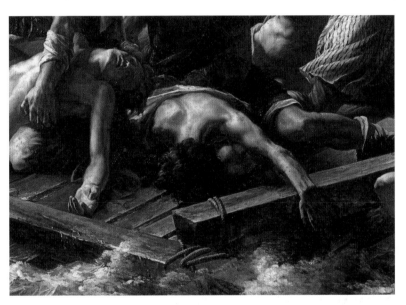

The Raft of the Medusa by Géricault
Detail showing prone figure modelled by Delacroix

for something more akin to Montaigne's *Essais* or Voltaire's *Dictionnaire philosophique,* works Delacroix much admired. Walter Pach, despite declaring thirty-five years of devotion to 'the great artist', was not in the least regretful or abashed about cutting 'pages of dross' for the first English-language publication:

> I have met but few persons who have even tried to get through the three solid volumes of the French editions. Most of those who have begun, with whatever pious intentions, to read the famous work have given up after floundering among allusions to permanently forgotten people, among pages of expense accounts . . . and among interminable lists of colours – the data from which the master's assistants worked on the great decorations – but of no use to artists today when Delacroix is no longer here to direct the proportion of colours used in one combination or another.

Michèle Hannoosh greatly expanded those 'three solid volumes' in her 2010 edition of the *Journal.* The original manuscripts were entirely re-examined, new supporting documentation added, while sumptuous annotation has pushed the original text higher and higher up the page as those 'permanently forgotten people' are given fresh temporary life, and those 'interminable lists of colours' restored to favour. It is a prodigious piece of editorial work, which may set a whole new generation of readers floundering, with some of them quoting Delacroix's entry of 1857 that 'Lengthiness in a book is a capital defect'. But this dauntingly full version serves those who are interested not just in the stories and the opinions and the self-portraiture, but in everything that the artist himself is interested in, including all the necessary professional drudgery and trudgery. The complete *Journal* might be a sapping read at times, but it brings you much closer to the daily truth about an artist's life.

And the more truth you get, the harder Delacroix becomes to pigeonhole. He belonged to that generation of French Romantics who were inspired by Shakespeare and Byron, Scott and Goethe; yet he also held tight to Voltaire as an exemplar. He seems to share a kinship with Berlioz and Stendhal, yet is frequently harsh in the *Journal* about the '*insupportable*' composer whose work was as slapdash as that of Alexandre Dumas, and whose *Damnation of Faust* is 'a heroic mess'. And though Stendhal was one of the first to recognise Delacroix, calling him 'a pupil of Tintoretto' in 1824, that was the very year in which Delacroix writes in his diary that 'Stendhal is rude, arrogant when he is right, and often nonsensical'. Unlike Berlioz, Delacroix does not welcome Beethoven as the great musical liberator; he admires him, sometimes greatly, but also finds him fatiguing and uneven, preferring Mozart, who 'breathes the calm of a well-ordered period'. Like many who are strikingly original within their own art, he is less accepting of new forms and methods in the other arts: so he is instinctively distrustful of Wagner – without having heard a note of his music – on the grounds that the composer wants to be 'innovative' both in music and in politics. 'He thinks he has reached the truth; he suppresses a great many of the conventions of music, believing that conventions are not founded on necessary laws.' (Ironically Nietzsche was later to conclude, in the course of a largely negative judgement, that 'Delacroix is a sort of Wagner'.)

Nor is there any normal easy association, as with other Romantic artists, between the art and the life. Delacroix's art speaks of extravagance, passion, violence, excess; yet his life was that of a self-defended man who feared passion and valued above all tranquillity, hoping and believing that man was 'destined one day to find out that calm stands above all else'. He qualified as a dandy, not by outer garb but by inner superiority of spirit. He was, in Anita Brookner's words, 'perhaps the most glamorous artistic personality since Rubens'; but he was also

(still in her words) of a 'fastidious and somewhat miserly tempera-
ment', and 'a recluse and an ascetic' in 'everything but his pictorial
imagination'. He disliked voluptuaries, and was suspicious of the
'terrifying luxury' on display at the salon of the *demi-mondaine* La
Païva, whose dinners left him 'still feeling heavy the next morning'.
He lacked Romantic optimism, believing that the arts had been in a
'perpetual decadence' since the sixteenth century, when all the great
problems of painting had been solved. He also disliked the way those
who took his side 'have enlisted me, whether I would or no, in the
Romantic coterie'. When some attempted flatterer praised him as
'The Victor Hugo of painting', he replied coldly, 'You are mistaken,
Monsieur, I am a purely classical artist.' Though his most popular
painting was probably *Liberty Guiding the People* (which many nowadays
misread as referring to 1789 rather than 1830), its creator's instincts
were generally reactionary. He judged man an 'ignoble and horrible
animal', whose natural condition was mediocrity. He thought truth
existed only among superior individuals, not among the masses. He
disapproved of agricultural machinery because its introduction might
give the peasant too much idleness (though one of his own profes-
sional rules, as reported by Redon, was 'Rest Often'). Like Flaubert
and Ruskin he hated the railways, and pessimistically imagined that
the future would contain 'a world of brokers', with cities full of
ex-peasants checking their stocks and shares, 'human cattle fattened
by philosophers'. He judged sentimentality a great defect, and human-
itarianism an even greater one (this from a man who adored George
Sand). There are times when it seems sensible to consider him not as
a Romantic at all, but rather as some great fiery explosion happening
at the same time as Romanticism.

And he is constantly surprising. He admired Holman Hunt's work.
He thought the women of Périgueux more beautiful than those of
Paris. He claimed he had just as good a time talking to 'imbeciles' as

to 'thinking men'. He was convinced (and it was a 'blasphemy' for his time) that Rembrandt was 'a far greater painter than Raphael'. In 1851 he became a founder member of the *Société héliographique* – the first learned society to devote itself to photography – and thus one of the earliest painters to consider the processes and likely consequences of the new art. He was not one of those who believed that 'From today painting is dead'. In May 1853 he examines a set of photographs by Eugène Durieu of nude models, 'some of them poorly built, overdeveloped in places and producing a disagreeable effect'. But then he compares this living evidence with some engravings of Marcantonio, which produce an 'effect of repulsion, almost disgust, at their incorrectness, their mannerism, and their lack of naturalness'. The benefits of photography are not, however, straightforward: on the one hand, Delacroix believes that 'a man of genius' might use the daguerreotype to 'raise himself to a height that we do not know'; but for the moment this 'machine-art' has only managed to 'spoil master-pieces', without 'completely satisfying us'. The following year, though, in August, he is again making drawings from Durieu's daguerreotypes, and by October 1855 he is much less ambiguous, examining 'with passion and without fatigue those photographs of nude men, that admirable poem, that human body from which I am learning to read'.

Alongside such open-mindedness ran a great fear of tying himself down – either artistically or personally – and an even greater fear of being tied down. He allowed himself to be fond of Jenny Le Guillou, and enjoyed her devotion to him, no doubt because such emotions were calm and calming. Yet despite not wanting to be beholden to anyone, he also wanted that *grand'croix* around his neck. And as with many other original French artists and writers, repeated rejection by the Institut merely increased his determination to belong (he was finally elected at the eighth attempt in 1857). Baudelaire was puzzled by such conformism, and in a letter to Sainte-Beuve three years after

49

Delacroix's death recalled asking the painter to justify such 'obstinate persistence' when 'many young people would prefer to see him as a pariah and a rebel'. Delacroix had replied:

> My dear sir, if my right arm were struck with paralysis, member-ship of the Institut would give me the right to teach, and providing I were still well enough, the Institut would serve to pay for my coffee and cigars.

This is reminiscent of our contemporary artistic knights and lordlings who with mock self-deprecation explain that the main point of a gong is that it makes restaurant-booking easier.

At the same time – and there is a lot of 'at the same time' with Delacroix – the painter had little desire to be viewed as 'a pariah and a rebel'. That was how Baudelaire wanted young people to see *him*, and much of the complicated relationship between the two men consisted of Baudelaire seeking to co-opt Delacroix and the painter declining co-option. This was partly fastidiousness, but also a pride which demands that he be praised for the correct reasons. Baudelaire may have puffed him as 'emphatically the most original painter of ancient and modern times', but the poet also sought to lay upon him what Brookner has called 'his deathless and morbid imprint'. Delacroix did not want *The Death of Sardanapalus* or *Les Femmes d'Alger* interpreted according to the brooding necessities of Baudelaire's private tempera-ment. There are revealingly few references to Baudelaire in the *Journal*, the most telling of which seems at first sight prosaic, indeed calm:

> M. Baudelaire came in as I was starting to work anew on a little figure of a woman in Oriental costume lying on a sofa, under-taken for Thomas of the rue du Bac. He told me of the difficul-ties that Daumier experiences in finishing. He ran on to

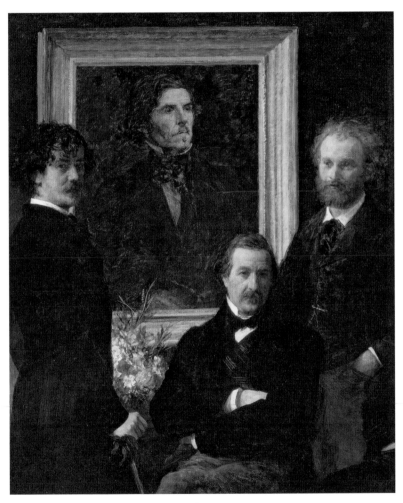

Homage to Delacroix by Fantin-Latour
Detail showing, from left, Whistler, the novelist Champfleury, Manet

Proudhon, whom he admires and whom he calls the idol of the
people. His views seem to be of the most modern, and altogether
in the line of progress. Continued with the little figure after his
departure, and then went back to the *Femmes d'Alger*.

This is the literary equivalent of that catlike figure on the narrow
pavement, keeping perfect balance. The critic comes to see the artist.
He talks of this and that. He is modern and progressive; the artist is
not. The critic leaves, and the artist goes back to work, first on a 'little
figure', then on a masterpiece.

Walter Pach may have excised those 'interminable lists of colours'
from his English-language edition, but such colours and their terminable
variations were what Delacroix devoted his life to. Maxime Du Camp,
in his *Souvenirs littéraires*, remembered the artist

> sitting one evening near a table on which was a basket full of
> skeins of wool. He kept picking up the skeins, grouping them,
> placing them one across the other, separating them shade by
> shade, and producing extraordinary effects of colour. I also recall
> hearing him say, 'Some of the finest pictures I have seen are
> certain Persian carpets.'

French art in the nineteenth century was, in broadest terms, a
struggle between colour and line. So an additional reason why
Delacroix sought the imprimatur of the Institut was that, in a society
where the arts have always been highly politicised, it would officially
endorse his kind of painting. At the start of the century, line had held
sway through David and his school; by the century's end, colour was
to triumph through Impressionism; in between, the mid-century was
taken up with a combat between the champion of line and the cham-
pion of colour (in the square corner, Ingres, in the round corner,

Delacroix). Nor was this confrontation always high-minded: once, after Delacroix had visited the Louvre, Ingres pointedly had the windows opened to dispel 'the smell of sulphur'. Du Camp tells the story of a banker who, innocent of artistic politics, managed mistakenly to invite both painters to dinner on the same evening. After much glowering, Ingres could no longer restrain himself. Cup of coffee in hand, he accosted his rival by a mantelpiece. 'Sir!' he declared, 'Drawing means honesty! Drawing means honour!' Becoming over-choleric in the face of the cool Delacroix, Ingres upset his coffee down his own shirt and waistcoat, then seized his hat and made for the door, where he turned and repeated, 'Yes, sir! It is honour! It is honesty!'

From the comfort of posterity, we may declare them both practitioners of honour and honesty, and sometimes closer to one another than they might either bear or recognise. Both grounded their work in that of the Old Masters; both believed that 'conventions are founded on necessary laws' and looked to literature and the Bible for subject-matter. In the murals and ceilings Delacroix painted in public buildings throughout his working life – from *Orpheus Bringing Civilisation* or *Virgil Presenting Dante to Homer* to *Jacob Wrestling with the Angel* and *Heliodorus Driven from the Temple* – it is not just the titles that suggest the two rivals were approaching similar truths and declarations by merely different paths. At the time, however, their quarrel seemed to be both vital and mortal: one form of high seriousness would perish and the other survive. If colour offered immediate appeal – vigour, movement, passion, life – this was also its tactical disadvantage. Delacroix wrote sarcastically in his *Journal* on 4th January 1857:

I know well that the title of colourist is more of an obstacle than a recommendation . . . The opinion is that a colourist busies himself only with inferior and, so to speak, earthly phases of painting: that a fine drawing is much finer when it is accompanied

by tedious colour, and that the main function of colour is to distract attention from the more sublime quality, which can get along very easily without any prestige that colour can give.

On the other hand, as he points out in one of the notes for his *Dictionnaire*, the 'superiority' of colour, 'or its exquisiteness, if you prefer', comes from its effect upon the imagination. In a Delacroix, colour leads: it directs the eye and the heart before the mind addresses questions of line and subject-matter. Looking back from the end of the nineteenth century, when colour had seemingly triumphed (before Cubism restored the primacy of line), Odilon Redon wrote of Delacroix finding 'his true way, which is expressive colour, colour one might call moral colour'. This, according to Redon, constituted a new raising of the stakes: 'Venice, Parma, Verona have seen colour only from the material side. Delacroix touches at moral colour; this is his oeuvre and his claim to posterity.'

When he lay dying at the age of sixty-five, Delacroix lamented the fact that he still had another forty years of work in him. As for posterity, he several times expressed the wistful hope that he might be allowed to return in a hundred years' time and find out what was thought of him then. When he mentioned this desire to Du Camp, the latter stopped himself from saying what he really felt: 'They will place you between Tiepolo and Jouvenet.' This unspoken remark tells us much about the taste and opinion of the time, which Delacroix had spent so many decades trying to overcome.

An Unmade Bed by Delacroix

Courbet: It's Not Like That, It's Like This

In 1991, the Musée Courbet at Ornans in the Franche-Comté put on an exhibition of the 'erotic' work of André Masson. It was mostly grim stuff: juvenile, facile and often plain nasty, reminding us that dredging the male subconscious can easily bring up dead dogs and rusty torture equipment. But for those who trudged through the gallery there was an unexpected reward at the far end. Alone and unsignalled was Courbet's rarely seen[1] *The Origin of the World*: the splayed female nude, from breast to mid-thigh, painted for the Turkish diplomat Khalil Bey, and which had latterly hung in Jacques Lacan's country house. Despite a century and more of subsequent erotica and pornography, it is still extraordinarily potent. Even Edmond de Goncourt, who found *'ce Jourdaens moderne'* too vulgar for his taste, his nudes 'untrue', and who after attending a joint private view in 1867 of Courbet's tribadic *Le Sommeil* and Ingres's *Bain antique* (both also painted for Khalil Bey) dismissed the two painters as *idiots populaires*, was won round by *The Origin of the World*. He saw it for the first time in 1889, ten years after Courbet's death, and offered in his diary 'honourable amends' to one who could render flesh as well as Correggio. It is painted with a lush delicacy, and the effect is intimidatingly realistic. No, it's not like that, it's like this, the painting seems

[1] Now more easily seen at the Musée d'Orsay. Its arrival there was celebrated by John Updike in a poem characteristically titled 'Two Cunts in Paris' (*Americana and Other Poems*, 2001).

The Mediterranean by Courbet

to declare (all Realism is essentially corrective). And the fact that it continues to make this declaration when surrounded by twentieth-century erotica, that it is capable of rebuking the future as well as its own past and present, is a sign of how alive Courbet's work remains.

He was always a great rebuker, a setter-right in both art and life. No, it's not like that, it's like this: the head-on sky-billowed seascape, the cocky self-portrait, the dense female flesh, the dying animal in the snow, all are imbued with a descriptive and instructive zeal. He is an in-your-face Realist painter, aesthetically assertive. 'Shout loud and walk straight' was apparently a Courbet family maxim, and throughout his life – in person, in paint and in letters – he shouted loud and listened delightedly to the echo. In 1853 he called himself 'the proudest and most arrogant man in France'. By 1861, 'I have the entire artistic youth looking at me and at the moment I am their commander-in-chief.' By 1867, 'I have astounded the whole world . . . I triumph not only over the moderns but over the old masters as well.' By 1873, 'On my side I have all of democracy, all women of all nations, all foreign painters.' He cannot go stag-hunting in the hills outside Frankfurt without reporting that his exploits 'aroused the envy of all Germany'.

Though much of this arrogance seems natural, it was also tailored to the market. Courbet – who was born in Ornans in 1819, came to Paris at the age of twenty and had his first picture accepted by the Salon five years later – created, or adapted to his use, the persona of the boisterous, belligerent, subversive, shit-kicking provincial; then, like some contemporary TV personality, he found that this public image had become indistinguishable from his true nature. Courbet was a great painter, but also a serious publicity act. He was a pioneer in self-marketing; he sold photographs of his pictures to help spread their fame; he issued press releases when a painting of his sold for a large amount of money; and he planned the first permanent exhibition centre devoted to a single artist – himself. In the Franco-Prussian

War he even managed to get a cannon named after him – whereupon he wrote to a newspaper caricaturist giving details of the 'schedule and route' of *'Le Courbet'*, asking him 'to cover it in one of the newspapers at your disposal'.

For all his libertarian socialism, his anti-establishment tirades, his genuine desire to cleanse the mucky stables of French art, there was more than a touch of Yevtushenkoism about him, of the approved rebel knowing how far he can go, and knowing how to turn outrage to his own advantage. When his anti-clerical *Return from the Conference* was kicked back by the Salon in 1863 (by no means his first rejection), Courbet commented with more complacency than was perhaps appropriate: 'I painted it so it would be refused. I have succeeded. That way it will bring me some money.' He was skilled at, or at least noisily involved in, the politicking that surrounded the choice and hanging of pictures at the Salon; he wanted to be accepted and refused at the same time.

He also wanted to accept and refuse, most notoriously with the *Légion d'honneur*. He needed the public offer of a decoration so that he could be publicly offended by it. He nearly got his way in 1861, until Napoleon III irritatingly struck his name from the list, and it was not until 1870 that the longed-for insult arrived. He turned it down – in a letter to the newspapers, naturally – with high Gallic pomp: 'Honour is neither in a title nor in a ribbon, it is in actions and the motivations for those actions. Respect for oneself and for one's ideas constitutes the greater part of it. I do myself honour by staying true to my lifelong principles [etc. etc.].' It is worth comparing the case of Daumier, who had been offered the *Légion d'honneur* earlier that year, and refused it discreetly. When Courbet upbraided him, Daumier, ever the quiet republican, replied, 'I have done what I thought I ought to do. I am glad I did, but that is no business of the public's.' Courbet shrugged his shoulders and commented, 'We'll never make anything of Daumier. He's a dreamer.'

The Meeting (detail) by Courbet

There is a trick photograph, taken in around 1855, of Courbet talking to himself: both parties look engrossed. His self-portraits are painted with an attentive sensuality verging on self-love, while the pose he arranges himself in is often deliberately Christlike. (Proudhon, his anarchist philosopher-friend, was not shy of the comparison either: witness his remark, 'If I find twelve weavers, I am sure of conquering the world.') In *The Meeting* (1854) Courbet, having just got down from a coach seen departing stage right, is being greeted in an open land-scape by his friend and patron Alfred Bruyas and Bruyas's servant Calas. It is hard to tell which of the latter two looks the more defer-ential. Bruyas has just removed his hat to greet Courbet, whereas Courbet's hat is in his hand because that is how, as a free artist, he chooses to walk; Bruyas lowers his eyes in greeting, whereas Courbet cocks his head and points his beard like an implement of interroga-tion. To make a further point, the artist carries a stick twice as big as that of his patron. There is no doubt at all what is happening: the artist is auditioning his patron for suitability rather than the other way round. The picture became known satirically as 'Wealth Greeting Genius'. How far we have come from the days when the patron or donor of a painting was depicted kneeling shoulder-to-shoulder with the saints, while the artist might at best disguise himself among the peasantry on the sidelines.

Or take *L'Atelier* (1854–5), the 'Real Allegory Determining a Phase of Seven Years of My Artistic Life': friends and patrons to the right, wider and lower world to the left, artist with attendant nude model in the middle. Courbet called it 'the moral and physical history of my atelier', as well as, naturally enough, 'the most surprising picture imaginable'. He revelled in its riddling quality: critics would 'have their work cut out'; the picture would 'keep people guessing'. And it still does. Who are these figures, placed in inert uncommunicating groups, and clearly other than a plausible cross-section of visitors to

Courbet's studio? Where does the light come from? Why is there a model present if he is painting a landscape – and why is he painting it in his studio? And so on. But however we try to solve, or over-solve the mystery – is it a political cartoon? does it have Masonic embellishments? (if in doubt, always wheel on the Masons) – there is no disputing the intense focus of the picture: the figure of Courbet himself at work. It seems a relatively small area to support such an enormous painting; but the image of the master wielding his brush is clearly thought powerful enough to do the job.

It's helpful to see *L'Atelier* hung in the Musée d'Orsay directly opposite Courbet's earliest great painting, *Burial at Ornans* (1849). The latter is designed as a grand frieze, tightly framed, with the ripple and dip of the mourners echoed in the distant cliffs above; then the painting is cut off at the top, with only a low strip of sky allowed, just enough to accommodate and emphasise the raised crucifix. This severity and close focus point up the sprawliness of *L'Atelier*, and especially the fact that two-fifths of that painting lies above the line-up of human figures, taking up a vast area of scumble and mud. Structurally, *L'Atelier* might remind us of a medieval triptych: Heaven and Hell on either side, with the vast empyrean above. And in the middle, what have we got? Christ with Mary? God with Eve? Well, Courbet with a model, at any rate, sitting there, reinventing the world. And perhaps this helps answer the question of why Courbet is painting a landscape in his studio instead of *en plein air*: because he is doing more than merely reproducing the known, established world – he is creating it anew himself. From now on, the picture says, it is the artist who creates the world rather than God (indeed, Courbet once said to the writer Francis Wey, 'I paint like *le bon Dieu*'). Read like this, *L'Atelier* is either a colossal blasphemy or a supreme claim for the importance of art, depending on your viewpoint. Or both.

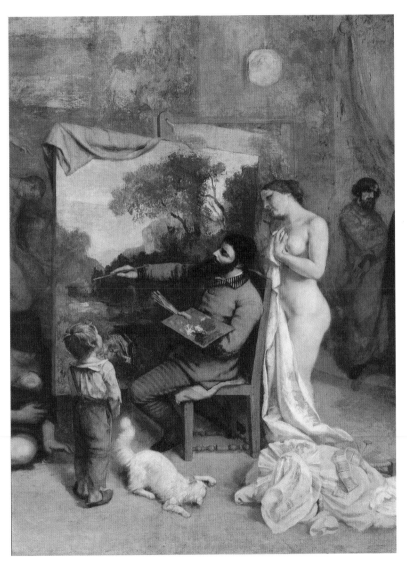

The Artist's Studio (detail) by Courbet

If Delacroix, the Romantic painter, had an unRomantic temperament, so Courbet, the Realist painter, had the egomania of a true Romantic. We are dealing, not just with a career, but with a mission. Baudelaire wrote that Courbet's 1855 debut, in a show he organised himself after both *L'Atelier* and the *Burial* had been turned down for the Universal Exhibition, took place 'with all the violence of an armed revolt'. And from then on, the painter's life and the future of French art are deemed to be indistinguishable. 'I am winning my liberty. I am saving the independence of art,' he writes, as if the second statement were merely an elaboration of the first. The cleansing destruction of stereotypical, academic and Romantic art (the stock symbols of Romanticism – guitar, dagger, hat with feather – lie discarded in the foreground of *L'Atelier*) was to be followed by a remaking of the form. In an open letter of 1861, addressed to the young artists of Paris, Courbet expounded the main elements of the new art: contemporaneity of theme (artists were not to paint the past or the future), individuality of manner, concreteness, realism (he once praised one of his own stag pictures for being 'mathematically precise' and containing not 'one ounce of idealism') and beauty. This beauty was to be found in nature, because nature carried 'within itself' its own artistic expressibility, which the artist had no right to tamper with. 'Beauty provided by nature is superior to all artists' compositions.'

This *profession de foi* is generally believed to have been written by Courbet's friend Jules Castagnary. Courbet fancied himself as a theoretician, but his cast of mind was practical rather than abstract. In any case, we should always trust (and judge) the painting rather than the trumpeted manifesto. The call for concrete Realism clearly doesn't rule out allegory, mystery or suggestiveness – as in *L'Atelier*. Equally, the bellicose rhetoric doesn't prepare us for either the delicacy or the sheer romping variety of Courbet's work: from the Bellini-esque early

portrait of his sister Juliette to those confrontational seascapes which at their best have a power beyond Realism, to the complex and torpidly erotic *Demoiselles des bords de la Seine*. Courbet was accused of beating 'the tom-tom of publicity' with the latter picture (and no doubt he was – when was he not?), but now that its history as provocation has passed, it remains a tensely compelling image. The scene is set in shade, yet gives off an oppressive heat; the seemingly languid atmosphere is denied by the bright, almost gaudy coloration; while the prone woman's sleepy, half-open eye contrasts with the frank gaze we are allowed to bring to her and her companion. This gaze of ours is also intrusively close, since the picture is framed with forceful tightness; the lush trees sit preternaturally low over the recumbent figures, and the spray of leaves in the bottom right-hand corner binds in this image of sultry enclosure. There is a further loose structural rope thrown round the picture. The boatman who has rowed these women down the Seine to this quiet spot has slipped away, leaving his hat abandoned in the boat moored at the back of the painting. Where has he gone? Presumably he has padded out of the frame in a soft semicircle and is now standing where we are, slyly observing his two pouting passengers. If the boatman does not actually merge with the spectator, he certainly stands close by, complicit and greedy-eyed, pressing back into the picture.

Just as there are weighted absences in several of Courbet's greatest pictures – the owner of the hat in *Demoiselles*, the out-of-shot corpse beneath the mourners' feet in the *Burial*, Mme Proudhon in the pellucid homage to the philosopher – so there are powerful silences in Courbet's letters. Of course, the survival of correspondence is a haphazard and unrepresentative process, but even so it is hard to think of a major painter who shows less interest in, or appreciation for, the work of others. No thrilled accounts of seeing a great picture for the first time, no encouragement of others

(except for them to be more like Courbet). The world divides into 'the ancients', i.e. those unfortunate enough to have been born before him, and 'the moderns', i.e. himself. He socialises with Boudin, is financially generous to Monet, has a good but brief word to say for Corot, and cites Titian as a useful point of comparison with his own work. The only person, or perhaps persona, before whom Courbet quails is Victor Hugo, the one Frenchman even he would have to admit was more famous, and to whom he writes uneasily ingratiating letters.

Courbet was a socialist (pre-Marxian, admittedly) who dabbled in the stock market and was keenly acquisitive of land; similarly, for all his millenarian convictions, his attitude to women was pungently of his time and class: brothels, mistresses and unreflecting laddishness. Thus: 'Women should concern themselves only with cabbage soup and housekeeping.' Or, pitching the same sentiment a little higher, as gallant aphorism: 'It is the ladies' task to correct, with their feelings, the speculative rationality of men among themselves.' He intermittently declared that his art left him no time for marriage, while just as intermittently trying to get married. In 1872 he settled on a young girl from his native Franche-Comté, grandly declaring that he and his family were not bothered by 'the social differences' between them, and blithely continuing, in his letter to a go-between:

> It is impossible that Mlle Léontine, despite the stupid advice she may receive from the peasants, may not accept the brilliant position I am offering her. She will be indisputably the most envied woman in France, and she could be reborn another three times without ever coming across a position like this one. Because I could choose a wife from all of French society without ever being refused.

Those who believe in the workings of hubris, and those who just enjoy a good soap opera, will be equally happy that Mlle Léontine declined to become the most envied woman in France. Courbet was left huffing and puffing about the rustic rival he had lost out to, and about 'village sweetie pies' who have 'an intellectual value about that of their cows, without being worth the same amount of money'.

Under the Second Empire, Courbet fought a noisy, obstreperous and admirable campaign for the democratisation of art, in its funding, administration and teaching. In 1870–1, during the Siege and under the Commune, he finally obtained the artistic power he supposedly craved; and yet, ironically, it led to his undoing. The whole story is strangely foreshadowed in his letters. In 1848 – that earlier year of revolution – Courbet writes to his family reassuring them that he is 'not getting very involved in politics', but that he will 'always be ready to lend a hand to destroy what is ill-established'. The next year he tells Francis Wey, 'I have always felt that if the law took it into its head to accuse me of murder, I would definitely be guillotined, even if I were not guilty.' And the next year, 'If I had to make a choice among countries, I admit that I would not choose my own.' Two decades later, Courbet instigated the campaign to demolish the 'ill-established' Vendôme Column, a symbol of Napoleonic imperialism; after the fall of the Commune, the law did indeed accuse him and, though perhaps not technically guilty (certainly less guilty than some, since he wasn't a delegate to the Commune at the relevant time), he was sentenced to six months in prison, later topped up with a ruinous indemnity of 286,549 francs and 78 centimes; whereupon the prospect of further imprisonment for debt forced him to make his 'choice among countries'. He opted for Switzerland.

Courbet accepted moral responsibility for the destruction of the hated Column; but neither this, nor his reminder to the authorities that during the Siege and the Commune he had saved many national

KEEPING AN EYE OPEN

treasures from possible loss, mitigated his position. He seems not to have understood the extent to which by 1871 he had become a perfect target for the incoming government. A charismatic public figure, professional provoker of the established order, socialist, anti-clerical, Communard delegate, a man who raised artistic independence to a political creed, who could write of Napoleon III, 'He is a punishment that I do not deserve', and whose closing line in his call to the artists of Paris in April 1871 had been 'Farewell old world and its diplomacy' – what more apt and exemplary victim when the 'old world' returned to power? And when the state decides to persecute an individual for reasons of public policy, it has more than the normal advantages of money and organisation; it also has the formidable benefit of time. The individual may get tired and depressed, feel his talent being affected, his years running out; whereas the state rarely gets tired and imagines itself immortal. The French state in particular can be unforgiving after wars, especially civil ones.

Even by 1876 Courbet still could not understand what had happened or, rather, why. 'Was it', he asked senators and deputies in an open letter, 'to punish me for having refused the decoration under the Empire that I must carry a cross of a different kind?' This is perhaps no more than a turn of phrase, but a revealing one from the painter who called one of his self-portraits *Christ with Pipe*. If the French state didn't crucify Courbet, it certainly did its best to break him: his property was requisitioned, his pictures stolen, his assets sold, his family spied upon. He continued to paint, and to fight his corner, from Switzerland; occasionally he would summon up all the old boastfulness: 'At this moment I have more than a hundred commissions. I owe it to the Commune . . . The Commune would have me a millionaire.' But his last years – cut off from family and friends, increasingly obsessed with those who had denounced and betrayed him – were sad and stressful. Eventually, worn down, he agreed to a negotiated

deal with the French government, according to which he promised to pay off the cost of rebuilding the Vendôme Column over a period of thirty-two years. 'I must go to Geneva to get a passport at the consulate,' he wrote optimistically in May 1877; but renewed turmoil in France kept him an exile until his death that December.

After visiting that Masson show in 1991, I sat at one of the café tables on the place Humblot and looked across the shallow, fast-flowing Loue – which Courbet had painted all the way back through the forests to its source – at the artist's *maison natale*. On its flank were the faded letters of the word BRASSERIE. This seemed all too apposite. The Belgian painter Alfred Stevens told Edmond de Goncourt that Courbet's consumption of beer was 'terrifying'; thirty *bocks* in an evening, while he also preferred to lengthen his absinthe not with water but white wine. On various occasions his friend Étienne Baudry despatched sixty-two litre barrels of brandy to the exile (Courbet's sister sent only 'splendid socks', to which he replied with gifts of a sewing-machine for her and a pepper-grinder for their father). Alcoholic abuse resulted in dropsy, causing the painter's body to swell to enormous proportions. The fearsome new technique of 'tapping' produced twenty litres of liquid, marginally more effective than the older system (steam-baths plus purging), which had rendered 'eighteen litres from the anus'. It seems grimly fitting that there is something extravagant and terrifying about Courbet's death, as there was about his life and his art.

Manet: In Black and White

a) Throwing the Brick

Those who attack works of art are not, in one sense, wrong. You don't assault something you are indifferent to, or something that doesn't threaten you; iconoclasts rarely smash images out of apathy. Take the man who raised his walking-stick against Manet's *Music in the Tuileries Gardens* when it formed part of a one-man show at the Galerie Martinet in 1863. The assailant left no account of his motives, but the picture's offence would surely have come under the heading of fraud: it was a masquerade, something that insulted not just him, the viewer, but the entire history of art, on whose behalf he was obliged to speak – or, rather, act. Further, the painting's very subject-matter – a swathe of contemporary Parisian life – would have been objectionable to a narrow-minded Salon-goer convinced that art's subjects should be high and mighty. This now seems ironic, since the painting was in fact about the sort of man who in all likelihood had attacked it, and the sort of life he and his friends then lived in Paris. Manet was saying: here, now, as it is.

When Napoleon III saw *Le Déjeuner sur l'herbe* at the Salon des Refusés the same year, he said it was 'an offence against decency'; while his consort, the Empress Eugénie, pretended the picture did not exist. (Nowadays, this would be perfect publicity; then, it was a disaster, as the Salon des Refusés was closed down and for the next

A Studio at Les Batignolles by Fantin-Latour
Detail showing Manet (at easel), Renoir (in the picture frame), and Monet (far right)

twenty years independent painters had no large public space in which to exhibit. When *Olympia* was shown at the Salon of 1865, physical threats meant it – she – had to be rehung above the doorway of the last gallery, so high that it was hard to tell 'whether you were looking at a parcel of nude flesh or a bundle of laundry'. Such imperial and public disapproval ensured that for much of his career Manet also had to put up with the sneers and sarcasms of the popular press. Again, they were not wrong, in the sense that their feeling was authentic: contempt rooted in unacknowledgeable fear. What they dreaded was perfectly clear to one of the most cultured and sophisticated loathers of Manet: Edmond de Goncourt. 'A joke, a joke, a joke!' he shouted into his diary after seeing the posthumous Manet exhibition of January 1884. But he recognised that the joke had long ago turned serious, and was on him and his kind:

> With Manet, whose techniques are lifted from Goya, with Manet and all the painters who have followed him, what we have is the death of oil painting, that's to say, of painting with a pretty, amber, crystalline transparency, of which Rubens's 'Woman in a Straw Hat' is the epitome. Now we have opaque painting, matt painting, chalky painting, painting with all the characteristics of furniture paint. And everyone's doing it like that, from Raffaelli to the last little Impressionist dauber.

Even those who were on Manet's side knew that you cannot have the arrival of something new without the death of something old. So Baudelaire, while hailing Manet as (possibly) the painter of modern life the age demanded – although the poet judged Constantin Guys the real thing – wrote to him: 'You are only the first in the degeneration of your art.' As Anita Brookner acutely commented: 'Does he sense in Manet the inception of art without a moral dimension?'

Ezra Pound said that he would throw the brick through the window while T. S. Eliot went round the back and grabbed the swag; and so it proved. And there's a sense in which Manet threw the brick and the Impressionists grabbed the swag: certainly if swag is measured in blockbuster exhibitions a century and more on. Big Manet shows don't come round that often, even in Paris (1983, 2011); but it's important to be reminded every so often of what he did to, and for, French art. He brightened and lightened its palette (where academicians began with dark tones and worked upwards to lighter ones, Manet's *peinture claire* did the opposite); he discarded half-tones and brought in a new transparency (growling at paintings that were 'stews and gravies'); he simplified and emphasised outline; he frequently discarded traditional perspective (the bathing woman in *Le Déjeuner sur l'herbe* is quite 'wrong' – too large – in terms of the assumed distance); he compressed the depth of field, and pushed figures further out towards us (Zola said of paintings like *The Fifer* that 'they break the wall'); he introduced 'Manet black' and 'Manet white'. Like Courbet, he also rejected large amounts of traditional subject-matter: mythological, symbolic, historical (his 'history' paintings are all contemporary). Like Daumier, he believed that 'One must be of one's time and paint what one sees.' He can be located by the triangulation of the three great writers who championed him: Baudelaire, the dandy and poet of modern life; Zola, the naturalist; Mallarmé, the pure aesthete. Has any painter ever had such writerly support? Yet Manet was not in the least a literary or illustrative painter. His most famous 'literary' painting – of Zola's *Nana* – is not at all what it seems. He portrayed the courtesan when she was still only a minor figure in the serialisation of Zola's earlier novel *L'Assommoir*. Huysmans, in a review of the picture, announced that Zola was going to devote a whole novel to Nana, and congratulated Manet on having 'shown her as she undoubtedly will be'. So you could say it was Zola who 'illustrated' Manet, rather than vice versa.

Much of Manet's achievement you can understand by reading the books and looking at the colour plates; much else is apparent only in front of the pictures themselves. 'Manet black' reproduces fairly well; 'Manet white' very poorly. *Olympia*, aside from its continuing erotic challenge, is also a Whistlerian Symphony in Off-White (subtle exchanges between flesh, coverlet, bedclothes, flowers and – the sharpest white of all – the paper in which the flowers are wrapped). In the portrait of Zola, a central patch of white blazes out: it comes, appropriately, from the pages of the book the novelist is reading. The tender portrait of Mme Manet, *La Lecture*, sets white dress against white sofa-covering against the greyer white of lace curtains. Even one of Manet's most radical – and most fearsomely ugly – portraits, of Baudelaire's mistress (tiny doll-head, enormous right mitt, plus improbable, possibly severed, right leg sticking out of frock), is, you suspect, mainly about the opportunity to fill the canvas from side to side with an enormous, billowing white dress.

All this is to look at Manet in terms of what he can be seen, retrospectively, to have achieved. But painters never live to see exactly what they have achieved. Further, painters have very varying trajectories: some, like Degas or Bonnard, follow a path it is easy for us to understand, and produce work of an almost scarily consistent quality. Others, like Manet, are much harder to follow; harder, perhaps, even for themselves to follow. One of the things the 2011 show at the Musée d'Orsay did was confirm what a restless, as well as what an uneven, painter Manet was. This truth emerged all the more clearly because of the approach the show's curators decided to take. Just as art moves on, so does art history and museum theology. Nowadays, curators – unlike audiences – seem to hate shows which just line up one masterpiece after another, and which retell the same old story. Frenchly, they call such an approach 'simplifying his modernity to an iconographic register'.

There is some point to this. Just as it's easy to forget how provoking Manet originally was, it's easy to forget how quickly the shock of the new becomes visually absorbed, museumified and commodified. (For some years I had a mouse-mat depicting the champagne bottles in *A Bar at the Folies-Bergère*.) Proust, in *The Guermantes Way*, describes how such appropriation can easily take place within a lifetime. His Duchess goes on a visit to the Louvre:

> and we happened to pass Manet's *Olympia*. Nowadays nobody is in the least surprised by it. It looks just like an Ingres! And yet, heaven knows how I had to take up the cudgels on behalf of that picture, which I don't altogether like but which is unquestionably the work of *somebody*.

The Duchess is wrong in the narrow sense (Manet never did look like Ingres, not then, not now), but correct in the wider one. So there is an obvious danger to the masterpieces-on-a-washing-line approach, which merely rehearses how art history settled down a hundred years ago: the risk being that we can no longer *see*, only take for granted. But where is the counter-narrative to be found? Currently, it lies in historical and social context, and specifically, for those 2011 Parisian curators, in the rejection of those who have hitherto 'vampirised' the painter 'in the name of modern art'. This led – astonishingly – to their presenting us with a Manet who was 'the upholder of traditional values'. For instance, the 'same old story' used to tell how the young Manet spent six years in the studio of Thomas Couture, a fashionable *peintre-pompier*, without learning very much from him. The d'Orsay show therefore opened with a roomful of Couture, encouraging us to conclude the opposite. It's true that one early Manet portrait closely resembles Couture. Yet the two most striking pictures in the room – a grave and melancholy study of his parents, and a portrait of a

small boy, *Le Petit Lange*, full of Manet black and with those intensely staring black Manet eyes – bore little influence of Couture; indeed, they demonstrated Manet getting away from his teacher's style as quickly as possible.

More bizarrely interesting is Manet's 'Catholic' period, to which the exhibition devoted a whole room, and which probably came as a great surprise to most people who thought they knew their Manet. Having established himself, and been roundly hissed for it, with *Le Déjeuner sur l'herbe* (1862–3) and *Olympia* (1863), Manet produced several religious paintings in 1864–5 – a massive dead Christ, a similarly massive Mocking of Christ, and a kneeling monk – which, as the catalogue had it, 'revolted his enemies as much as they embarrassed his admirers'. Manet's great friend Antonin Proust left them out of that posthumous show which Goncourt dismissed as a joke. Quite right too: they are the sort of derivative, academic monsters you nowadays find hung high up in provincial Musées des Beaux-Arts, long exiled there by a relieved Paris art bureaucracy ('Look, we are sending you a Manet!'). You can see why they might form part of a curatorial counter-narrative – these works did occupy a lot of the mature Manet's time; but equally, the counter-narrative seemed to involve not so much the democratisation of value as its suspension. 'A Suspect Catholicism' was that room's title. Better: The Shock of the Bad.

The 'Catholic' period acts as a useful early warning that Manet was not always 'Manet'. Quite a few of his paintings might well cause an upset in any artistic blind-tasting. For instance, a Whistlerish, Japanesey *Bateaux en mer* with a sail shaped like an oriental monogram, or a Boulogne beach-scene which is like a Boudin suddenly brought into crisp focus (also with some perspectival oddities, like an improbably giant male figure on the right). The first came from Le Havre, the second from Richmond, Virginia. The curators had been diligent, and original. They showed Manet to be a different painter from what

one might lazily expect; but not a greater one. Manet's most famous paintings are rightly his most famous; they never fail, and still surprise. (For instance, I hadn't previously noticed that the naked figure in *Le Déjeuner* has an almost imperceptible black ribbon in her hair: it's as if Manet is saying, 'Nude – what nude? Can't you see she's wearing a ribbon?') The disappointment of the show was that if he painted, say, twelve (or fourteen, or sixteen) incontestable masterpieces, under half were present: no *Music in the Tuileries Gardens* (which John Richardson has called 'the first truly modern picture'), no *Chemin de fer*, no *Argenteuil*, no *Nana*, no *Lunch in the Atelier*, no *Bar at the Folies-Bergère*; the Boston *Execution of Maximilian*, but not the Mannheim one (or the Degas fragments); the lesser of the two pictures of Monet on his *bateau-atelier*; not the famous bunch of asparagus, but the single extra one Manet painted and sent along as a 'tip' after the buyer had generously overpaid. There may have been difficulties over loans, and the rooms at the d'Orsay are fairly cramped (though enormous space was given to another piece of empty pomp – Jean-Baptiste Faure singing the title role in Ambroise Thomas's *Hamlet*); but most likely it was that the curators were determined to find, if not impose, a new narrative thread. At times they seemed deliberately to mock our expectations. Thus there was a tiny copy of *Le Chemin de fer* – a photo embellished with watercolour and gouache – by Jules-Michel Godet. It's as if the curators were saying: You're missing one of your favourites? Have it like this, then.

Away from all the scuffle of argument and counter-narrative, there was a quiet space for still-lives. This genre accounted for one-fifth of Manet's entire output (not least because of its saleability). On a trip to Venice in 1875 with his wife Suzanne and fellow-painter Tissot, he announced – while standing in the fish market – that he wanted to be 'the St Francis of still life'. At the vegetable market he spotted a pile of Brenta pumpkins and cried out, 'Turks' heads in turbans!

The Bouquet of Lilacs by Manet

Trophies from the victories of Lepanto and Corfu.' On the same visit, he concluded, 'A painter can say all he wants to with fruit, or flowers, or even clouds.' In the still-life room at the Musée d'Orsay, two simple images held me: flowers in tall crystal vases, painted in 1882, the year before his death. Manet, the dandy, the happily married *coureur de femmes*, died (like Baudelaire) of tertiary syphilis. It was an atrocious end: locomotor ataxia, the wheelchair, gangrene, an amputated leg, then death. In this last stretch of his life, Manet repeatedly painted the ephemeral beauty of flowers. As if he were quietly repeating the words the stick-wielder had refused to hear all those years previously, and saying one last time: yes, here, now, as it is.

b) Less is More

How long do we spend with a good painting? Ten seconds, thirty? Two whole minutes? Then how long with each good painting in the sort of 300-item show which has become the norm for a major artist? Two minutes with each exhibit would add up to ten hours (with no lunch, tea or toilet break). Hands up those who spent ten hours at the Matisse, the Magritte, the Degas? I know I didn't. Of course we pick-'n'-mix, the eye pre-selecting what appeals (or what it already knows); but even a spectator with nifty gallery skills, who understands the correlation between personal blood-sugar levels and aesthetic delight, who can work the open spaces and is unafraid if necessary to follow a painter's chronology backwards, who declines to waste eye-time on catalogues and title-craning, who is tall enough to gain an unimpeded view and robust enough to fight off the shoulder-charges of art fans lassooed to their headsets – even such a spectator can come to the end of a big show with a truculent feeling of what might have been.

It's better, of course, in some vaguely ideal way, for as many people to see as many pictures as possible. But the bigger the show, the bigger

the crowds needed to support it, which means bussing them in with the promise that the event will be not just aesthetic but socio-aspirational (and, being social, it has its class structure: those on the inside track get private viewing while the masses pant outside). If in recent years the elephantiasis of exhibitions has eased somewhat – that 2011 Manet show in Paris had a mere 186 items – this is more the result of the economic downturn than of curatorial policy. And yet there is plenty of evidence that smaller displays, with smaller crowds, offer greater pleasure; that you often understand an artist better by seeing less of his or her work, rather than more.

One of the very best shows I've seen in the last thirty years was at the National Gallery in London in 1993. It occupied six rooms but was all about one picture or, rather, one subject: Manet's *The Execution of Maximilian*. Themed and purposeful, it brought together for the first time since Manet's death in 1883 his three accounts of the *Execution*: the loose-brushed, gloomy-hued, sombrero-filled first version from Boston; the fragmentary one (salvaged by Degas after Manet's death) from the National Gallery's own collection; and the best-known, final image from Mannheim. To see these three canvases all in the same room (but not side by side – you had to turn your body to make the comparison, a physical reminder that time and reflection lay between each image) made for a direct, thrilling, intimidating challenge. Why did Manet do this, junk that, adjust the other? By what process of thought or feeling, sudden jump or chance, did he get from *a* to *b* to *c*? To help us out, this triple centre to the show was backed by sixty or so supporting items: formal portraits of the main participants, newsy lithographs, François Aubert's photographs of contemporary Mexican scenes and personalities, *cartes de visite* showing the firing squad and the Emperor's bloodied shirt, plus an assemblage of sources and spin-offs and oddities. None was odder than a photo

of Maximilian and his court playing cricket in *c.*1865, presumably at or near the castle of Chapultepec on the outskirts of Mexico City. The Emperor stands behind the stumps next to Sir Charles Wyke, the British ambassador. The 'pitch' seems to need not so much the heavy roller as a gang of stone-breakers.

Nowadays, when a debtor nation is obliged to defer its financial obligations, the powers-that-be send in teams from the IMF, the European Central Bank, the European Commission, and so on. In 1861, when President Benito Juarez of Mexico declared a two-year moratorium on his foreign owings, the response was a troika of its own time: 6,000 Spanish troops, 2,000 French plus a handful of British turned up at Veracruz. The British were timid, the Spanish aimed at forced conciliation, but the French preferred conquest. They installed the Austrian archduke Ferdinand Maximilian as Emperor in 1864, guerrilla war broke out the following year, the occupation collapsed, the French withdrew, Maximilian declined to abandon his puppet throne, and the returning Mexican government executed him with two of his generals on the Hill of Bells outside Queretaro on 19th June 1867. The event made international news. On 18th July, Flaubert wrote to the Princesse Mathilde that the execution (carried out despite protesting telegrams from Garibaldi, Victor Hugo and others) had horrified him. 'What an abomination. And what a miserable thing the human species is. It is in order not to think about the crimes and stupidities of this world (and not to suffer from them) that I plunge myself headlong into art: a sad consolation.'

The news also made Manet plunge himself into art, though exactly how, and why, and with what intentions or expectations, and with what adjustment of tactics along the route, we remain in benign and freeing ignorance. His progress towards his final image is much less well attested than, say, Géricault's towards *The Raft of the Medusa*. There is, Juliet Wilson-Barreau tells us, 'No record in the Manet

archives of the people to whom he turned or the materials he used to construct his paintings – no newspaper cuttings or illustrations, no photographs, notes or rough sketches.' No useful *obiter dicta* or studio gossip have come down to us. We do not know why he abandoned the second version of the painting (structurally very close to the final one), or what it looked like when it was complete, since our earliest record, a photo of 1883, shows it already lacking the two left-hand figures of the Emperor and General Mejia. There is even an enticing blank when it comes to the *Execution*'s presumed aesthetic source: Goya's *The Executions of the Third of May 1808*, which has a similar ground plan and the same scary closeness of rifle muzzle to victim. We know that Manet visited the Prado, signing the visitors' book on 1st September 1865, but if he saw Goya's painting of the May uprising (then hanging uncatalogued in a corridor, and barely alluded to in the guidebooks), he never mentioned the fact. So we must proceed by guesswork and X-ray, our prime source of knowledge being the images themselves: three large canvases, one oil sketch, one lithograph, one traced drawing, plus Manet's later recycling of the main figure-cluster in *The Barricade*, a scene from the Commune.

It's normally tempting to confuse time sequence in art with progress. In fact, Manet's first *Execution* is so different in colour, tone and feeling that it stands not as some botched first attempt but as a grand and haunting alternative. The shared elements consist of a trio of victims, a huddled firing squad, and the single detached figure of a soldier designated (honoured? cursed?) to carry out the *coup de grâce*. In the first version, this NCO is the only character given any sort of defined face, and that is grimly expression-free; for this is a tight, swirling encounter, something vicious and shameful, in which one group of unidentifiable people wrests life from another, and where the oceanic colours run through executioners, victims and the backing

countryside alike. It even seems to be night-time (as in Goya's *Executions*), though we may work out that it isn't.

The shared image of versions II and III is tonally quite distant from I, being posed, sunlit, lucid. Even the smoke from the rifles carefully expends itself in such a way as not to obscure the victims' faces. But though the position of the main participants (and the structural echo of Goya) hardly varies from II to III, what happens behind them makes for a very different effect. In II the scene takes place on what looks to be a stretch of open ground, or perhaps a low hill; beyond are blue mountains and the sky. The action is therefore unspectated, anonymous, a moment of judicial brutality set amid nature, which seems in its warm blue continuity to be as indifferent as the firing squad. In III the participants are in what might be a prison yard, with sand underfoot, a high wall behind, spectators (protesting and woeful) hanging over the wall, more spectators up on the back hillside, and the cypresses and white tombs of a graveyard in the top left-hand corner. Now there is an element of the bullfight (death in the sand, aficionados at the palisade); there is internal comment on and reaction to the event, and an endorsing *memento mori* in the background. It is all more weighted, designed, and argued as a picture; it is also (compared to II) more conventional in its directing of our responses. In this sense III marks 'progress' from II. But in another way it is regress: as if Manet took the notion of indifference to its extreme form in II, and then retreated from its stripped-down bleakness.

They both, however, present images of extraordinary power; and it begins with the feet. In Goya's *Executions* the firing squad's stance is a crucial element: the hard ankle, the locked knee, the supporting back leg placed at the correct professional angle, and this stance echoed down the line of Napoleonic soldiery: these are the legs of oppressors, legs that stamp on protest, and whose rigidity marches on through the body until it reaches the final rigidity of the rifle.

The Execution of Maximilian (detail) by Manet

Whereas in the Manet *Execution* the soldiers are not lined up (technically there may be two lines of three, but the effect is of a huddle), and their feet are turned out at an angle of 120 degrees or so; one soldier keeps his heels together, others have their feet apart; the squaddie in the middle is idiosyncratically putting all his weight on his left foot, grounding only the heel of his right foot. These feet are clearly meant to be noticed, since Manet has embellished them with white spats (not a feature enforced by realism – the uniform Manet depicted was notional, synthetic). They are feet sinking themselves in for useful work, like when a golfer shuffles for balance in a bunker. You can almost imagine the NCO's pre-execution pep-talk about the importance of getting comfortable, relaxing the feet, then the knees and the hips, pretending you're just out for a day's partridge or woodcock . . .

So these executioners are not a block of death-dealers, as in the Goya: they are soldiers carrying out quotidian duties which happen to include executing an emperor. This theme of diligent routine is separately exemplified in the figure of the NCO. In the Boston painting (I), he stares straight out at us, turning his back on the execution and at the same time confronting us with the reality of his trade as a finisher-off of the inadequately slaughtered. In II and III he has become an equally insistent but much more subtle focal point. He is now placed at ninety degrees to the firing squad, neither attending to the execution nor turning away from it; equally, he is indifferent to us. Instead, eyes down, he is attending to his professional moment, cocking his rifle in anticipation (III) or checking that it is cocked (II). Significantly, Manet deprives his NCO of spats: we aren't to be distracted by his feet (in III they are further muted by being in a patch of darker ground) and we can therefore concentrate as intently as the soldier himself does on the cocking of his rifle. The NCO varies in two key aspects between II and III. In II his face is smoothly finished

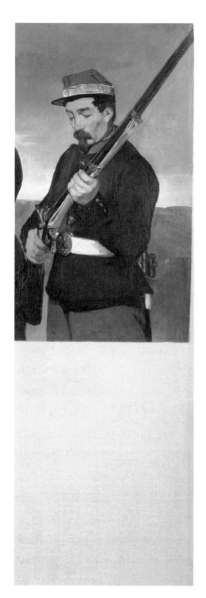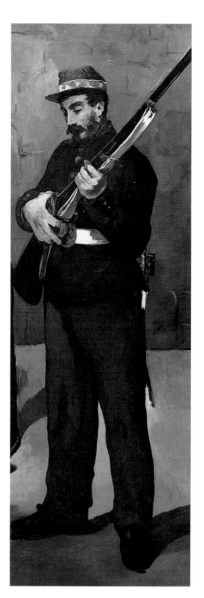

The Execution of Maximilian by Manet
Detail of the NCO cocking his rifle from the painting in London (left)
and the version in Mannheim (right)

and more characterised: this, you believe, is a particular person charged with this particular business. In III the brushwork is looser, the figure a trifle less specific: he becomes a bit more of an ordinary soldier like the rest of the squad. Both versions have their virtue and their defensibility. Where III does not seem an advance on II is in the treatment of the right hand. In II it is rendered naturalistically and in scale; in III it is larger, pinker, more spread: half as big again as his left hand, and bigger even than the painting's other fistic focus – the two joined hands of Maximilian and the general on his left. It draws attention to itself in an almost melodramatic way: Look what I am up to, the hand shouts from the canvas. This seems a small and unnecessary coarsening.

One contemporary critic complained that Manet's work manifested 'a sort of pantheism which places no higher value on a head than a slipper'. Pantheism, impersonality, indifference: just as the *Execution* works with a hard, even light, and flat, thinned planes, so its moral effect is strange, thinned, modern. It illustrates, of course, a dramatic moment, and we may admire the steadfastness of the victims, especially after Manet's plausible invention of the Emperor holding the hands of his two generals (in reality, he hadn't been in the middle when executed, and the generals might well have been shot in the back while sitting on stools, a common method of despatch for those judged traitors). But we may also admire the steadfastness of the executioners, their splay-footed comfortableness. This is not a history painting with a moral message about heroism: Manet used the phrase *peintre d'histoire* as the worst of insults. And maybe it is only passingly a political image: when the lithograth of the *Execution* was banned in 1869, Manet described it in a press statement as '*une oeuvre absolument artistique*'.

This was, of course, a little disingenuous, since Manet had chosen to portray a moment of extreme humiliation for the imperial dream

of Napoleon III, and had done so while adorning the figure of Maximilian with hints of martyrdom (that saint's halo of a sombrero, and perhaps even the central, Christly positioning); further, the uniform he had concocted for his firing squad was ambiguous enough to look French as much as Mexican, permitting the insinuation that the French, by abandoning their puppet emperor when things got rough, had as good as executed him themselves. This was certainly Zola's interpretation, though his two statements on the picture make an instructive contrast. In an unsigned contribution to *La Tribune*, the novelist, parroting the painter, announced that the lithograph had been banned despite 'M. Manet having treated this subject from a purely artistic point of view', wondering sarcastically if the government would soon start persecuting people merely for asserting the fact of Maximilian's death. Four days later, however, Zola was pointing out the ambiguity of the uniforms and remarking on the 'cruel irony' of Manet's picture, which could be read as 'France shooting Maximilian'. It is not just the hypocritical authorities who like to have things both ways.

Zola can't have it both ways; nor can Manet. Either the work is artistically 'pure' and just happens to have been taken from recent political events; or it isn't. But it's also true that the very act of banning the picture (which was never seen publicly in France in Manet's lifetime) had the effect of politicising it willy-nilly. Not of popularising it, though: *The Execution of Maximilian* was no *Guernica*, stirring sentiment outside its native land while banned within it. When exhibited in New York in 1879 (corner of Broadway and Eighth Street, admission twenty-five cents) it had little success. It played somewhat better in Boston, but the proposed tour to Chicago and beyond collapsed, and the canvas was shipped back to France.

Why exactly was the lithograph banned, and Manet warned in advance that the final painting would not be accepted by the Salon

of 1869? Again, an inviting blank looms. No official docket exists with ticks in the relevant columns for seditious intent or unreliable aesthetics. John House has argued that Manet's offence must have been much stronger than the mere portrayal of an event embarrassing to the government, since two other paintings relating to the execution, by Jules-Marc Chamerlat (both unfortunately lost – another blank), were accepted for the 1868 Salon. Perhaps the additional reason behind Manet's exclusion lay in the painting's 'seeming detachment from the drama and its refusal to point a clear moral', even in its 'summary brushwork and seeming lack of finish'. Perhaps; but it may be a mistake to be too rational (or too aesthetic) about the workings of censorship bodies. They are notoriously quixotic, developing their own eccentricities and exaggerated fears. If in doubt, ban it, is often the basic rule; especially ban it on the mere reputation of the artist in question (Manet was a known republican). But whatever the irre-coverable truth, the censorship of the *Execution* continues to act, by limiting posterity's knowledge. It was not just that the picture (and its affiliated lithograph) were suppressed, but also the reactions of the generation for whom it was painted, those who could tell us best how to read it. This absence adds to the picture's opaqueness for today's spectators. To this extent, censorship succeeded, as it often does.

Fantin-Latour: Men in a Line

Thirty-four men, twenty of them standing, fourteen sitting, spread across four paintings and twenty-one years. Almost all are sombrely dressed, in the black frock-coat worn by bourgeois and artist alike in the France of their day; the least sartorial departure – a pair of light trousers, a coat of proletarian grey, a white painter's smock – startles. The spaces in which these men are depicted are matchingly sombre, narrow from front to back, airless and claustrophobic: there is not a window in sight, and only in the final painting is a door indicated; otherwise, there seems no means of escape. There may be pictures on the wall, but not of the sort that offer any view outwards; they are darkly unreadable, returning us to the intense clusters of men. Occasionally, a slight relief comes in the form of flowers, or fruit, or a carafe of wine, and there is a red tablecloth, but even this is a murky red which does not break the dark tonality and funereal mood. And though each set of men has been gathered for a common purpose – to pay homage to a dead painter, to watch a living one wield his brush, to hear poetry read, to gather round a piano – none of them seems to be having any fun. There is not a laugh, not a smile to be had from the whole thirty-four of them (thirty-three, in fact, as one appears twice). Most give off a sense of gravity and high purpose, though quite a few appear distrait, lost in their own private world, even bored. Some are friends (two are lovers), most are allies, collab-orators, members of a self-selecting elite or avant-garde; and yet there

A Corner of the Table by Fantin-Latour
Detail showing (from left) Verlaine, Rimbaud and Léon Valade

is very little interaction between them. None of the figures touches his neighbour; they may abut, overlap, hide behind one another, but there is no contact. It is almost as if they can't wait for the sitting (and the standing) to be over, so that they may return to their own studio, workshop, study, music-room.

These four paintings by Henri Fantin-Latour (there was a fifth, which he destroyed after the critics trashed it at the Salon) are all now in the Musée d'Orsay. I have seen them several times in passing, and looked at reproductions in various books, but never realised before quite how peculiar they are, because – like most people, I imagine – I have never really examined them as paintings. I have always treated them just as examples of collective portraiture, and as such they are of the highest quality: look, we say, here's Manet, and there's Baudelaire and Monet and Renoir and Whistler and Zola, all to the very life. And here, just here, where most people stop, at the far left of *Corner of a Table*, is the most famous section – the corner of a corner – of any of Fantin's four paintings, because it shows Rimbaud and Verlaine sitting side by side. Rimbaud, the beautiful boy amid the beards, chin cherubically in palm, gazes out past our left shoulder; Verlaine, prematurely balding, is in half-profile, and looks tense, his right hand grasping a glass of the wine into which he will all too soon disappear. Yet even this pair, closest and most notorious of the thirty-four, are not looking at one another, let alone looking like bedmates. Inevitably, with such pictures, we concentrate on the famous names; it is virtually impossible for the contemporary viewer to give more than a brief, pitying glance at the likes of Louis Cordier, Zacharie Astruc, Otto Scholderer, Pierre-Elzéar Bonnier, Jean Aicard, Arthur Boisseau, Antoine Lascoux, and so on. And our pity contains an admixture, not exactly of guilt, but of unease: we are the posterity that has consigned them to oblivion.

We look at these pictures – at first, anyway – as anecdotal, as documentaries. It's the same with any group portrait, whether it be Ingres's *Apotheosis of Homer* or the latest colour-mag line-up of the Best of Young British Novelists. Who's new, who's hot, who's good, who's not going to cut the mustard? The critical triage starts immediately: I remember lining up with my fellow Young Novelists of 1983, and after we had left our images in Lord Snowdon's camera, one of our more sardonic members remarked, 'Well, they chose the best twenty from seven.' Few looked at the published photo to assess Snowdon's sense of composition, just as few pause aesthetically while the eye skates from nonentity to notable in a Fantin at the Musée d'Orsay. So Bridget Alsdorf's first achievement in *Fellow Men*[1] is a simple but serious one: she has turned Fantin's paintings back into paintings – into works which begin with an idea and a hope, and proceed through drawings and stubbornly wrong ideas to possible solutions, and then to more drawings, and finally oil sketches, and then via last-minute problems of sitter-unavailability to a final image which would all too soon be made available to the judgement of fashionable Salon-prancers, to critical misunderstanding and cartoonists' mockery.

Those four surviving pictures are enormous: the smallest is 160 x 222 cm, the largest 204 x 273.5 cm. They are not quiet mementoes for like-minded associates, but giant public statements, intended to insist, even bully. These are the coming men you should be paying attention to, the writers and painters we advise you to bone up on (though the final picture, *Around the Piano* [1885], is combative less on behalf of its individual participants than of the idea they all supported – Wagnerism). For a painter previously and subsequently known only for self-portraits and flowers, they offered a huge technical challenge: how do you arrange a number of similarly clad chaps in an interesting

[1] *Fellow Men: Fantin-Latour and the Problem of the Group in 19th-Century French Painting* by Bridget Alsdorf (2012)

way, how do you make them evidently and distinctly themselves, while also representing the wider idea they are assembled to publicise? Each picture adopts a different structure. The first, *Homage to Delacroix* (1864), looks rather turgid: four seated figures with heads at the same level, six standing figures with heads at the same level, and, on the wall behind, his head a little higher than those of the standers, a portrait (in fact, rather complicatedly, a painting of a lithograph based on a photograph) of Delacroix. The second, *A Studio in the Batignolles Quarter* (1870), is more innovative, with a diagonal, widening cascade of heads leading down to the canvas on which Manet is shown working. The third, *Corner of a Table* (1872), is the subtlest and also the least confrontational, both in title, point of focus (an open book from which a poet has, probably, just been reading) and structure: a curve of five sitters, closely backed by three standers, with the sides and front of the picture decorated with leaves and flowers and fruit. The fourth has a more conventional architecture, with an open score at its centre, and four black-clad men on either side of this creamy musical blaze.

But what sort of tribute, or manifesto, do these paintings deliver? Not at all a straightforward one. *Homage to Delacroix*, for instance, is fundamentally not a homage, simply because it is a painting by Fantin-Latour. In its realist mode, unflamboyant hues and rather tight-arsed structure, it is the very opposite of a Delacroix; while the fact that these homage-payers are all facing us, and thereby turning their backs on the image of the dead hero-painter, implies that they are certainly not going to carry on painting as he did. Hail and farewell, the painting implies. *A Studio in the Batignolles Quarter* turns out not to be of a studio in the Batignolles quarter, but rather a Studio Very Like Fantin's Own; the 'Batignolles School' itself was more a 'retrospective construction than reality' by the time Fantin memorialised it; while the very man who had originally baptised it, Edmond Duranty, was left out

of the picture because he had quarrelled with Manet (a falling-out for which he blamed Fantin). Such a back-story is perhaps not unusual: belonging to a group is often important for the younger artist (and writer), when mutual encouragement and a collective identification of the immediate enemy are vital; but soon, as the individual acquires more self-confidence, he or she frets at being labelled and grouped. So *Corner of a Table*, which might appear more homogeneous and harmonious, in that it features only writers (whereas the two previous group portraits mixed painters and writers), in fact shows a group as fissiparous as the preceding two. Rimbaud and Verlaine, by their public behaviour as much as their poetry, were to blow this little Parnassian world apart; and while the picture's softer greeny hues and the presence of fruit and flowers might suggest less austerity and more harmony, the large pot plant at the right-hand edge was forced on Fantin when Albert Mérat declined to appear with the pair of 'pimps and thieves' flaunting themselves in the picture's opposite corner.

Bridget Alsdorf's external evidence persuades us that all is not as solid as it seems in these monumental mementoes. But her internal evidence – scholarly, exact and closely argued – is clinching. When the critics of the day examined these non-touching, non-connecting, non-smiling assemblages of uncollegiate colleagues, what they mostly complained about – beyond Fantin's egotism and the group's self-promotion – was the pictures' lack of formal unity. Alsdorf convincingly argues that this lack of interaction between the figures, far from being a formal failing, is the very subject of the painting. What Fantin is interested in, and what he represents in paint, is the individual's internal negotiation with the group. The apparent awkwardness is intended: the participants are trying to work out how to protect and retain their individuality in the presence of brothers and colleagues who may also be competitors and swampers. Some of Fantin's preliminary drawings show animated exchanges between the different artists

Homage to Delacroix by Fantin-Latour
Detail showing Fantin-Latour

and writers, but these are eliminated as the image moves towards its final form. One of Alsdorf's most fruitful comparisons is with *Studio on the rue de la Condamine* (1870) by the middle-ranking pre-Impressionist Frédéric Bazille (who himself features in *A Studio in the Batignolles Quarter*). Bazille gives us a high, airy, open space, with a tall studio window, pictures of healthy nudes on the walls, and artistic activity going on in three separate places: to the right, someone is thumping the piano; to the left, two men (one halfway up a staircase) are in lively, doubtless aesthetic discussion; in the centre, Bazille himself stands beside his easel, showing a finished picture to two fellow-painters (one is certainly Manet, the other probably Monet). Art may still be only for blokes, but this is a light, bright, cheerful scene – it looks as it might if the breadliners of *La Bohème* had struck lucky and moved upmarket to grander quarters, with Mimi, restored to health, about to arrive with an enormous packed lunch. It is also, compared to Fantin's *Studio*, banal, both in conception and execution. Bazille's picture says: This is what it looks like to be an artist. Fantin's says: This is what it is *really* like to be an artist.

The life of such an artist is one of high anxiety and self-doubt, combined with ceaseless work which sometimes leads to nothing. These exact traits are typified by Fantin's second picture in his sequence, the one he destroyed on its return from the Salon (he kept only three portrait heads – of himself, Whistler and Ambroise Vollon). Alsdorf describes it as 'the most ambitious and disastrous of Fantin's group portraits'. It was called *The Toast! Homage to Truth*. If *Homage to Delacroix* was in part a protest against the quick public forgetting of its subject (Delacroix's funeral was poorly attended, and press coverage minimal), *The Toast!* (1865) was intended to make a noisier and more general claim for art – and for Fantin himself. Critics had been irritated by what they deemed his self-promotion in *Homage to Delacroix* – he not only stood out in his brilliant white smock against

a room of black frock-coats, he also conspicuously animated the picture by holding his palette out towards us, while the bunch of flowers in front of the dead *Maître* was Fantin's signature subject. *The Toast!* would prove a greater provocation still.

Alsdorf's intense discussion of the preliminary stages of *The Toast!* – which portrays Truth as a naked female figure holding a mirror amid a studioful of male artists – shows what effort Fantin expended to try and make his concept work. As it develops, it swerves between a pseudo-classical allegory (with other arts personified) and a more realistic Nude with Group Portrait; the supporting cast of artists constantly shifts shape and character; but the main and insoluble problems arise from the painting's central interaction between the figure of Fantin and the mythological figure of Truth. Painters had, over the centuries, frequently included themselves in multi-figure pictures, though usually stationing themselves at the edge, looking on with a slightly knowing expression, displaying an ostentatious modesty. But putting yourself centrally into a picture was a formal challenge as well as a critical hazard. Fantin's immediate point of reference would have been Courbet's *L'Atelier*, that massive, Promethean gesture which implicitly showed the Artist supplanting God as creator of the universe. But Courbet's ego was armour-plated compared to Fantin's; and Courbet depicted himself calmly painting the world (and being admired), whereas Fantin was trying to present himself in a complex engagement with a mirror-wielding allegorical nude. At first she is seen from behind, holding her mirror high, with an artist responding by holding up a big sign announcing VERITE. This is obviously crude. Next she is shown picking out the palette-wielding artist who responds with his other hand with a 'Who, me?' gesture (which makes for a kind of blasphemous Annunciation). Gradually, Fantin worked his way towards the picture's final form – evidenced by a late oil sketch – in which naked Truth with her

now-lowered mirror stands facing us from the centre back; all the artists (as in *Homage to Delacroix*) also face outwards – except for Fantin himself, who, while keeping one eye on us, reaches out an arm and points to Truth. As he put it in a letter to his English dealer Edwin Edwards, 'I am the only one who will see her.' Fantin was thus laying himself open even more to the charge of vanity; worse, the presence of a naked woman surrounded by clothed men was to revive the hysteria set off at the Salon two years earlier by Manet's *Déjeuner sur l'herbe*. Fantin was rightly worried that the public would view his picture as 'a painters' orgy'.

What Fantin didn't try, in all his adjustments, was making Fantin less central: putting himself, say, at the traditional edge of events. Alsdorf cites Félix Vallotton's (equally massive, and rather enigmatic) group portrait of the Nabis[1] (1902–3); here, the painter makes himself slightly smaller than the others, and a little off to the back, rather like a head-waiter watching over a lively gestural discussion. Fantin never considered this. Nor did he try an even more radical solution: lose the muse. Akseli Gallen-Kallela's *Symposium* (1894) is a Munchishly hallucinatory group portrait set at the Kämp Hotel in Helsinki after much drink has been taken. On the right sit Sibelius and his composer friend Robert Kajanus, in red-eyed, stupefied half-profile, cigarettes burning; next to them is the unconscious figure of the composer-critic Oskar Merikanto; standing to the left, and looking at us, is the artist

[1] The Nabis (of whom much more later) were the art group with one of the least appealing, and least usefully descriptive, names. The best christenings are often made by hostile critics: thus Impressionism and Cubism. The term Nabism – whose main adherents were Bonnard, Vuillard, Vallotton, Maurice Denis, Ker-Xavier Roussel and the sculptor Maillol – was officially coined by the poet Henri Cazalis. *Nabi* means 'prophet' in Hebrew and Arabic; so the Nabis were to revitalise painting as the ancient Hebrew prophets had revitalised religion. But there was nothing seer-like either in their subject-matter – modern, everyday urban life – or in their personal demeanour, which was generally modest. One satirical observer suggested that they were so named because 'most of them wore beards, some were Jews, and all were desperately earnest'.

himself. He is half-shadowed by what Sibelius and Kajanus are staring at: a pair of deep-red raptor's wings. The Mystery of Art has just called in on them, but is now flying away, we are invited to conclude. It is a melodramatic image which verges on the preposterous, but would certainly have seemed more so if Gallen-Kallela had stuck to one of his original ideas: no departing wings, but instead a naked, symbolic woman lying atop the tablecloth. Now that really would have looked like 'a painters' orgy'.

Even before he completed *The Toast!*, Fantin had major doubts, fearing that his subject-matter was 'truly absurd'. The picture was indeed accused of absurdity, pretension and vulgarity. One critic diagnosed 'a crisis of pride'; another dismissed the picture as one of 'these beer-mug paradises where the artist claims the role of God and Father, with his little friends as apostles'. Like much French criticism of the time, such remarks are malicious, smug and largely wrong, yet just right enough to curdle any self-doubt the painter might have felt. By destroying *The Toast!* Fantin admitted the picture's failure, and also the personal charge of egotism. Thereafter, he absented himself from his group portraits, and began a slow withdrawal from collegiality. He had been a passionate republican in early manhood, but was never a painter who went down into the street much; his way of representing the politics of the day was to represent those who were more active in them than he was (*Corner of a Table* was nicknamed 'The Communards' Meal'). So it was not a disaster – given the nature of his talent – that he chose increasingly to retreat to the Louvre, and to his own studio. In 1875, he wrote to the German painter Otto Scholderer (who stands to the left of Manet in *A Studio in the Batignolles Quarter*), 'You're right about Artist gatherings . . . Nothing measures up to one's interior.' In November 1876, he told Scholderer of his desire 'to go and live alone, away from all artists, as I don't feel I am like them'.

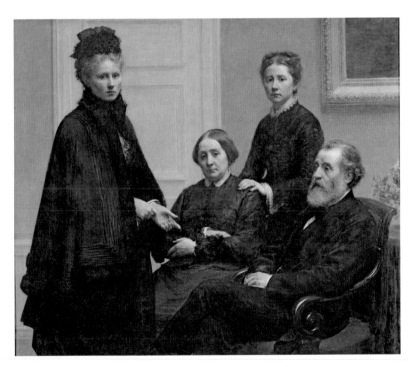

The Dubourg Family by Fantin-Latour

Coincidentally, that very same month he also got married, to Victoria Dubourg, a painter he met when they were both copying in the Louvre. Two years later he produced *The Dubourg Family* (1878), a group consisting of his wife, her sister Charlotte and their parents. Anyone suspecting an apparent incompatibility between wanting 'to live alone' and getting married should examine this painting: it must be one of the most sombrely alarming depictions of in-laws in artistic and marital history. Four black-clad figures – the parents seated, the daughters standing – inhabit a narrow space in front of a dun wall bearing the corner of a picture, which itself offers no relieving lightness; to the left is a door which looks as if it might be screwed shut. The feeling of dense and deadening domestic enclosure makes you think of early Mauriac novels; or of Chekhov's remark that 'If you are afraid of loneliness, don't marry.' In a further surprise, Fantin also formally privileges Charlotte over Victoria: from this, and other portraits of the sisters, you can't help wondering if Fantin wasn't himself wondering if he might have married the wrong sister. At least, and for a change, this group portrait does contain one figure who actually manages to touch another: Fantin's wife lays a gentle hand on her mother's shoulder. It is a strangeness of Fantin's considerable talent that his human portraits have the eerie, funereal look of still-lives; while his still-lives, the flower paintings by which he made his money (and also his name in this country), display all the vigour and life and colour of which he was inherently aware.

Cézanne: Does an Apple Move?

Cézanne had his first one-man show in 1895, at the age of fifty-six. His dealer Ambroise Vollard put the *Bathers at Rest* of 1876–7 in the window of his shop, safely knowing that it would cause offence. He also suggested that his client make a lithograph of the painting. Cézanne produced a sizeable work, known as *Large Bathers*, and heightened some of the impressions with watercolour. In 1905 Picasso bought one and took it off to his studio. Two years later its secrets fed into *Les Demoiselles d'Avignon*. Cézanne's influence on Braque was just as clear, and openly admitted. 'The discovery of his work overturned everything,' Braque said in old age. 'I had to rethink everything. There was a battle to be fought against much of what we knew, what we had tended to respect, admire, or love. In Cézanne's works we should see not only a new pictorial construction but also – too often forgotten – a new moral suggestion of space.'

Artists are greedy to learn and art is self-devouring; the handover from the nineteeth to the twentieth century was swiftly done. As was the handover from one kind of artist to another. Cézanne was an obscure figure even when famous; he was secretive, frugal, unacquisitive; he would often go missing for weeks on end; his emotional life, such as it was, remained deeply private and protected; and he had no interest in what the world called success. Braque, though a recluse by contemporary standards, was a dandy with a chauffeur; while Picasso single-handedly embodied the twentieth century's ideal

Homage to Cézanne by Denis
Detail showing (from left) the painters Redon and Vuillard,
and the art critic André Mellario

of an artist – public, political, rich, successful in all the meanings of the word, camera-loving and concupiscent. And if Cézanne might have thought Picasso's life vulgar – in the sense that it detracted from the time, and the human integrity, required to make art – how austere and high-minded Picasso would come to seem compared to the most 'successful' artists of the twenty-first century, flogging their endless versions of the same idea to know-nothing billionaires.

As a boy in Aix-en-Provence, Cézanne was robust, stubborn and adventurous; with his schoolfriends Émile Zola and Baptistin Baille, he formed a group who called themselves 'The Inseparables'. All came up to Paris, the aspiration of most ambitious provincials, in the early 1860s (Baille was to become a professor of optics and acoustics); but of the three, Cézanne was the most ambivalent about what might be gained there. Young and unknown in the metropolis, he and Zola together pondered 'the terrible question of success'. Their much later 'quarrel' turned out to be less a separation caused by Zola's novel *L'Oeuvre* – which outsiders assumed to be about his old friend – than a drifting-apart based upon the different answers each found to that question. (It's generally true that success, however defined, drives artistic friends apart more than failure does.) Zola needed his literary success to be expressed in material terms: big house, fine food, social advancement, bourgeois respectability; whereas the better known Cézanne became, the more he avoided the world. In his later years, when his work was being traded by the insatiable Vollard (who in 1900 bought a Cézanne from one client for 300 francs and immediately flipped it to another for 7,500 – an argument for *droit de suite* if ever there was one), the painter was living in a quarry, seeing as few people as possible, and reading Flaubert. In the modern world, one of St Antony's temptations would be that of artistic success.

Valéry held up Cézanne as 'the example of the dedicated life'. Alex

Danchev, in his new biography[1], calls him 'the exemplary artist-creator of the modern age'. An example more powerful than that of the artist who throws it all up (Gauguin found the voluptuous consolations of Tahiti in work and play; Rimbaud made good money as an arms trader), or the artist who goes mad and/or kills himself. More powerful because continuing to live can require more heroism than suicide: the constant work, constant striving, the frequent destruction of unsatisfactory work, and the need, as Cézanne saw it, for an incorruptibility in the life, on which incorruptibility of the work depended. Clive Bell noted the 'desperate sincerity' of Cézanne's work. David Sylvester concluded that his art, with its full acceptance of human contradiction, offers us 'a moral grandeur which we cannot find in ourselves'.

These are high claims, and Danchev skilfully holds in balance what Cézanne was, what he pretended to be and what others made of him. The myth was of a kind of noble, self-taught savage, an artistic *idiot savant*. True, he called himself 'a primitive', and was, as Renoir observed, 'as prickly as a hedgehog'; while, far from mellowing, 'he immatured with age', as Danchev nicely puts it. But the myth took root partly because he fostered it, played the game of 'being Cézanne', an artistic version of the wily peasant who always knows more than he lets on, and wins by pretending to lose. Underneath, Cézanne was cultured, literary and – to begin with, anyway – bourgeois. His hatter-banker-rentier father was more understanding than many such fathers, even finding a neatly self-congratulatory reason for supporting his son in his crazy calling: 'I couldn't have engendered an idiot.' He hadn't: Paul won literary prizes at school (his friend Zola won the artistic ones); later, his father bought him out of army service. He was well read in the classics; and also proved that it is possible, if rare, to be a Balzacian, a Stendhalian *and* a Flaubertian all at the same time. Monet

[1] *Cézanne: A Life* by Alex Danchev (2012)

called him 'a Flaubert of painting': certainly, Cézanne had the monk-ishness required; also, the belief that the artist behind the art should remain obscure. Though he was also – unlike Flaubert – rather prudish and proper when it came to women. He deeply disapproved of Zola's *sale-bourgeois* maid-tupping; and when, in old age, he painted female bathers, he used the life-drawings from his younger days rather than trouble a model (and, perhaps, himself).

Inevitably, we see him as the point where modern art began: so the first room of the Museum of Modern Art in New York, in its current hang, gives us a Gauguin and three Seurats on the left; out-numbering them, on the right and straight ahead, are half a dozen Cézannes. We also tend to prioritise his impact upon the mainstream Modernists who learned from him. Yet Cézanne's influence was much broader than this, affecting even painters who didn't follow his lead. This was very well put by the (formerly Swiss, then French, formerly Nabi, then independent) painter Félix Vallotton. On 5th June 1915, Vollard gave Vallotton a copy of his book on Cézanne, published the previous year. The painter read it straight through, and next day wrote in his diary:

> Reading the book didn't add anything to what I already knew of the man, nor to my view of his painting. Cézanne was a man who was necessary from every single point of view. We needed his example to bring things into focus, to make everyone take stock of themselves, of their methods of painting, of art in general, of life and 'success'. You aren't obliged to adopt the Cézanne 'style'; but when you spend time sharpening up your ideas, looking more closely at nature, at your palette and the tools of your trade, only good can come of it. Cézanne will have done immense service even to painters whose work is diametrically opposed to his own.

Some of his contemporaries suspected where he might lead; but they saw just as clearly where he had come from. So a friendly critic called him 'a Greek of the *Belle Epoque*'. Renoir said that his landscapes had the balance of Poussin, while the colours in his *Bathers* 'seem to have been taken from ancient earthenware'. Like all serious members of any artistic avant-garde, Cézanne was constantly learning from previous masters, studying Rubens all his life. And while we might admire his daring fragmentations of vision, what the painter himself sought was 'harmony', which was nothing to do with 'finish' or 'style'. It began with setting two tones in juxtaposition – just as Veronese had done. Cézanne hardly saw himself as founding something which others would later call Modernism; for him, painting meant expressing the truth about nature through the conduit of his own temperament.

'Talk, laugh, move,' Manet used to tell his models: 'to look real you must be alive'. Cézanne's sitters, by contrast, had to be guardsmanlike for hours. When Vollard made the mistake of falling asleep, the painter bawled him out: 'Wretch! You've ruined the pose! I tell you in all seriousness you must hold it like an apple. Does an apple move?' And when another sitter turned away to laugh at someone's joke, Cézanne threw down his brush and stormed out. So his portraits are the opposite of those made to catch a mood, a passing glance, a fugitive moment which releases the sitter's personality out towards the spectator. Cézanne despised such triviality, as he scorned the sedulously lifelike and the attempt to define character. 'I paint a head like a door,' he once said. And: 'If a head interests me, I make it too big.' On the other hand, there was something beyond 'character'. 'You don't paint souls,' Cézanne growled. 'You paint bodies; and when the bodies are well-painted, dammit, the soul – if they have one – shines through all over the place.' A Cézanne portrait, as Danchev wisely puts it, 'is more a thereness than a likeness'. David Sylvester called

The Card Players by Cézanne

the painter 'supreme in dealing with the problem of re-creating the density that people seem to have as we look at them'.

So Cézanne's portraits are all still-lives. And when they succeed, they do so as paintings governed by colour and harmony, rather than as visual descriptions of human beings who do normal human things like talk, laugh and move. Those card players bent over their table are never actually going to play a card or take a trick; they may be staring at the best hand they've ever seen, but the undertaker will arrive before they will be permitted to lay it down. Mme Cézanne, strapped into her chair by her husband's stern command to immobility, is not going to reveal her personality to us, however many times he paints her. She might as well have been his favourite door.

Though, of course, a door, or an apple, or a bowl, can be just as interesting, and just as 'alive' as a human being. Danchev quotes Huysmans, in somewhat exasperated admiration, referring to 'skewed fruit in besotted pottery'. That 'besotted' is wonderful. Because though an apple, unlike an art dealer, can hold an obedient pose until it begins to rot, it is also more than an apple, if we define an apple in terms of shape, colour and edibility. Virginia Woolf noted that the longer you stare at Cézanne's apples, the heavier they seem to get (so in a sense, yes, an apple does 'move'). Cézanne would doubtless have approved the aperçu. 'Grappling directly with objects' was central to his purpose. 'They buoy us up. A sugar bowl teaches us as much about ourselves and our art as a Chardin or a Monticelli . . . People think a sugar bowl has no physiognomy, no soul. But that changes every day, too.'

A bowl with a soul. Does a sugar bowl change every day? Of course the light on it may change, and so might our feelings (about its asso-ciations, or its intrinsic beauty), but the bowl itself? Its weight, its form, its surface? True, it may lead us towards wider, greater things: 'the crack in the teacup opens / A lane to the land of the dead' (Auden).

Madame Cézanne in a Red Armchair by Cézanne

But there is a point where a stern and principled pantheism shades into an implausible pathetic fallacy. Kandinsky wrote that 'Cézanne made a living thing out of a teacup, or rather in a teacup he realized the existence of something alive. He raised still life to such a point that it ceased to be inanimate.' This may be true, but then so is its opposite – that he lowered or sat on human life to the point where it almost ceases to be animate. Movement in the paintings is generally the movement of the viewer's eye, following the movement of the paint, rather than the representation of movement. Occasionally there might be a scurry of shorter brushstrokes animating the branches of a tree; but just as his colours rarely blaze – he used bright colours but in a grey light, as his friend and closest colleague Pissarro observed – his landscapes rarely stir. What they do, nonetheless, is express and inspire joy. One side of Cézanne holds the world down, paints it thickly as if to keep it pinned in place; another part has a buoyancy and dancingness about it – what John Updike called 'this oddly airy severity, this tremor in the face of the mundane'. It is also a lot about the colour blue: when the Barnes Collection moved into central Philadelphia and was rehung as before, but with greater natural light, Cézanne's blues (and greens) suddenly shone out in a new – old – way. If you were asked in a roomful of Cézannes that crass but reliable question – Which one would you steal if you could? – most people, I suspect, would choose either 'skewed fruit in besotted pottery' or one of those bluey landscapes with trees, water, a rising river-bank, hillside and the lozenge of a red roof in the distance.

Art, for Cézanne, had a parallel existence to life rather than an imitative dependence upon it. It had its own rules, sought its own harmonies, purged old-style interpretativeness and announced the democracy of tache-painting, whereby a patch or stain in the form of a pair of trousers was as significant as a patch or stain representing a head. Happily, all theories fall foul of life, and the inhabitants of

Cézanne-world were sometimes no more obedient than in the parallel world they occupied when posing. The painter, working on a portrait of his old friend the baker (and pipe-smoker) Henri Gasquet, tried to explain his procedures to Gasquet's son:

> Look, Gasquet, your father, he's sitting there, isn't he? He's smoking his pipe. He's listening with only one ear. He's thinking – what about? Besides, he's buffetted by sensations. His eye is not the same. An infinitesimal proportion, an atom of light, has changed, from within, and has met the changing or almost unchanging curtain in the window. So you see how this tiny little minuscule tone which darkens under the eyelid has shifted. Good. I correct it. But then my light green next to it, I can see it's too strong. I moderate it . . . I continue, with almost invisible touches, all over. The eye looks better. But then, there's the other one. To me, it squints. It's looking, looking at me. Whereas this one is looking at his life, his past, you, I don't know what, something which is not me, not us . . .

At which point Gasquet, permitting himself to break the pose and move his lips, observed, 'I was thinking of the trump I held until the third trick yesterday.' You don't paint souls, you paint bodies, and the soul shines through. But sometimes the soul is really concerned about the six of hearts.

Pissarro observed that when Manet came along, he made Courbet suddenly seem just 'part of the tradition', adding that Cézanne would do precisely the same to Manet. This proved true. And if Cézanne did to Manet what Manet did to Courbet, what have those – starting with the Cubists – who took over, absorbed and cannibalised Cézanne left behind of him? It is clear that he is where modern art – even Modern Art – begins; he is the unmissable link. Yet nowadays, on the

walls of the great public collections, he fits smoothly into what has become the tradition. We see the debts owed and paid to him. We understand why his fellow-artists valued and admired and collected him. On the other hand, we probably don't share his low opinion of most of his contemporaries, his utter contempt for Gauguin, or his preposterous notion that Degas 'isn't enough of a painter'. We certainly revere him as an example of artistic integrity, and savour the harmonies – which seem timeless as much as 'modern' – of his greatest paintings. Is this right? Is this 'enough'? Not for Danchev, who claims both at the start of his biography and at its conclusion that Cézanne's 'impact on our world, and our conception of our world, is comparable to that of Marx or Freud'. This seems more an enthusiastic, loving flourish than a sustainable argument. Danchev quotes Bresson saying that Cézanne 'went to the brink of what could not be done'. This may be true, but painting has continued, and art has changed, sometimes building on Cézanne's discoveries, sometimes not. Has our daily vision really become Cézannified? Is it as full of visual tropes as our mental life is of Marxian or Freudian tropes? At this point the reader might, like one of the painter's card players allowed to unfreeze for a moment, rap the table quietly and murmur, 'Pass.'

Degas: And Women

Great artists attract base prejudices; base but instructive. Jean-François Raffaëlli (1850–1924), painter of the Parisian suburbs, claimed in 1894 that Degas was an artist 'seeking to render ignoble the secret forms of Woman'; he was someone who 'must dislike women'; and in evidence Raffaëlli reported the words of one of Degas's models: 'He's a strange gentleman – he spends the whole four hours of the sitting combing my hair.' Edmond de Goncourt (who had his own sarcastic doubts about Degas, as about everyone else) noted down these charges in his diary and added, as a clincher, a story told him by the writer Léon Hennique, who had at one time had a mistress whose sister was Degas's mistress. Hennique's 'sister-in-law' had apparently complained of Degas's 'lack of amorous means'.

Could anything be plainer? He's got a small one (and/or can't get it up); behaves oddly with models; hates women; rubbishes them in his art. Case closed, defendant guilty, bring on the next artist for biographical slaughter. Nor should we laugh knowingly at such century-old crassness and putative envy (Raffaëlli was just about to start addressing the subject of Woman with his own brushes). Here is a critic of our time, Tobia Bezzola:

It is not known whether Degas had sexual relationships with women; at any rate there is no evidence that he did . . . [His] series of monotypes depicting brothel scenes is the most extreme

example of the mixture of voyeurism and abhorrence with which he reacted to female sexuality.

Or, if you prefer an even more catch-all version, listen to the poet Tom Paulin on *The Late Show*. Paulin went to the 1996 Degas exhibition at the National Gallery with the foreknowledge that Degas had been anti-Semitic and anti-Dreyfusard:

> I wondered how this would affect the paintings. You can't see it in the paintings, and I thought, Well, I should be admiring their beauty, but then I realized from reading this study of Eliot [by Anthony Julius] that misogyny and anti-semitism are closely connected, so that what we have in this exhibition are women in contorted poses . . . They're like performing animals, they're like animals in the zoo. There's some deep, deep hatred of women, and I thought, What does this remind me of, and I thought, Something like a concentration camp doctor has created these figures . . . I'm inside the head of someone who's a deeply, deeply hateful person . . . I think it's coded – basically what he's thinking about is women on the loo, and I think that is his eroticism. He's an old tit-and-bum man – a woman wiping herself – I kept thinking what would children think of this? – a woman wiping herself, it goes on and on.

Where to begin? With the fizzing puritanism, the biographical fallacy, the swift disengagement of first eye, and then brain? With the insistence that, even if you 'can't see' the wicked things you want to see in the paintings, you can still announce their presence anyway? With the discovery that 'admiring beauty' is a suspect business best dismissed by asserting that beauty's creator is someone you wouldn't employ as a child-minder?

Apotheosis of Degas by Edgar Degas and Walter Barnes

The exhibition that provoked this hissy-fit was of late Degas. (And, for the record, it included a single picture of a woman sponging the side of her knee, on which Paulin seems to have based his notion that all Degas's women are 'wiping themselves' lavatorially.) It showed a great and ageing painter working at that border-crossing between Truth to Life and Truth to Art, pushing constantly at or against form and colour and technique. Most single-artist shows tend to be cherry-picking jobs: the best example of this or that phase of the artist's 'development', the canvases on which the painter plays our favourite tunes. They are not actually misleading, but they are subtly deceptive if we therefore view the artist's career as a succession of lottery numbers, of wins and losses – masterpiece, dud, dud, semi-masterpiece, dud, masterpiece. An artist's career, as this show demonstrated, is more likely to be a matter of obsessional overlap, of ferrying back and forth, of process rather than result, journey rather than arrival.

Many of the works were on tracing paper, for reasons both aesthetic – tracing paper takes pastel particularly well – and practical: the image proposed (rather than arrived at) can be copied again and again. Copied, that is, in order to be reused and redeveloped, or even reintegrated into an entirely different composition. That twist of the hip, throw of the head, splay of the feet may turn up again sometimes on the same wall, sometimes two rooms away. The pose or gesture segues from charcoal to pastel to oil to sculpture (the role of the sculptures – not cast until after Degas's death – is nicely enigmatic: were they sufficient unto themselves, made to help the paintings, developments of the paintings, or all three?). Is it sentimental to sense an anger behind such fretful and unceasing investigation of certain forms? An artistic anger, that is, fury about time running out, about light running out (Degas's blindness was encroaching), when there was still more to be seen, still forms to be pushed further.

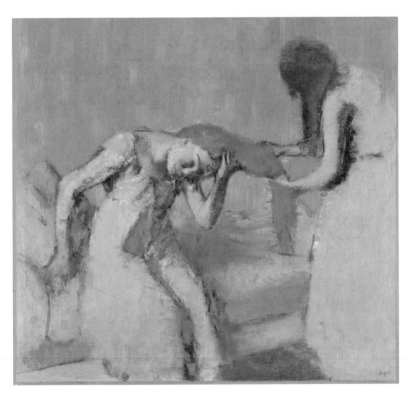

Combing the Hair by Degas

Time. Degas spent four hours combing a model's hair. What a strange gentleman, when the norm might have been: get your kit off, hop on that pedestal, and how about a quick drink afterwards? The 'strange gentleman' was always looking; and hair is a complicated matter. There is a story of Degas coming out of a party one evening and turning to his companion with the complaint that you never saw sloping shoulders in society any more. It's the tiny aside of a great artist. Goncourt reports the remark, confirms its justice, and seeks its explanation in habits of physical breeding over several generations; but it is Degas – the artist, rather than the novelist, social observer and art critic – who has *seen* it. Degas's tone, it's worth noticing, is one of lament. The story remains unannotated by Goncourt, but the lament is presumably an artistic one: at the realisation that the great and fundamental shape which was the subject of so many paintings was changing, if not exactly before his eyes, but within his lifetime – and would continue to change thereafter.

Four hours (and this was only one 'four hours' among many): Degas's work is full of moments in which hair is 'seen'. Intimate, informal hair – hair with its hair down. Degas knows how a woman holds her hair to comb it, how she supports it when another is combing it, how she alleviates scalp-strain with a flattened palm at the tuggingest moments of the business. But (truth to life melting into truth to art) hair is also malleable and metamorphic, eager to take abstract form. In many of the after-the-bath pictures, it echoes and plays against the twists and cascades of the towel, sometimes appearing to trade places. In *Woman at her Bath* (1893–8) there is even a jokey piece of visual misleading: what we take to be the woman's bunched-up dark hair is in fact the maid's water-jug, poised to rinse, while the head itself is ducked down forwards.

The modern female body represented in a state of intimacy by an observing male. A century on, we have become more self-conscious spectators; queasiness and correct thinking have entered the equation.

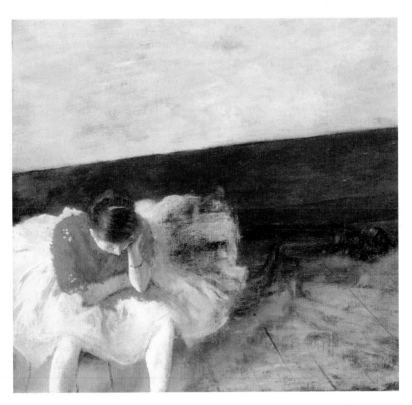

The Dance Lesson (detail) by Degas

The artist also helped things along with his much-quoted statement that 'Women can never forgive me; they hate me, they feel I am disarming them. I show them without their coquetry.' Perhaps extremely coquettish women did hate him for his art; perhaps the models he shouted at (but whom he also treated with 'enormous patience') felt they had earned their corn. But we should avoid being too easily outraged on behalf of people we have never met. And there is another point to remember: as Richard Kendall has demonstrated, it was often women who were the first purchasers of these intimate scenes of female grooming.

This isn't an easy area: we all import our prejudices. At the National Gallery press view I ran into a museum director who said he thought the pictures were all about 'the decay of the flesh'; whereas it seemed to me that Degas was portraying flesh at its most robust. His ballet-dancers are not the sylphs and nymphets – delicate but also mildly porno – that previous male painters had portrayed. They are real women engaged in hard physical work, who sweat and complain, tear muscles and bleed from the toes; but who even in their states of exhausted resting (that hands-on-waist, backstrainy, can't-wait-for-the-day-to-end pose) imply a vital physical life. Is this just my prejudice? As it's my prejudice to differentiate between the life, in which Degas may or may not have expressed the misogyny of his time, and the art, in which it seems to me that Degas plainly loved women. That remark needs immediate qualification, of course (when he painted he wasn't 'loving women', he was making a picture, and the picture was doubtless what filled his mind), but otherwise let it stand. Do you constantly and obsessively fret at the representation of something you dislike or despise? 'For each man draws the thing he loathes'? On the whole, not. Would Degas's 'lack of amorous means' (if true – and there is, absurdly, some recently discovered evidence of condom-buying to dispute it) have made him a misogynist? Not necessarily: it might even make him the more attending observer.

The artist as 'voyeur'? But that is exactly what the artist should be: one who sees (and voyeur can also carry the sense of hallucinatory visionary). The painter who tortured his models by forcing them into uncomfortable poses? Except that he used photography, and also memory (and tracing paper). The brothel-depictor who thus let slip his 'abhorrence' of female sexuality? Yet Degas's brothel monotypes seem to me to reflect all the jollity, boredom, absorption and professionalism of those engaged in this assembly-line trade; while the tone is no more abhorring than it is in Lautrec's brothel pictures. Perhaps Lautrec's reputation as a merry figure marginalised by dwarfism – and thus on a moral level with the marginalised prostitutes – works for him, whereas Degas's works against him. The graphic output remains the same either way. But if you look at, say, Degas's *La Fête de la patronne* and see only abhorrence of female sexuality, then I suspect you are in deep critical – and maybe also personal – trouble.

Another line of disapproval proposes that the frequent averting of the face in the later paintings indicates quasi-pornographic intent. All arguments imply their opposite: you might equally argue (if you wanted to) that the averted face is that of a woman ignoring the painter/spectator, aloof in her privacy and self-involvement. More to the point: this is not portraiture; or at least, not portraiture as the depiction of revealed character. It is portraiture of the body as form, the end of a lifetime's search, which had begun for Degas long ago with Ingres's instruction: 'Draw lines, young man, draw lines.' Degas at one point owned Ingres's *Angelica Saved by Ruggiero*, as well as a pencil study for *La Grande Odalisque*. How far Degas took the representation of the female body can be seen by reconsidering these two works. The painting shows the nude as all about finish, sheen: woman depicted in exalted splendour even when in peril and torment. The drawing shows the nude as all about line: woman with a spine as architectural as the keel of a Viking ship and a breast which, despite

what the turning-away pose would have done for it, keeps a silicone splendour. Chez Ingres, the mammarial is marmoreal; chez Degas, the breast has the mobility, slope and fall of real life. Idealisation versus naturalism. Of course, male artists depicting the female nude are bound to get it in the neck from someone; we have our current preferences and principles – though they are, of course, only current.

The National Gallery show included *The Millinery Shop* (1879–84). You could, if you were a plodder, see it as another example of the 'averted-face' approach; for yes, here is the milliner with her face half-turned away. But that's because this is a painting about hats. It's not a portrait, it's not about work, it's about hats; here, fabric is the equivalent of flesh. Its plain boldness of design recalls Degas's great portrait *Woman with Chrysanthemums*. This is, more properly, *Chrysanthemums with Woman*: the sunburst of flowers occupies the centre of the canvas, while the woman looks out of frame to the spectator's right. Whenever I see this painting (which lives at the Metropolitan Museum in New York), I hear a challenge and an implicit question: You think you know what a portrait is? There are more ways to paint a woman and a bunch of flowers than you or I have even dreamed of, this picture whispers. And in this respect it foreshadows what we see more vividly and hauntingly in late Degas: the artist pushing at form, at colour, at the still-expandable possibilities of human form and movement. If he was unforgiving of his models, he was no less unforgiving of himself, and of what art could see and show.

Redon: Upwards, Upwards!

There is a strong tradition in the nineteenth century and on into the twentieth of artists seeing marriage as the enemy of art. Love, yes; marriage, no. Flaubert took the wedding of any literary friend as a personal betrayal, and beyond that, a betrayal of their shared art. The Russian Impressionist painter Leonid Pasternak worried that domestic happiness had undermined his talent, and that his art had required more pain to gain its fullest expression. The composer Delius believed that the artist shouldn't marry, or if he did, it should be to a woman who loved not his person but his art. There is, usually, no answer to this dilemma: only, far in the future, lost alternatives long in the past. But the notion that the bourgeois institution of marriage cages and tames the wild, truth-seeking artist was widespread, and is typified by this entry from the diary of the *littérateur* Paul Léautaud. It is 11th February 1906, and he has been dining with his friend Henri Chatelain:

We talked about the influence of a domestic life on an artist. Advantages: fewer material anxieties. Disadvantages: the change of atmosphere and mood, a diminishment of individuality and of independence: one can no longer write one's most secret thoughts or describe one's most secret adventures, except by transforming them into a work of the imagination. You would need to possess: 1) An absolute will to be free and independent

in this sense, in respect of and despite everything. 2) A well-developed sense of doubleness: in the dining-room, with one's wife, one is like so – while at the same time, in one's study, one is a man alone, free and without entanglement . . .

The woman (assuming the artist is male) is always on a loser: if she brings money into a marriage, this is imprisoning; if she doesn't, she brings anxiety. If she makes him happy, she dulls his artistic edge; if she doesn't, she acts as an additional distraction from his art. And then there is sex (which a lot of this is often about). Even if prevailing social hypocrisies apply, and the man is allowed to roam – but appearances are kept up – what happens if he wants to write about it? The difficulty, or impossibility, of divorce was also an unspoken factor; and in this respect things are easier. I remember reading an interview with Brigid Brophy in a student magazine back in the Sixties; asked what a writer needed most to help him or her write, she replied, 'A wife' (read: secretary, shopper, cook, typewriter-ribbon-changer, therapist . . .). Flaubert advised artists to be regular and ordinary in their lives, so that they might be violent and original in their work. Marriage is one way of being regular and ordinary.

However, we may be looking at things back to front. Perhaps, instead of looking at an artist's life and letting it colour or decide our view of his or her art ('lacks boldness', 'not enough imagination', 'needs to have experienced more pain' – 'ah, if only he/she hadn't married'), we should look at things from the opposite direction. Can we deduce a writer's, painter's, composer's marital status from their work? Who sees marriage more clearly, the married or the unmarried? Do the childed or the unchilded portray children better? Jane Austen, Flaubert and Henry James were all secretly married and had multiple children: if this discovery were made tomorrow, would it change our view of their work? Courbet failed to impress a 'village sweetie-pie'

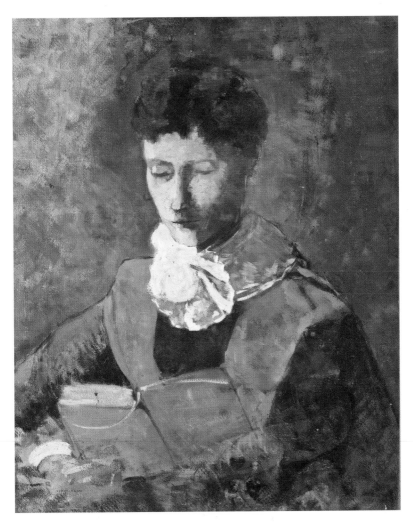

Madame Camille Redon Reading by Redon

and never married; Delacroix imagined marrying a woman equal, if not superior, to him, but quickly gave up the search; Manet was married, but a serious chaser (and catcher) of other women. Do we imagine they would have painted differently had their statuses been reversed? It is unverifiable; also unfalsifiable.

If you were shown Odilon Redon's work and asked to deduce his life from it, what would you say? His strange world is filled with the fantastical and the phantasmagoric, with dark and aberrant images, and you might feel justified in guessing a similar life – a Baudelairean one perhaps, filled with opium, hallucination, mulatto mistresses and travel (or the dream of travel) to exotic lands. You would be unlikely to guess that he lived an entirely happy married life, was deeply uxorious, painted his wife constantly over thirty years, and wrote the following:

> You can tell the nature of a man from his companion or his wife. Every woman explains the man by whom she is loved, and vice versa – he explains her character. It is rare for an observer not to find between them a host of intimate and delicate connections. I believe that the greatest happiness will always result from the greatest harmony.

He wrote this not as a complacent husband, but nine years before he met his wife, Camille Falte. He also said that no decision he took as an artist was as clear-cut and unshadowed by doubt as when he said Yes on their wedding day.

So, an easier, less theoretical question. How, as an artist, would you fare in the chimney-flue test? Rodolphe Bresdin, etcher, lithographer and teacher of the young Redon, put it this way, with 'gentle authority', one day in 1864:

Look at this chimney flue. What does it say to you? To me it tells a legend. If you have the strength to observe it well and to understand it, imagine the most strange, the most bizarre subject; if it is based and remains within the limits of this simple section of wall, your dream will be alive.

Redon, reflecting on this advice in later years, complained that most of the artists of his generation had looked at a chimney flue and seen nothing but a chimney flue. They were, as he put it in *À soi-même*, 'true parasites of the object', who 'cultivated art on a uniquely visual field'. A few of his contemporaries (unnamed, but presumably the first wave of Impressionists) are given light praise for having followed 'the path of truth in the forest of high trees', for having walked 'with the swagger of convinced rebels', and having held 'for an instant a part of the truth within the truth'. But there is no room for compromise: Redon was equally condescending about Ingres ('lacking in reality') and Bonnard ('a good sort of painter, serving up easel paintings which are often witty'). True art couldn't content itself with a uniquely visual field; and true artists shouldn't settle for less than the whole of the truth within the truth. Art, he maintained, only begins with what 'surpasses, illuminates or amplifies the object and amplifies the mind into the realm of mystery'.

We don't know why Bresdin fixed on the chimney flue rather than anything else around the house, but the choice has a particular pertinence to Redon. A chimney flue is a system for carrying transformed matter upwards: such, too, might be a basic definition of Redon's art. It is an art of aspiration and transubstantiation, embodied in images which rise on an upward draught towards the higher reaches. Pegasus the winged horse stands here as symbol of the artistic imagination; heads, severed or lightly tethered, float as if helium-assisted; Berenice's teeth levitate snappingly amid the library shelves; the horses of

Apollo's chariot roar aloft; humanity seeks everywhere to rise from barbarous sliminess. Images of buoyancy and upward-floating are so central and thematic that they invade even Redon's calmer and more naturalistic work. Beneath the waves there are hovering seahorses borne aloft by currents; above the ground there are larvae pupating into butterflies. Nor is it just larvae: in his more seething flower pieces, the very flower heads – de-stemmed, hovering, fantastically coloured – are halfway to flapping butterflies. Nasturtiums are in a way the perfect Redon flower: they offer vibrant colour, and when placed in a vase don't stand sentry-like but flop and float, their leaves and flowers displaying circular self-reliance. At first it's surprising he didn't paint them more often. But perhaps the problem with nasturtiums is that they do the work for you: stick them in a vase and they immediately diminish the artist's transformational function.

Set against the upward surge of Redon's art is a terrible countervailing fear of being grounded, earthed, abandoned, cut off from the ability to soar. A mournful centaur looks wistfully up at the cloud that gave him birth; a fallen angel scans the lost heavens; a manacled angel is prevented from take-off. Mankind too is handcuffed, cabined, stunted: the frontispiece to Redon's 1879 album of lithographs, *Dans le Rêve*, shows the poetic imagination coming to the aid of a pollarded tree that represents the human spirit. As much as we want to soar, we are held back by corporeality, by melancholy, by our lower desires. Or we may soar, and yet still not escape them: one of Redon's key *noirs* is of a hot-air balloon, its canopy decorated with the face of a noble, aspiring human, while in the basket squats a monkey, the embodiment of all we cannot leave behind. This theme, image, question – if we can soar, how can we soar? – is examined obsessively in Redon's sequence of severed heads. Some lie flat on dishes, others float; some are attached like plant heads, others are loose on a frolic of their own; some have little wings

Chimera (Fantastic Monster) by Redon

attached, others hidden gas-burners. The severed head might look like the result of an execution, a final grounding, but in fact is often the opposite: if the mind is to be elevated, then it must be separated from the body, these *noirs* frequently argue. Sometimes the severance is literal, or rather scriptural, as in the case of John the Baptist. More often it is emblematic and phantasmagoric: the weeping spider, the rearing cactus head, the whirling tadpole, dark members of a bodiless tribe of serene, grinning, anguished and lamenting heads. Their example even haunts some of Redon's later, calmer work. The mood of the 'Closed Eyes' sequence of paintings is contemplative and mystical, and their colouring couldn't be further from that of the *noirs*; but the fact of the image (eyes closed as in death) plus their repeated framing (portrait cut off at neck or top shoulder as if by a guillotine) brings an echo of the darker earlier work.

Redon's reputation has been on the rise in recent decades: there have been big shows in 1994–5 (Chicago / Amsterdam / London) and in 2011 (Paris / Montpellier). They have confirmed his obsessiveness of image; but also, more surprisingly, his artistic restlessness. He is forever on the move between techniques and subjects, always experimenting. 'The painter who has found his technique', he once wrote, 'does not interest me.' He is also unusual in that he had his dark period first rather than last: he escaped the shadows, rather than feeling them close in with the years. First the blasted landscapes, the Poeish horror, the melancholy terror and abandonment of the *noirs*; later the phosphorescent palette, the lapis blues and conker browns, the hazy purple and nasturtium orange, the pastelly blush and bruise. First, too, the more personal, the suggestive, the private dreaming; later the more public, the more programmatic. And no, there doesn't seem to be any obvious biographical connection between this artistic line of fracture and events in Redon's life.

That the narrative breaks so sharply into two halves is a curator's dream: and in both Amsterdam and Paris the shows were organised to body it forth. At the entry level the earlier work lived among lowish ceilings and – of necessity – lowish lighting: here dwelt the severed heads, the dark fantasies, the grounded angels. Upstairs, with full light, high ceilings and uncurtained windows, Redon's art burst into full colour and (literally) flower: here were the crammed vases, the burnished and symbolical barques, the exalted profiles glowing as if through stained glass, the society portraits, the tapestry chair-backs. Downstairs was the work so hailed by Huysmans ('exceeding the bounds of pictorial art and creating a new type of fantasy, born of delirium and sickness') and so reviled by Goncourt ('fantastical productions extruded by a senile lunatic at stool on a commode'); upstairs the work hailed by the Rosicrucians and latter-day mystics, the work praised by Matisse and loathed by Tolstoy, who saw *The Golden Cell* in London and thought its colours – mainly ultramarine and goldeny-brown – were proof that modern art had gone mad.

And now? There are two main problems with Redon, one of them ours, one of them his. Ours springs from the normal tendency to see artists in terms of influence and descendency, and from the normal pleasure we take in self-congratulation. We look at his work and handily spot, say, a bridge from Romanticism to Surrealism, or a graphic precursor of psychoanalytical studies. The literary connections in his work give us good excuse for otiose verbalising: Poe, we murmur, Baudelaire, Flaubert, Mallarmé, Huysmans. At a Redon show there is the buzz of the twentieth (and twenty-first) century applauding itself for the fact that Redon was on its side and had so accurately predicted us. Does not *Dans le Rêve* prefigure Magritte and Ernst? Could not *The Distributor of Crowns* have been painted by some 1920s German satirist? Nor is Redon's descendency by any means confined to high art. His winged heads lead to Monty Python; *Young Woman in a Hat: Mlle Botkin*

The Cyclops by Redon

is pure Adrian George; while his gobstopper eyes have become a kitschy park-railing trope. Some of what is bad in modern art and wider visual culture finds a possible source and justification in Redon, which makes it difficult for us to see the originals in an unprejudiced way: the 'Closed Eyes' series, with their quietly queasy colours and slight air of smug mysticism, seem like shop-signs for some cut-price, joss-stick-waving guru. At times there is so much aesthetic static around Redon that it comes as a relief to hear the occasional bark of guiltless philistinism. In Amsterdam I was halted in front of the late and leering *Cyclops*, uncertain what to make of it, when a party of Frenchwomen came past exuding that breezy yet proprietorial manner which somehow only the French are confident enough to affect in art galleries. The first woman donated the painting a glance and crisply announced, as if art were merely life, *'Ah, quelle horreur!'* This sublime lack of irony caused her two companions to pause briefly and tame the portrait of the one-eyed giant. *'C'est une dorade,'* suggested one. *'Non, c'est un turbot,'* replied the other; and having thus despatched Redon to the fishmonger's stall, they passed on to the flowers. *'Ça, c'est beau.'*

Redon's own problem – and it is the more interesting one – lies in the answer to the following question: How far does an artist's individuality develop as the result of pursuing and refining the strengths of his or her talent, and how much from avoiding the weaknesses? You would think both, of course – yet Braque will have something to say on the matter (and bring in the countervailing example of Picasso, who had no obvious weaknesses, only a sackful of competing strengths – which may itself work as a weakness). With Redon, the weakness, of which he was well aware, was both particular and basic. In *À soi-même* he describes his artistic education, recalls the 'tremblings and fever' incited by his first view of Delacroix, and the 'fervour' he

felt at his initial contact with the work of Millet, Corot and Moreau. He continues:

> When, afterwards, I went to Paris to direct my work towards a more complete study of the live model, it was too late, fortunately: the fold had been made.

This is true: he never drew the human body as well as he drew a tree. There is no figure drawing to match *Pollarded Tree*, no portrait to match the *Tree with Blue Sky* of 1883, with its triangular, semi-abstract trunk and floating mist of foreground foliage. He was also much better at rocks, and many of his early-period women have a chunkily carved quality to them: his *Angel in Chains* would have a hard time becoming aerodynamic even without its chains. When he took to portrait painting in later life, he fell back on stylisation: many of his women tend towards the same decorative aquilinity, and their main interest often lies elsewhere: for instance, in the pastel of Madame de Domecy, the way the flower background invades the sitter, petalling her blouse and perhaps even her jacket.

'Fortunately' is the key word in Redon's statement. He means, presumably, that his art escaped the dead hand of the painting schools, and would have been hindered, if not actively trampled, by some enforced back-to-basics. Naturally, and rightly, he made a combative virtue of the lacuna in his art education:

> I am quite willing to admit that modelling is essential in our art, but on condition that its only aim is beauty. Outside of that this famous modelling is nothingness.

Put this view beside another of his quotes from Bresdin the Flue-man – 'Colour is life itself, it abolishes line under its radiance'

– and you have the makings of his later art. It glows and sizzles with colour; it creates its form by overlappings and coalescings; it tends to act centrifugally rather than centripetally. It is an art of luscious high-mindedness and iridescent monumentality. It aims to uplift and inspire, and when it doesn't it can seem clunkingly pious, if not actively potty. Are there any takers for *Monk Reading (Alsace)*?

If Redon no longer attracts Tolstoyan or Goncourtian antipathy, he still provokes some oddities of judgement. David Gascoyne asserted in *Surrealism* (1935) that 'were Des Esseintes alive today he would have a special weakness for Salvador Dalí, whose horrors easily surpass those of Redon'; while the poet John Ashbery finds 'Redon's realistic paintings more fantastic than the imaginary ones, and the flower pieces stranger and more disturbing than the monsters who lurk in his graphic work'. Ashbery's line seems one of mere willed paradox (*Disturbed by Flowers* – a sequel to C.S. Lewis's *Surprised by Joy*). Redon is one of those painters so variously and at times so flagrantly talented (his few still-lives are tremendously bold – look at the russet background of the *Still Life with Peppers and Pitcher*) that we are tempted to go round the critical block more than once. But only perversity would take us away from the certainty that the *noirs* are – as he thought too – his best work. They represent the moment when his technique most closely matched the forms he wished to create.

The *noirs* are also more purely artistic, less literary and referential than the later work. This may seem paradoxical, since any number of them are presented as illustrations: to Poe, Flaubert, Pascal, and so on. But the images themselves are so fiercely invented that they float free of their originating text: the 'illustration' to Pascal's *The Heart Has Its Reasons* shows a man naked to the waist before a stone doorway (or perhaps window), with a Picassoid head and long ringlets, thrusting his right arm up to the wrist into a cavity in his chest. It is a simple, terrifying image – fist-fucking the heart – whose source is

irrelevant, whose impact pure Redon. The haunting, floating *Teeth* don't send us back-pedalling to Poe, while an image like *The Tell-Tale Heart* may well be the more haunting if we *don't* go back to the text; likewise the chimeras and wreathed skulls of the *Temptation of Saint Antony* series. The later Symbolist paintings, on the other hand, even if they don't have their source in lines of text, seem more 'literary'. They need more explanation, more briefing notes; they stand on their own less well, and they seem to insist not just on our understanding their symbols, but on our accepting them. Unlike traditional Christian painting, where an agnostic can mug up the story and imaginatively enter the picture, what Redon asks you to mug up on seems specialist, rebarbative and even spiritually silly. His work does indeed divide into two levels. We tan lightly in the glow of his later colours while remaining indifferent to the message; whereas the *noirs*, which are Redon's glory, hover, haunt and linger like mutant products of the world's shared private imagination.

Bonnard: Marthe, Marthe, Marthe, Marthe

In May 1908 André Gide went to an auction in the rue Drouot in Paris. 'A Bonnard is put up,' he records in his *Journal*:

> rather badly put together, but racy; it represents a naked woman dressing, and I have already seen it somewhere or other. It climbs rather painfully to 450, 455, 460. Suddenly, I hear a voice shout '600!' – and I am dazed, for I myself am the one who just shouted. With my eyes I implore a higher bid from those around me – for I have no desire to own the painting – but nothing is forthcoming. I feel myself turning purple and begin to sweat profusely. 'It's stifling in here,' I say to Lebey. We leave.

Gide's stress is on the absurdity of the impulse, the inadequacy of the object that incited it, and, subsequently, on the peculiar generosity of the auction house, which rounded his bid and their invoice down to 500 francs – as if sympathising with an obvious fit of lunacy. But you might, if you chose, read the story a different way: work by a great artist penetrates the soul even when we don't want it to, when we mentally resist it, even when its 'raciness' is aimed at another sexual orientation. Despite all this, the painting makes you fling your paddle in the air.

As Gide's story implies, Bonnard can be a wrong-footing artist. I remember once seeing three major shows of his work within a single

The Anabaptists: Pierre Bonnard by Vuillard

decade, and each time my initial response was: What a skilful curator to have chosen almost nothing but masterpieces, with very few of those pictures that a novelist might mistakenly buy at auction. It's as if there was some fierce, subliminal emanation of Bonnard's famous modesty inhibiting the correct response: what a great *painter* to have *painted* so many masterpieces, so few duds. The second response – this time uninhibited – was to be startled each time by his solidity of purpose and passage: once he emerged from subtly blockish Nabism and lampshaded Intimism, he became unequivocally, unswervingly Bonnard. He painted only what he was best at painting, and echoes of other artists are rarely heard. Is that *Large Yellow Nude* briefly reminiscent of Matisse? Perhaps a bit, at first (though others name Munch); but not for long.

Nor does 'being Bonnard' imply some cud-chewing repetitiousness. There is, as Larkin pointed out, a totemic emphasis nowadays on what is called an artist's 'development'; whereas an artist's true development may be less a discussable succession of styles than a determined readdressing of visual truth, a fretting at the way in which beauty emerges from form, or form develops out of beauty. When Bonnard, towards the end of his life, told a group of visitors to Le Cannet, 'I am an old man now and I begin to see that I do not know any more than I knew when I was young', he was not (or not only) being modest. He was also being wise.

Bonnard's breakout from half-lit, dark-hued Intimism to bright hotness was dramatic: the awakening first to yellows, oranges and greens, then to pinks and purples. This explosion, or liberation, looks at first to be merely topographical: the apartment-bound Parisian discovers the sunny south. But light now blazes indoors as well as out. There is also a shift in the time of day being represented: previously, there were many evening scenes, in mood as well as in fact; now there are almost none. Everything – even Marthe in her bath –

seems to take place a few hours either side of lunchtime. There is another shift too – of personnel. Bonnard's early work is quite normally populated: street scenes, conversation pieces, family gatherings; in the south, the population is quickly reduced to one dog, a cat or two, the painter himself, a visitor perhaps, and Marthe, Marthe, Marthe, Marthe.

Bonnard's subject-matter is sometimes so seductive as to be problematic. These French domestic interiors, with heat outside and languor within, these meals, this fruit, those fat-bellied jugs, the window, the view from the window, the blood-red under-tablecloth, the propped-open door, the fat radiator, the appealing cat – doesn't this look like the ultimate, the platonically ideal *gîte* from Vacances Franco-Britanniques? Bonnard is the painter of the Great Indoors, even when he's painting the Great Outdoors. Landscape is frequently viewed from the safety of the house, through a window, from the perch of a balcony. But even when directly confronted, it remains charged and static like an interior. Those dappled woods are like wallpaper – though, since this is Bonnard wallpaper, it is wallpaper almost as alive as nature. Is there any wind in a Bonnard landscape? His skies are dramatic in their colour, rather than in any present or threatened action. And since there is so little wind, Bonnard leaves never fall from Bonnard trees. One London critic, infuriated by such dense luxuriance, described the gardens glimpsed through Bonnard's windows as 'over-planted'. At last – a painter brought before the tribunal of *Gardeners' Question Time* ('And whiles we're about it, that Douanier Rousseau feller's bin plantin' too many of them giant succulents on his patch').

But even Bonnardistes occasionally find themselves wondering if they aren't enjoying all this a bit too much; or for wrong, rather cheap reasons, not unrelated to grey London skies. John Berger called Bonnard's world 'intimate, contemplative, privileged, secluded': two

Nude in the Bath by Bonnard

descriptive adjectives followed by more morally tinged rephrasings. Maybe there's some truth in Picasso's assertion that Bonnard had an 'extra dose of sensibility' which made him 'like things one shouldn't like' – and, presumably, love things one shouldn't love. Marthe would probably come under this heading. What's he doing, shut up with this woman, painting her 385 times? Either he's some sort of domestic obsessive, or a wimp whose wife won't let him paint anyone else. A second London critic found it 'incredible' that Bonnard was still painting Marthe in the bath five years after her death. Time to move on, old chap! Just because she's your muse, your obsession, your prime subject, doesn't mean you have to carry on after she's dead. Find a new hobby. What about thinning out your garden for a start?

Yet Marthe is also the way past our doubts about this initial over-seductiveness. There she always is, time and again, here, there and everywhere, in the bath, on the bed, with and without clothes, pouring coffee, feeding the cats, lazing the day away, indolently intrusive, with her catlike face and pudding-basin haircut. It takes a while to realise that the repeated presence doesn't add up to a portrait – or, at least, not a portrait which might tell us, as, say, a Lotto or an Ingres might, that here is a wise ruler, a domestic tyrant, a skilled courtesan. What, after such multiple exposure, is Marthe 'like'? We don't know in any traditional sense. After seeing her around so much, a verbal account of her, such as the one in Timothy Hyman's excellent *Bonnard*, comes as a complete surprise. She was, he tells us:

a 'touchy elf', whose speech was 'weirdly savage and brash', who dressed eccentrically, who hopped about on very high heels like some bright-plumaged bird.

We get no sense of Marthe being 'like' this from the paintings, except, perhaps, for her taste in shoes. This could, of course, be

because such descriptions are outsiders' impressions, whereas Bonnard is painting someone he has lived with in daily contact for twenty, thirty, forty years. Time changes marital focus, making it both more intense and less immediate. And/or the reason could be formal. Bonnard believed that 'a figure should be a part of the background against which it is placed'. Among the jugs and tablecloths, shutters and radiators, tiles and bathmats, Marthe has become – in the nicest, most vibrant way, of course – part of the furniture.

But it goes beyond this. Bonnard isn't painting Marthe's likeness (let alone her character) so much as her presence and its effect. Those many paintings in which just a bit of her appears at the edge could be taken as a conscious or subconscious attempt to marginalise her, to push her away; in fact, they're the opposite – proof of her immanence. And when not even an elbow or the back of her head remains, she is still present: those coffee things, that abandoned plate, that empty chair, are as sure signs of Marthe Having Been There as holy footprints in the rock from which some ancient church-founder hopped into the sky. So what the politically disapproving might see as merely bright testimony to a lazy lifestyle in fact offers up something much more elusive and enigmatic.

The palette seems to tell us one thing, the scene itself another. Is the energy and complexity of colour a correlative of the sensual experience alluded to – the meal just eaten, the sex just had or possibly to be had, the walk in the hot, scented air – or is this palette an excessive, almost ironic way of depicting a neurasthenic, restricted, underpopulated life, where all one can do is lie around and keep out of the heat? Are these happy paintings, or sad ones: can we even answer that? They can be both, of course – domestic epiphanies caught in such a blazing manner that the fleeting nature of such moments of plenitude is inevitably invoked. The more intense the celebration, the sadder the effect.

Fifty years ago, things were simpler. Bonnard's nephew, Charles Terrasse, prefacing the catalogue to the 1948 MOMA show, wrote that his uncle 'wished only to paint happy things'. There is room here for an ambiguity (he wished to, but failed), though it probably wasn't intended. In any case, this isn't good enough nowadays. Happiness? A great painter doesn't *only* want to paint happy things, surely? Happiness writes white, and happiness paints with the palette of what some call merely a 'great colourist'. Not good enough. At which point biography rides dubiously to the rescue, delivering to us the person of Renée Monchaty. If ever an artist needed a human sacrifice to help his reputation along, it was Bonnard, and the story was a timely emergence. Now, in place of Bonnard's lifelong obsession with Marthe as model, mistress and wife, we have Bonnard, after thirty years with Marthe, falling for Renée, an aspiring artist many years his junior, proposing marriage to her in 1921, losing his nerve (or having the project quashed by Marthe) and finding Renée dead in a Paris hotel room. The year after Renée's suicide, Bonnard married Marthe.

So we can speculate on a remaining lifetime of guilt for the painter, now manacled to his passive-aggressive gaoler; we can understand the non-erotic later nakedness of Marthe and the fact that Bonnard's self-portraits increasingly make him look like a miserable, desiccated travelling salesman; we can produce as evidence *Young Women in the Garden*, a picture reworked after Marthe's death to show a refulgent Renée outshining a sidelined Marthe. (We can, for that matter, suggest that every cat in Bonnard's work is a punning reference to Mon/chat/y.) Or can we? A little biography is a dangerous thing. One early version of the Renée story had Bonnard finding her dead in the bath, a 'fact' that would add grotesque and terrible overtones to every subsequent aqueous portrayal of Marthe. But then it turned out that Renée had 'merely' shot herself on her bed, having first surrounded herself with flowers.

It doesn't really matter whether an artist has a dull or an interesting life, except for promotional purposes. I remember a concert-interval talk on the radio in which it was suggested that the centenary of Brahms's death had been overshadowed by the bicentenary of Schubert's birth because Schubert had a sexier (in all senses) life. Poor Brahms. For a long time his terrestrial existence had been 'made interesting' by the fact that as a sensitive teenager he had played the piano in a sailors' brothel, an experience which had apparently made him flinch thereafter from the coarseness of the erotic. Alas, recent biography has shown this succulent detail to be apocryphal. In Bonnard's case, imagine if the Monchaty story turned out to be a hoax: would we then read the pictures differently? Isn't there something slightly disappointing about our need to equip all artists with a certificate of darkness?

You could, if you were being merely pragmatic, argue that this tragic melodrama helps in the posthumous battle against Picasso, the modern artist who best understood how the life might be offered up as validation of the art. Picasso is the bouncer at the door of Modernism. Bonnard may not have joined the queue, but Picasso barred him anyway. His grounds – as they survive in the fabulous total recall of Françoise Gilot – are worth quoting at length:

> Don't talk to me about Bonnard. That's not painting, what he does. He never goes beyond his own sensibility. He doesn't know how to choose. When Bonnard paints a sky, perhaps he first paints it blue, more or less the way it looks. Then he looks a little longer and sees some mauve in it, so he adds a touch or two of mauve, just to hedge. Then he decides that maybe it's a little pink, too, so there's no reason not to add some pink. The result is a pot-pourri of indecision. If he looks long enough, he winds up adding a little yellow, instead of making up his mind

what colour the sky really ought to be. Painting can't be done that way. Painting isn't a question of sensibility; it's a matter of seizing the power, taking over from nature, not expecting her to supply you with information and good advice. That's why I like Matisse. Matisse is always able to make an intellectual choice about colours. Bonnard . . . [is] not really a modern painter: he obeys nature, he doesn't transcend it . . . Bonnard is the end of an old idea, not the beginning of a new one. The fact that he might have had a little more sensibility than some other painter is just one more defect as far as I'm concerned. That extra dose of sensibility makes him like things one shouldn't like.

You wouldn't expect Picasso, the public, left-wing show-boater, to like Bonnard, the private, right-wing stay-at-home. Bonnard – or rather, the reputation of Bonnard – must have been irksome to Picasso. The more so because Matisse certified straightforwardly that Bonnard was a genius. Perhaps not being able to get rid of Bonnard (from other people's minds as well) increased Picasso's satirical aggression; also his inaccuracy. For a start, Bonnard didn't scuttle back and forth checking colour variations in the sky; he painted from formidable memory.

Picasso invokes against Bonnard a central antithesis of art: is the artist the servant or the master of Nature, a worshipping mimic or a hairy-chested rival who single-handedly steer-wrestles the Great Bitch to the ground? It's clear what your preference should be if you are seduced by the idea of the Artist as Hero (though there is nothing irredeemably modern about such a concept: see Courbet). Picasso's attitude to Nature is pretty much that of Yul Brynner to the incredulous, seemingly all-powerful Eli Wallach in *The Magnificent Seven*: Ride on!

But the great antithesis is largely false, and largely disappears with time. Even the most timorous, floppy-hatted hedgerow copyist is

operating a rough system of selection, order and control – of supplanting by reinvention – when crouched over the pussy-willows. This is what Art in its various major and subsidiary forms, from painting to fiction to landscape gardening to cookery, is about. Throwing sand in Nature's face, setting up as rival creator of a parallel or tangential universe is macho aesthetics, but all artists' universes depend for their effect on the primary one we inhabit. 'Seizing the power' may sound thrillingly Promethean, but in art it's the equivalent of being allowed to borrow a Zippo lighter while the gods control the National Grid. Cubism only makes sense by presupposing our conventional and continuing apprehension of the visual world. If it succeeded in displacing that world, then it would itself become the standard experience which we would in turn call 'Nature'.

Picasso declared that Bonnard was 'the end of an old idea', not really 'a modern painter'. The stern John Berger concurred: the work contained 'very little of the post-1914 world'. Yet strangely, Bonnard refused to lie down, a sleek and pattable presence like his dachshund Ubu. At the time of his death in 1947, he was widely considered a minor master; twenty years on, an alarmed Berger noted that 'Some now claim that he is *the* greatest painter of the century.' What had gone wrong? In Berger's view, the rise in reputation coincided 'with a general retreat among certain intellectuals from political realities and confidence'. This is a bit unspecific, but presumably: 1956, 1968, crisis of the Left, leading to nostalgia for art that is 'intimate, contemplative, privileged, secluded'. Or perhaps, more happily, it's a case of the painter's reputation no longer being dependent upon the doctrinal self-confidence of 'certain intellectuals'.

There are various defences available against Picasso's assault. You could refuse Modernism's setting of the terms: what does it matter whether Bonnard was a great Modernist painter as long as he was

A Corner of the Table by Bonnard

still a great painter? You could ask why an artist must be so narrowly of his time: Turgenev was attacked by Russian critics for being out of touch and out of time because of all his Westernising; nowadays we read him as a great novelist, unconcerned about whether or not he was ten years behind in describing the nihilist position on serf emancipation. In Bonnard's case you could also plead that by the end of the First World War he was already over fifty and had been elaborating his style for thirty years. There is nothing more humiliating and counter-productive for an artist than jumping through the train doors just as the next style is about to leave.

Or you could argue that, for all his post-Impressionist camouflage, Bonnard *is* a Modernist, if a quieter one than most. His exploration of space within the pictures, his compressions and elasticities, his use of the discordant angle and vertiginous drop, may be less flamboyant than the disruptions of Cubism, but they are just as radical. Those bath paintings are constructed from a melange of roving, contradictory viewpoints, while *Corner of a Table* (c.1935) is one of the most discreetly alarming pictures of the century. As for colour: Picasso's modernising project favoured dramatic simplification; Bonnard's, dramatic complication. In Art, one of Time's jollier revenges is to make school-squabbling an increasingly pointless business.

Bonnard's last completed painting was *Almond Tree in Blossom*. The tree was in his own garden. He had barely signed the picture when he died. On the day of his funeral, 23rd January 1947, snow fell on the pinkish brightness of the almond, as it did on the yellow brightness of the mimosas. Quite obviously, Nature was bidding farewell not to a grovelling servant but to a passionate love. What, out of interest, did Nature do for Picasso when he died?

Vuillard: You Can Call Him Édouard

I remember the first time I stood in front of Piero della Francesca's *Flagellation* in Urbino. A great painting compels the spectator into verbal response, despite our awareness that any such articulations will be mere echoes of what others have already put more cogently and more knowledgeably. So words came into my head (and out of my mouth) about the combination of solid structure and serene atmosphere, about lucidity and numinousness; a brief notion about the greatest art being that which combines beauty with mystery, which withholds (Vermeer, Giorgione) even as it luminously declares. Then, immediately, a counter-notion: what if what we call 'mystery' is mere subsequent ignorance or forgetting? Perhaps the *Flagellation*, or Giorgione's *Tempesta*, or a Vermeer of a waiting woman in front of a wall-map, were transparently readable to those who saw them fresh-painted? In which case, the radiant mystery we celebrate is just a bit of bogosity mixed into our amateur appreciation. With knowledge running out, assertion was called for: 'Well, it goes straight into my top ten,' I concluded.

Back home, I read Aldous Huxley's essay on Piero:

Nothing is more futile than the occupation of those connoisseurs who spend their time compiling first and second elevens of the world's best painters, eights and fours of musicians, fifteens of poets, all-star troupes of architects, and so on.

The sinner knows best the sin: Huxley admits by the very title of his essay – 'The Best Picture' – that he is as susceptible as anyone else to this futile, if harmless, game. For him the Best Picture is Piero's *Resurrection* at Borgo San Sepolcro. Best by personal taste, but also by the absolute standard of art, which is a moral one: 'whether a work of art is good or bad depends entirely on the character which expresses itself in the work'. Artistic virtue and integrity, as we know, are independent (sometimes startlingly so) from personal virtue and integrity. Bad art, the art that is a lie and a sham, may get away with it in the artist's lifetime. But 'in the end, lies are always found out'; the fake and the charlatan are eventually exposed. Huxley is right (we hope), though the paradox must also be noted that while truth slowly triumphs, the ignorance of the subsequent viewer about what is actually going on in a picture may be on the increase.

Back home, I wanted to know more about Piero himself, so I looked up Vasari. There I read how the life of one whose art was so ordered and so trustingly serene had ended in misfortune and betrayal; how, at sixty, an attack of catarrh had left him blind for the last twenty-six years of his life; and how, after his death, his fame was stolen and his memory almost annihilated by an envious pupil, Fra Luca del Borgo. These melancholy facts provoked the response they would in anyone – until I read the notes to my edition. Vasari hadn't just been embroidering; he'd stitched a whole tapestry. The story of the blindness was unfounded, while the pupil, far from stealing Piero's arithmetical and geometrical treatises, had merely published some routine workings-out of Euclid, which contained no original theorising by Piero. 'In the end, lies are always found out'? With biography, only sometimes.

Top-tennery and biography: these are the mild, distracting, yet seemingly innocent vices which tempt us when faced with a few square feet of oil, tempera, pastel or watercolour that please us beyond

Woman Sweeping by Vuillard

any possible anticipation. The first time I visited the Phillips Collection in Washington I saw a painting which instantly entered my top ten and has remained there ever since. (In fact, I saw several others that did the same – a Courbet, a Degas and a Bonnard – but then I've never counted up my top ten, which runs to well over a hundred by now.) This particular painting is more or less square, about eighteen inches per side, in hues of brown tending towards gold, and shows a plump woman in a stripey day-dress sweeping a room. There is an open door on the left, which chimes with the other plainish flat space of a chest of drawers back centre. In the left foreground is the tumultuously patterned hump of a bed-cover; behind the chest of drawers, some answering wallpaper. The woman is sweeping stolidly with a flat-brushed broom. It is an intense organisation of space and colour, full of Huxleyan virtue and integrity. Beyond that, I decided, it was a deeply wise painting: the work of an artist in full maturity, or more likely old age, which expressed his deep knowledge of life, and with an autumnal, perhaps valedictory tenderness to it; the celebration of an ordinary, domestic, democratic moment, yet one filled with more understanding than many a mighty piece of public art. The measly black-and-white postcard, all that was then available, told me that Vuillard (whom Huxley much admired) had painted *Woman Sweeping* in about 1892, when he would have been twenty-three or twenty-four; while biography asserts that 'knowledge of life', as usually conceived, was something Édouard Vuillard didn't have much of at the age of twenty-three or twenty-four. Yet each time I see that painting again, I am convinced that I am right and chronology is wrong. It *is* a wise painting, filled with the tenderness of age; it is just that Vuillard must have had these attributes preternaturally early. Well, he did once say of the artistic process: 'You get there either in a flash or through old age.'

Biography and Vuillard. At the front of the catalogue to the monumental 2003–4 Vuillard show (which illuminated Washington,

Montreal, Paris and London) there is the perfect photograph of the artist in his studio – indeed, of any artist in his or her studio. Vuillard sits in a wicker chair with hands clasped between his knees, looking serious and faintly melancholy. He is also, thanks to the amateurishness (or perhaps super-subtlety) of the photographer, out of focus. The studio stove and iron coal-scuttle some six to eight feet behind the painter are crisply clear; so too are some of his paintings – including a portrait of the young Bonnard – tacked to the wall behind him; but Vuillard himself is a bit of a blur. This is, you suspect, exactly what he would have wanted. Look at what I see, not how I am.

For a century and more, this strategem, or tact, or modesty, worked. Besides, the French have a fairly low regard for biography, especially of artists; while families tend to keep their secrets. Claude Roger-Marx's *Vuillard et son temps* – begun with the painter's approval, yet not published until 1945, five years after his death – opens with the conclusive words: 'Vuillard's life, like his work, is not anecdotal, and is marked by not a single external incident.' He was indeed shy, secretive and spectatorial; he lived with his mother until her death, by which time he was sixty. He was far from a hermit – he knew Valéry and Mallarmé (who wanted him to illustrate *Hérodiade*), Lautrec and Degas, Giraudoux, Proust and Léon Blum. He also travelled more widely than his paintings suggest; he came to London several times with Bonnard (and did set designs for *The Master Builder* here in 1895). But he glides through the interstices of social and artistic life; he leaves few traces in the journals and correspondences of the period; his personal life seems to consist of being quietly present in the drama of other people. In the early 1920s, for instance, he encountered Edith Wharton (via her great friend Walter Berry, whose portrait he had painted in 1918); but this potentially fascinating conjunction has come down to us as no more than his surname in a social jotting of hers.

In the same way, though he was acknowledged as a master, he was not the sort of master whom the next generation felt it useful or necessary to knock over in order to advance its cause. Picasso, for instance, was sufficiently threatened by Bonnard to dismiss his work violently; but in the same source (Françoise Gilot's memoir), Vuillard is mentioned only when he comes in handy as a side-swipe. Gilot recalls Picasso taking her to see Braque in his studio shortly after the Second World War. Shown his host's latest work, the pathologically rivalrous Picasso commented: 'Well, I see you're returning to French painting. But you know, I never would have thought you would turn out to be the Vuillard of Cubism.' No compliment was intended to either party.

Yet of course no-one really has a life 'marked by not a single external incident', not even one who says of himself, 'I have never been anything more than a spectator'; not even one whose women friends were discreet and protective. Misia Sert tells in her memoirs – and it is about the only anecdote ever attached to Vuillard's life – of walking through a beetroot field with him as the light was closing in, of tripping on a root and nearly falling, of him helping her regain her balance, of their eyes meeting . . . whereupon Vuillard burst into sobs. Sert gives a separate paragraph to her next line (and so maybe we should too):

'It was the most beautiful declaration of love ever made to me.'

And she certainly had many from which to make the comparison. Beautiful, but also characteristic – of the man, and of the painting too. John Russell drew an astute comparison between Mallarmé's precepts about poetry and the young Vuillard's practice as a painter. Mallarmé's instruction was 'to paint not the thing itself, but the effect which it produces'; he also wrote, 'Somewhere in the creative act is the attempt to evoke an object by placing it deliberately in shadow and referring to it allusively and never by name.' Vuillard's painting

The Nape of Misia's Neck by Vuillard

is always less ethereal and less excluding than Mallarmé's poetry; but the incident in the beet-field is the Mallarméan aesthetic applied directly back to life. Vuillard's sobs are not a statement of love, but a display of the effect that love produces.

It is now clear that his relationship with Misia was the first true sexual passion of his life; while his decades-long attachment to her successor as social and artistic helpmeet, Lucy Hessel, was also not platonic. Further, his journal, which only became available to scholars in 1981, attests that the man Jacques-Émile Blanche described as a 'gourmand turned ascetic' wasn't all that ascetic. At the time of that 2003–4 show its general curator, Guy Cogeval, explained to me that the journal, written for the most part with the dryness of a sea-captain's log, contained coded entries indicating amorous adventures. I asked what code Vuillard used. 'He used to write *d'ici – passion*', Cogeval explained. Yes, I thought, a strange code – 'from here – passion' – but rather easily crackable. In fact, I had misheard, and the code was blatantly uncoded: the word he wrote was *dissipation*.

So Vuillard, hitherto thought as monkish as Henry James, had a sex-life, and we can all be pleased or relieved (or indifferent) about that fact. Does it change in any way how we read the pictures? There is a small, oblong, tender painting called *La Nuque de Misia* (Misia's Nape). In fact it is only a half-nape, with as much bare shoulder as back of the neck. Misia is seen slightly from above, with her head down, hair covering her face; she is wearing a white blouse. It is, indisputably, an intensely erotic work by a shy person. As I was looking at it in Montreal, a passing French journalist murmured, *'C'est une vraie déclaration d'amour.'* Indeed; but the painting is still the same whether or not Vuillard and Misia were physical lovers when he painted it. We look at a *Flagellation* of *c.*1455–60 and are distracted by our ignorance (who are those three blokes in the foreground?); we look at a secular painting of 1897–9 and are distracted by our knowledge (guess what *they* got up to?).

Biography cannot be neutral, and some of Vuillard's early paintings are currently being subjected, however well-intendedly, however high-mindedly, to a kind of creeping anecdotalism. Facts about his life are becoming known; the pictures are in existence; conclusions are being drawn. In Montreal the big show was marketed with an alarmingly crass slogan: 'The experts call him Vuillard. You can call him Édouard.' As if you go to an exhibition in order to get to know the artist better, rather than to get to know the art better. But the attempt – at different levels – to make Vuillard into a regular sort of guy who used paint to tell us the story of his life is highly contentious. See the show twice and you can call him Ted.

Painters don't date paintings if the date is unimportant to them; nor do they give them titles unless they want them to have titles. But in the outside world paintings, like children, can't exist without being named and given some official date of birth. Vuillard's paintings have been rechristened more than most. Sometimes, of course, this is necessary. There is a painting of c.1891 which for decades was known as *The Third-Class Carriage*. An intense mix of blacks, ochres and umbers, it shows a beaky, possibly bereted man in profile, turning to a woman and child seated beside him. The title refers us to Daumier's variations on this theme, and a few years later Vuillard did several pictures called *The First-Class Carriage* (openly admitting Daumier's influence in his journal). However, in 1990 it was pointed out that if *The Third-Class Carriage* is indeed a representation of a third-class railway carriage, then it must have been one unique in the history of public transport because it appears to contain a flowering tree. The more sober title of *In the Garden* is now attached to this work.

But other retitlings are more dubious. For instance, it is an established truth (established by Cogeval) that Vuillard was the chief mover behind the marriage of his sister Marie to his close friend

and fellow-Nabi, Ker-Xavier Roussel – a plan old Mme Vuillard thought misconceived since Roussel was an unstable womaniser. Around this time Vuillard painted two of his best-known works: *Interior with Worktable*, which shows a figure like that of Roussel putting his head round the door of the dressmaking workshop to look at a figure like that of Marie; and *Interior with Red Bed*, which shows a figure like that of Marie standing with a tray in front of a yellow screen while two women tidy the room behind her. They are typical Vuillard paintings of the time: interiors with figures bent upon tasks, in which the identity of the figures and exact nature of the tasks are subsumed into the tonal and structural demands of the picture. The first is cool and playful in mood, all blue-grey and grey-brown; the second hotter, with scarlet and orange and yellow (but also more black). When Jacques Salomon, the husband of Vuillard's niece Annette, saw *Interior with Worktable* at the Smith College of Art, he 'astutely' (according to the 2003–4 catalogue) assigned to it the title *The Suitor*; and that is how it is now known. In the same way, *Interior with Red Bed* has been renamed *The Bridal Chamber*. Such rechristening is only 'astute' in the sense of commercial branding – Hey, don't be scared, you can call him Édouard. Artistically, it is far from astute. It's saying: Oh, and by the way, this is what he was *really* painting, it's just he didn't like to tell us at the time. Such an approach is reductive, and while it couldn't make the pictures banal, it makes them seem more ordinary. It treats them as narrative, as conversation piece, as domestic autobiography. It invites us to look for theme rather than composition and aesthetic. It is a small but significant betrayal of the artist.

Vuillard's first period is one of the most supreme and complete explosions of art in the last 200 years. He barely has any juvenilia; by his late twenties he is master of oil, pastel, watercolour and pen; he finds, happily close to home, the perfect raw material (often literally

The Chat by Vuillard

so – the bolts and swathes of cloth used in his mother's dressmaking business). This he transforms into intense, jewel-like tonal meditations in which movement and links of colour and shape override the 'facts' of the scene. They are not, of course, abstract; they are pictures of (mostly) interior spaces, including the people who live and work in those spaces. Bodily position – a hunch, a crouch, a turning-away – is key; Vuillard bears out Edmond Duranty's dictum that 'a man's back can reveal his temperament, his age and his social position'. But face is rarely key; the paintings may imply, even actively indicate, temperament or mood, but identity is irrelevant.

Thus *The Chat* may now be sub- or retitled *The Bride*, and we may be assured that it's 'about' a mother giving prenuptial advice to a daughter; but what it's really about is the relationship of the white-dressed daughter to the white flowerpot above and behind her, the relationship of the black-clad mother to the inchoate black item (counterpane? discarded cloak?) on the bed behind her, and the further relationship of this white and this black to the browns – ruddy, ochre, tawny, greenish – which occupy most of the rest of the space. As Gide wrote of Vuillard:

> He never strives for brilliant effect; harmony of tone is his continual preoccupation; science and intuition play a double role in the disposition of his colours, and each one of them casts new light on its neighbour, and as it were extracts a confession from it.

Thus the extraordinary *Nude in an Armchair* (c.1900), one of Vuillard's rare nudes, is an encounter between beigey-pink (the model's body, the wall behind) and chestnutty-brown (the model's hair, both head and pubic, the chair, the floor) with only a peacekeeping line of grey-blue to keep the shades apart.

The seriousness of gaze and high aesthetic creed are animated by a human playfulness and visual wit. Fabric and textile, clothing and wallpaper lucidly leap their normal bounds, fuse and intertwine. In what is now called *Interior: the Artist's Mother and Sister* (though its 1909 stock title at the Bernheim-Jeune Gallery was *La Robe noire et la Robe verte*) the younger woman, in a broad-checked dress, is backed up against wallpaper as vigorous as a flowering hedge, into which you feel she might at any moment just fall back and disappear, leaving only her boot-heels sticking out. In these luxuriant interiors there is little need for potted plants or hanging baskets when women like *The Lady in Blue* are wandering past with public gardens on their heads. Or take *Ker-Xavier Roussel Reading the Newspaper* (1893), in which the subject sits on a low couch wearing a black morning jacket and a pair of billowing brownish zouave trousers. There is a preliminary drawing which resembles the final structure in all but one key detail. In the drawing, Roussel is sitting with his legs apart and the newspaper falls between them. In the final painting, Vuillard has wittily adjusted the tumbling newspaper to cover, and replace, the right trouser-leg and waist of Roussel's pants: it's as if he's reading the crotch of his own fancy two-tone trews.

In his Nabi phase, Vuillard was the clear leader; Bonnard at his best seemed as if he was just trying to keep pace. Early mastery comes at a price (though not such a high one as early incompetence does). Signac visited Vuillard in 1898 and in his diary describes this 'highly strung painter' with 'an unresting passion for art'. Despite finding too much fantasy in Vuillard and wishing him more realistic, Signac was very impressed by the work. He did, however, foresee a problem:

So strong, in his work, is the element of fantasy that he has to keep to these little panels; it would be impossible for him to go further . . . His finished pictures are like sketches. If he had to

work on a big scale he'd have to be more exact – and what would become of him then?

What indeed? Signac seems unaware that Vuillard had already – since 1894, when he did *Les Jardins publiques* for the Natansons – been painting on a big, indeed enormous, scale. But in any case, this is where the challenge of Vuillard begins. Bonnard, who has outstripped him in public recognition in the half-century and more since their deaths, is a painter whose artistic direction is easier to follow. He deepens, he extends, but remains manifestly the same artist; he is charming, appealing – he includes us in what he depicts. Vuillard is not like this: his interiors are too dark, too hermetic, vaguely claustrophobic. However charmingly, they exclude: we are not especially wanted here. And then, suddenly, there is an immense gear-change. Even if we know about them, the series of decorations he did in the 1890s and 1900s come as a towering surprise. In 1971, when he curated the previous major Vuillard show in Toronto, John Russell lamented that the nine panels of *Les Jardins publiques* 'can never be brought together again'. They had last been shown in all their togetherness at Bernheim-Jeune in 1906; but almost a century on, five separate owners were persuaded to let them be reunited. Standing before them, and also the panels of the *Place Vintimille* (1911), you can understand why Vuillard thought that large-scale decoration was a higher form of art than easel-painting. ('Decoration' is an unhelpful term, seeming to suggest idle diversion for the salon-prancer.) The stakes, like everything else, are simply bigger: for instance, the matter of what happens between the pictures – the silence between the notes – and how the brain and eye are controlled and cajoled from one frame-edge to the next. These are paintings grouped with as much communal intent as any altar polyptych.

The gear-change isn't just of scale, but also of style and subject-matter. Vuillard got bigger – and bigger still; he became, as Signac

had predicted, more exact in representation; and he began painting a different social stratum. In his youth he had said, 'One can make a thing of beauty out of one's cook', and turned his familiars and his mother's employees into intense arrangements of colour; by 1928, he was painting commissioned portraits of the Princesse de Polignac and other figures of the *haut monde*. Identity is now specific, indeed necessary, given who is paying the bill. For some, this was as if Debussy had gone off to write scores for Hollywood: a failure of nerve, or an acceptance of comfort; at any rate, a disappointment. In a large 300–400-work show, given that normal ocular fatigue sets in after about ninety minutes, many will joyfully linger in early Vuillard, admire the rarely seen decorations, and then freewheel through the later work. But this in turn might be a failure of nerve. If he could paint as he did at the start of his career, we owe him at least the duty of full attention thereafter. Félix Vallotton was a harsh critic of most other contemporary painters (himself included); the only one he consistently admired was Vuillard, whose art always remained 'intact and exemplary'. During the First World War, Vallotton succumbed to anxiety and depression, barely able to see the point of painting in the face of such a catastrophe; Bonnard got through by ignoring the whole thing; only Vuillard, of these original three Nabis, was both fully aware of world events and still able to find the concentration and discipline to work.

His was a long, complicated, sometimes tortuous progress, producing some great triumphs and some dismaying failures. Perhaps the best place to start is with technique. One unexpected side-effect of Vuillard's work in the theatre was his discovery of *peinture à la colle*, a glue-based distemper used for painting sets. As far as Cogeval knows, no regular easel-painter had or has used it before or since (though eighteenth-century decorative artists employed it for panels and screens). It was a tricky, cumbersome process that involved boiling

up colours in copper pots, with perhaps as many as thirty on the go at the same time; there was also a constant problem in matching the hues of yesterday's boilings to today's. The advantages over oil were that large areas could be covered much more quickly; that the distemper dried fast and so could be painted over sooner; and that the paper on which you painted could be laid on the floor (and later attached to a solid surface like canvas or wood). This was the technique Vuillard used for his large decorative panels; and it was gradually to replace oils in his favour.

Quite why remains undocumented; there is only a single reference to *peinture à la colle* in the journals. One abiding reason for its use in the theatre was that the surface absorbed any glare from the petrol-lamps that lit the stage. John Russell exactly describes the *à la colle* technique as producing 'a subdued inner glow, a matt, felted, contained eloquence'. But it's also quite possible to get a matt, felted effect with oil: see, for instance, the *Île-de-France Landscape* of 1895, which is also, confusingly, as vast as any of Vuillard's decorations. If he could get fairly similar effects with both oil and distemper, what guided his choice? The reasons may have been mainly psychological. He told Jacques Salomon that the attraction of *peinture à la colle* was its very laboriousness, which put a rein on his 'excessive facility' and allowed him to deliberate more fully. Could there be an emotional linkage as well? Glowing oil for the domestic paintings involving his immediate family; distemper for the *beau monde* he went out into? Perhaps.

Peinture à la colle encouraged him to paint much larger. Like Bonnard, he began to depict the great outdoors as well as the great indoors – though Vuillard often went outdoors in the north, and his palette therefore remained cooler. Also, he began moving in rich and fashionable circles: first those revolving around Misia and Thadée Natanson, later those around Lucy and Jos Hessel. In the latter household he seems to have occupied a place similar to that of Turgenev

chez Viardot: the acknowledged lover/soulmate in a sophisticated and complaisant threesome. Hessel was an art dealer, more concerned about the problems of handling Vuillard's work than about what his wife got up to in bed; while the painter, for his part, was furious if anyone tried to disparage his mistress's husband in his presence.

The distance Vuillard travelled, both artistically and socially, can be exactly measured by one of his finest late paintings – indeed, one of the great twentieth-century portraits. In the early 1890s he was doing small oils of the family business in the rue de Miromesnil, which Mme Vuillard ran in a 'narrow, corridor-like space squeezed in between two storeys of an old-fashioned house'. Forty years later he was at work on the large, commissioned distemper portrait of *Jeanne Lanvin*, head of one of the first modern fashion and luxury-goods empires. Like Vuillard, she had risen in the world: from modest beginnings as a milliner to a position of power and influence – by 1925 the house of Lanvin employed 800 staff in twenty-three workshops. Lanvin's style attracted such customers as Mary Pickford and Yvonne Printemps; while her social position was confirmed when her daughter married Count Jean de Polignac.

Vuillard claimed: 'I don't paint portraits; I paint people in their homes.' And offices: here sits Mme Lanvin at her desk in the rue du Faubourg Saint-Honoré, interrupted at her work, relaxed yet authoritative. On the right-hand side of the painting, picked out by the full light from the offstage window, are the simple tools of her trade: sharpened pencils standing in a pot and a laid-down pair of spectacles. On the opposite side, at about the same level, is an icon of the social outcome of these tools: a plaster bust of Lanvin's daughter Marguerite, now aristocratic by marriage. (The bust stands in a glass case, which was doubtless representationally true, but perhaps also more widely suggestive.) This is a painting about work, skill, dedication, money, success and class. The traditional low-tech craft of pen and paper is

displayed and meshed with the modern world of Art Deco furnishings and the telephone. (Vuillard loved telephones, and especially their cords – in the *Portrait of Henry and Marcel Kapferer* of 1912 a prominent multicoloured flex romps exotically across the carpet like some Amazonian snake.) It contrasts the disorder of creation – samples, fabrics, loose papers and other items falling off the front right of the desk – with the absolute orderliness of money: the neat account books, the safe-like metallic drawers behind the sitter. The painting is held together by colour: from bottom left to top right, the greens of the glass sculpture case, the sitter's jacket, and up into the grey-green shadows; from bottom right to top left, the reds of the fabric samples, sitter's lips and book spines. The two colours intersect cannily – and no doubt truly – in Mme Lanvin's jacket: there, on the green lapel, sits the scarlet ribbon of the *Légion d'honneur.*

It is a triumph of relevant detail. It is also a very long way from paintings of seamstresses in which there was minimum facial particularity and the figures indicated attitude more than character. When Vuillard was on his way to paint Anna de Noailles, the sitter said to her maid, 'For heaven's sake put away that cold cream! You know how Monsieur Vuillard never leaves anything out.' (Anything relevant, that is.) *Jeanne Lanvin* is thus a very un-Mallarméan picture, full of the things themselves rather than the effects they produce. It contains, nevertheless, some typical Vuillard ambiguities in the form of impossible reflections: try working out how the book spines in the bottom left-hand corner are compatible with the reflection of the plaster bust beside them; consider the implausibility of the reflection of Mme Lanvin's sleeve (or perhaps jacket). It is also, sadly, one of several pictures in a state of decline. The sitter's face seems at first full of unflattering wrinkles; in fact it is full of the consequences of *peinture à la colle.* Vuillard had normal difficulties with the face, and distemper allowed him a superabundance of reworkings; but such multiple layers

are inherently unstable. Worse, the medium is, according to Cogeval, impossible to restore.

In 1910, writing in *The Art News*, Sickert distinguished between 'artists who are masters of their customers' and those, like Jacques-Émile Blanche, whose every touch shows itself 'painted for the owners of the rooms'. Sickert (who much admired Vuillard) goes on: 'Livery is an honourable wear, but liberty has a savour of its own.' Did Vuillard in his later years slip from liberty to livery, just as two years before his death he accepted election to the Académie des Beaux-Arts? Sometimes this is undeniable. The huge portrait of Marcelle Aron is yawningly empty; that of Mlle Jacqueline Fontaine embarrassingly kitsch. Here it looks as if – to return to Huxley's terms – artistic virtue has gone missing. The monumental *The Surgeons* (1912–14) and the wartime *Interrogation of the Prisoner* (1917) seem examples of a different kind of unsuccess: that of working against the grain of your natural genius, making the sort of art that you think you ought to do. But against these we may rightly set the famous *Théodore Duret in his Study* (1912) or the wonderfully playful double portrait of Sacha Guitry and Yvonne Printemps (1919–21).

In 1938, the last major Vuillard show in Paris until that of 2003–4 was curated by Vuillard himself; and he deliberately emphasised his later work, thinking it would be of greater interest to the young. It was an implausible hope; the more so as by now he bore the curse of being hailed by conservative critics as the defender and upholder of 'authentic' French painting. But with time, the subject-matter of art becomes less important; and just as subsequent generations can see past the fact that Proust is 'all about posh people', so we ought by now to be able to look at Vuillard's later work more even-handedly. In particular – since Vuillard was highly intelligent and deeply absorbed in the history of painting – we might look at seven late pictures whose subject is art itself. The *Self-Portrait in the Dressing-Room Mirror* (1923–4)

is as bleak and unsparing as any of Bonnard's late self-portraits: the reflection of a white-bearded, Oedipal-eyed old man in a mirror surrounded by pictures, who thus seems himself on the verge of fading into the history of art. Next, the suite of four paintings called *The Anabaptists* (Bonnard, Roussel, Denis and Maillol, 1931–4), in which Vuillard's four colleagues – two of them by then dead – are seen dwarfed by the art they are creating. Denis gazes out from behind a barricade of vast paint-pots; Roussel sits behind a palette given four times the area of the painter's head; Maillol, a dumpy figure in striped suit and straw hat, is chipping away at the feet of an enormous marble goddess like some subservient pedicurist. As for Bonnard, he is given (perhaps rightly) the greatest physical presence of the four: he is shown tall, full-length, centrally placed. But let the colours tell the story: the painter is managerially suited, with specs and grey hair, throwing a dark shadow, while on the wall in front of him blazes his own picture of *Le Cannet*, and behind his back, more subversively, blazes his open paint-box.

Finally, there is a suite of decorations Vuillard did in 1921–2 for Camille Bauer, depicting the art of museums: in particular, two that represent the Salle des Cariatides and the Salle La Caze in the recently reopened Louvre. In the former, the vast Borghese Vase and other classical items occupy nine-tenths of the picture; at the very bottom are the faces of a handful of spectators – a woman in a blue hat (actually, Vuillard's niece Annette, but identity has once again shrunk to unimportance), a man in a homburg – who are utterly and comically dwarfed by the art. In the latter, the living figures beneath the eighteenth-century French pictures are given somewhat more space: two of them are copyists bent over their tasks; another is reading the gallery guide; a fourth, in a fine fur and hat, is gazing out of shot. These paintings, according to the 2003–4 catalogue, are 'a celebration of the human gaze'. Up to a point; but, significantly, only one of the

nine figures represented is shown actively looking at any of the art objects around them. Vuillard may have described himself as nothing more than a spectator, but we who look at his pictures are even more spectatorish ourselves: sometimes mere copyists of the genius of others, sometimes attentive, sometimes mere idlers. We wander through the great galleries, appreciative or dismissive according to our knowledge, our temperament, the state of our digestion and the fashion of the times, putting this or that picture into our top ten, and remaining incorrigibly curious about this or that artist's private life. But the art itself goes on regardless, above our heads, massive and uncaring.

Vallotton: The Foreign Nabi

At the turn of the twentieth century, the Cone sisters of Baltimore, Dr Claribel and Miss Etta, inherited a fortune stitched from cotton, denim and mattress ticking. They chose to spend it on art. Over the next decades, buying mainly in Paris, they put together with fine taste and the help of experts – including Leo and Gertrude Stein – a great assembly of Matisse, plus works by Picasso, Cézanne, Van Gogh, Seurat and Gauguin. Before Dr Claribel died in 1929, she signed one of the most manipulative wills in the history of art. Her share of the collection would go in the first instance to her sister, with the 'suggestion, but not a direction or obligation' that after Etta's death it pass to the local Museum of Art 'in the event the spirit of appreciation for modern art in Baltimore becomes improved'. This wonderful challenge from a dying woman to an entire city was coupled with the proposal, or threat, that the Metropolitan Museum in New York should be the fallback recipient. The next twenty years – up to Miss Etta's death in 1949 – naturally contained some major politicking from the Metropolitan, but plucky little Baltimore eventually proved its fitness and modernity. The Cone Collection is now the main reason for visiting the Baltimore Museum of Art on the campus of Johns Hopkins university.

When I was teaching there for a semester in the mid-Nineties, I used to call in at the museum between classes. At first, Matisse and the other big names occupied me, but the picture I found myself

The Lie by Vallotton

standing most faithfully in front of was a small, intense oil by the Swiss painter Félix Vallotton; it was called *The Lie*. There was another Vallotton in the collection, a massively brooding image of Gertrude Stein (1907) – which Vuillard wittily dubbed '*Madame Bertin*' – which would undoubtedly have become her known public face, had not Picasso stolen pre-eminence of the subject the previous year. But I was entrapped by *The Lie*: painted in 1897 and bought thirty years later by Etta Cone from Félix's art-dealing brother Paul in Lausanne. It cost her 800 Swiss francs: no more than small change, given that on the same day, and from the same source, she bought a Degas pastel for 20,000 francs.

One of my writing students had handed in a story based around a mysterious lie, and so I found myself describing the Vallotton to my class. A man and a woman sit in a late-nineteenth-century interior: yellow-and-pink striped wallpaper in the background, blocky furniture in shades of dark red in the foreground. The couple are entwined on a sofa, her rich scarlet curves bedded between the black legs of his trousers. She is whispering in his ear; he has his eyes closed. Clearly, the woman is the liar, a fact confirmed by the smiling complacency of the man's expression and the way his left foot is cocked with the jauntiness of the unaware. All we might wonder is which lie he is being told. The old deceiver, 'I love you'? Or does the swell of the woman's dress invite that other favourite, 'Of course the child is yours'?

At my next class, several students reported back. One, the Canadian novelist Kate Sterns, politely told me that my reading was diametrically wrong. For her, it was obvious that the man was the liar, a fact confirmed by the smiling complacency of his expression and the jauntiness of his cocked foot. His whole posture was one of smug mendacity; the woman's that of the pliantly deceived. All we might wonder is which lie she is being told. If not 'I love you', then perhaps

that other male perennial, 'Of course I'll marry you.' Other students had other ideas; one cannily suggested that the title, rather than referring to a specific untruth, might be a broader allusion – to that necessary lie of social convention, which makes honest dealing between the sexes impossible. Vallotton's use of colour might confirm this. On the left are the couple in sharply contrasted hues; on the right, a scarlet armchair blends seamlessly with a scarlet tablecloth. Furnishings can harmonise, we might conclude; humans not.

Vallotton, like compatriots as various as Liotard, Le Corbusier and Godard, did that Swiss thing of appearing to the outside world to be French; indeed, he went further, and a year after marrying into the Parisian art-dealing family of Bernheim in 1899, took French citizenship. He was a member of the Nabi group and a lifelong friend of Vuillard. Not that any of this raised his profile in Britain. Baltimore was the first place I registered Vallotton's name; and domestic gallery-goers needn't be embarrassed if they find it unfamiliar. Any embarrassment better belongs to the nation's art acquirers. In Britain he is not so much the Forgotten Nabi as the Unknown Nabi. There has never been a public exhibition of his paintings in this country; though in 1976 there was a touring Arts Council show of his woodcuts. A recent check with the Fondation Félix Vallotton revealed that we have only a single painting of his in public ownership, *Road at St Paul* (1922), which belongs to the Tate only because it was donated by Paul Vallotton after his brother's death. It hasn't been displayed since 1993; nor has it been loaned out in that time, either. The main holdings of his work are in the major Swiss cities, and at the Musée d'Orsay; elsewhere, you will rarely come across more than a couple of his pictures hanging together. Many of them, including some of the best, are still in private hands and don't emerge even at the invitation of powerful curators.

Vallotton has often been undervalued, even patronised: Gertrude Stein snootily called him 'a Manet for the impecunious'. But there is

another reason why he is bypassed. His output was large, and he is a painter who, more than any other I can think of, ranges from high quality to fierce awfulness. The Musée des Beaux-Arts in Rouen, for example, has two Vallottons on display in a rather dingy, over-hung corridor. One is a theatre study, of nine tiny blackish heads peering down over a gallery rail and made specklike by the vast creamy-yellow bulge of the balcony-front beneath them. It has none of the busy Impressionism, the shifting light and the gilt of, say, Degas or Sickert's theatre-work; rich yet spare in tone, it is a fine study of the propinquitous isolation of modern city life. But on the opposite wall of the corridor is a nude of such turn-your-back dreadfulness that had you seen it first, you might have noted the artist's name in order to ensure that in future you avoided his work at all costs. A Swiss friend of mine once asked me ruefully, 'But have you *ever* seen a good nude by Vallotton?'

The first time I went to a concentrated Vallotton show – at the Zurich Kunsthaus in 2007 – my initial response was one of relief: he was an even better artist than I had imagined, and over a wider range of subject-matter. I also realised that for all his marriage and nationality-taking, his summers at Étretat and Honfleur, and his official Parisian status as 'the foreign Nabi', he was scarcely a French artist at all; rather, an awkward independent who fits uneasily into any wider narrative of painting. In 1888, after a trip to Holland, he wrote to his friend, the French painter Charles Maurin: 'My hatred of Italian painting has increased, also of our French painting . . . long live the North and *merde* to Italy.' Though a committed Nabi, who painted modern life and everyday urban happenings, Vallotton was pulled instinctively towards narrative and allegory, towards hard edges and the north – Germany and Scandinavia; and towards an affectless style that at times prefigures Hopper (who could have seen Vallotton's work during his Paris stay of 1906–7). He was also more political, more

satirical, more authority-hating. Perhaps his most symbolic act of solidarity with his French colleagues was when he, Bonnard and Vuillard were offered the *Légion d'honneur* at the same time; all three turned it down.

Temperamentally, he appeared in his early years to be French, or French enough: 'affable, relaxed and happy' to be in Paris. Naturally, he had a model/mistress, Hélène Chatenay, known as '*la petite*', who just as naturally was a seamstress. At one point he seems to have thought of marrying her, but was advised against it by Maurin, who told him: 'I have known friends who were so sweet-natured before and so disagreeable afterwards.' Portraiture paid the bills; though he also had financial help from his family. His brother Paul, not yet an art-dealer, was in the business of chocolate, cocoa and nougat manufacture, and Félix would be sent on errands round possible Parisian outlets. 'Send cocoa, please,' he would write home. Through the 1890s he slowly but steadily came to notice with his caricatures and satirical woodcuts; he collaborated on the *Revue Blanche*, and served as artistic director of the *Revue Franco-Américaine*, a luxury magazine funded by Prince Poniatowski, which collapsed after three issues. He became officially a Nabi by appearing in their third group show of 1893. He had met Vuillard a few years previously; he knew Mallarmé, and the writer Jules Renard, who wrote in his Journal for April 1894: 'Vallotton, gentle, straightforward and distinguished, his flat hair separated by a clear, straight parting; sober in gesture, with uncomplicated theories, and a pretty egotistical flavour to everything he says.' He was in his early thirties, making his way, self-sufficient, on the up.

And then, in 1899, Vuillard writes to him: 'I hear that there has been a revolution.' There had indeed: Vallotton had announced his intention of marrying Gabrielle Rodrigues-Henriques, daughter of the picture-dealer Alexandre Bernheim. He had known her for four

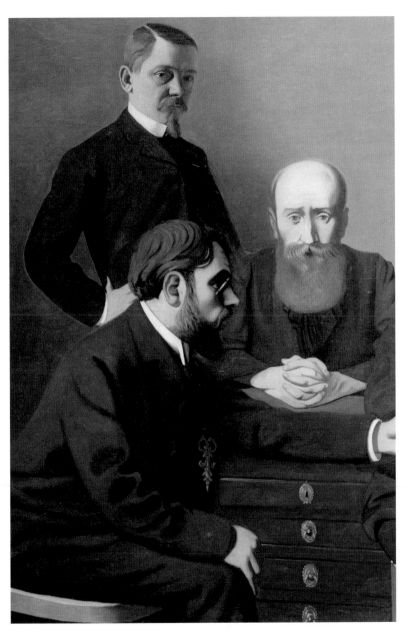

The Five Painters by Vallotton
Detail showing Vallotton (standing), Bonnard (left) and Vuillard

years; it seems to have been a marriage based on both love and good sense. Vallotton, never over-emotional in expression, told his brother Paul that 'she is a woman of surpassing goodness with whom I shall get along very well'; everything would be 'very reasonable'; while the Bernheim family was 'very honourable and rich'. Gabrielle, thirty-five to his thirty-three, a widow whose first husband had killed himself, had three children between fifteen and seven – 'and I shall love them', Vallotton assured his brother (and himself). A revolution indeed: marriage; step-parenthood; a move from Left Bank to Right Bank, from the rue Jacob to the rue de Milan; from independence, insecurity and a taste for anarchism to bourgeois comfort. At this point he also abandoned his journalistic career and largely stopped making wood-cuts. From now on, as the century turned, he would devote himself to painting, and to marriage. What could possibly go wrong?

What indeed? On the 24th April 1901 the twenty-nine-year-old Paul Léautaud went to dine chez Paul Valéry, where the guest of honour was Odilon Redon. The painter talked at length about the Bordeaux vineyards, before making an unexpected leap:

> Gossip about Vallotton, who married a very rich widow not long ago. It turns out he can't get any work done, because he's always having to pay social visits, or receive them.

Both Valéry and Redon were married (and both their wives were present), so perhaps there is an implicit smugness: *we* know how to be married artists and still get on with our work – he doesn't. In fact, like most gossip, this was only partly accurate. The first years of the century were a good time for Vallotton's art, and include the tenderest pictures he ever painted – all of his new wife. Gabrielle in her dressing-gown, in her bedroom, sewing, knitting, hemming, rummaging in a closet, playing the piano, standing before an enfilade of rooms which

seem to lead deeper into happiness: there is no doubt that this was a loving relationship. But it was also a bourgeois marriage. Gabrielle, despite her father's business, was not very interested in her husband's work; while Félix found that he had exchanged the money worries of a bohemian for the larger-scale money worries of a bourgeois. Over the years 1897–1905 his income actually went down. Further, the luxurious life he had moved into was not one that suited his temperament. In December 1905, he wrote to his brother from Nice: 'We are living in a sumptuous villa surrounded by palms and orange trees. This makes me uncomfortable: I would rather be in a hut in the countryside.' And though he still kept in touch with Hélène Chatenay, bourgeois convention meant that Bonnard could not visit the Vallottons if accompanied by his *petite*, Marthe de Méligny.

Some of this had been strangely (or not so strangely) anticipated in the work Vallotton did immediately before his marriage. This was the series of pictures from 1897 to 1899 known as *Intimités*, of which *The Lie* was one. They are from his high Nabi period: colour-block composition, sumptuously opposed hues, interior setting and generally tenebrous lighting. But whereas for Vuillard and Bonnard colour and its harmonies were supreme, and the inhabitants of their domestic spaces were colluding shapes rather than people, Vallotton was always interested in what was happening between the humans he portrayed. His figures have a life beyond the paint that depicts them; they both offer (and withhold) a narrative. In *Waiting*, a brown-suited man, half-camouflaged by heavy brown curtains, squints through lace to catch the arrival of, presumably, a woman: but is he shyly hopeful or menacingly predatory? In *The Visit*, another man (or perhaps the same one) greets a purple-coated woman, and the force-lines of the painting lead you ineluctably to the open bedroom door at the back left: but which of them is in charge here? *Interior, Red Armchair and Figures* shows the aftermath of a quarrel: a seated woman, chin in hand, with a standing

Money by Vallotton

man whose black shadow falls on her skirt like a sinister sexual stain. In others, couples huddle or embrace in semi-darkness; even the furniture seems complicit in what is going on. These are paintings of anxiety, discontent, conflict. They are enigmatic narratives about the sexual life: it is rarely clear who is dominant, who is paying, and in what currency. They have been called 'violent interiors', which may be over-interpretative; certainly they are paintings of deep emotional dissonance. Around the same time Vallotton did a series of ten woodcuts, also known as *Intimités*, though there is only one directly repeated scene: that of *The Lie*. The woodcuts are more sharply satirical – and more directly readable – illustrations of emotional war. *The Triumph* shows a merciless woman reducing a man to tears; *Getting Ready for a Visit* a fiercely bored husband waiting while his wife primps and perks herself; *Extreme Measure* a dinner-table argument – the wife standing, back turned, face buried in her napkin, the husband, guilty, rising to placate her. The most powerful of all, *Money*, has a couple standing at a balcony on the left-hand edge of the picture; the man, dressed in black, is pointing out something to the woman, dressed in white. What she cannot see, but we can, is what is behind the man: an entire swathe of black filling two-thirds of the picture, taking over and inhabiting the man's body, so that only his left hand and face emerge from it. This, we understand, is money, and this is how it presses inexorably into the couple and their relationship. All cut into wood so soon before Vallotton married his 'very rich' widow.

The prints are where he most fully expressed his playfulness, wit and bright sardonic eye for *fin-de-siècle* Paris. They are all in high-contrast black-and-white, and of small dimension (often seventeen by twenty-two centimetres). Yet within this medium he is able to differentiate subtle textures of fabric; and within this restricted space he is able to marshal dynamic crowd scenes. Demonstrators flee a police charge; umbrellas go up in all directions against a rain squall; lumpen

gendarmes descend on a slender, poetic anarchist. This narrative element also reminds us that Vallotton was a rare artist in another respect: he had literary ambitions. Like many painters, he kept a journal. But he also worked as an art critic, wrote eight plays, two of which were briefly produced, and three novels, none of which found a publisher in his lifetime. The best of these, *La Vie meurtrière*, is a 'violent interior' more overtly bloody than any of the *Intimités*: the Poe-ish story of a lawyer turned art critic who from childhood finds that his mere presence brings death to those around him. He is there when a friend tumbles into a river, when an engraver stabs himself with his burin and dies of copper poisoning, when an artist's model falls against a stove and suffers fatal burns. How complicit, or unwitting, is he in what happens? Is he obscurely cursed, and if so, how can he avoid causing further deaths? Vallotton's narrative is another organised enigma.

He was too clear-headed to think himself obscurely cursed; but the solution he imagined he had found in Gabrielle – a life of painting, marital understanding and the love of stepchildren – did not transpire. *Dinner by Lamplight* (1899) shows the nape of a (doubtless Swiss) head at the dinner table; to his right, in a pink dress, Gabrielle gazes across at her elder son Jacques, who is idly chewing fruit, while directly opposite sits a small girl gazing wide-eyed at the interloper at the table. This is not a picture about texture and colour harmony; it is all about colour opposition and psychodynamics. And it is predictive. Vallotton's relationship with his stepchildren quickly went wrong – 'their spontaneity frightened him', said one observer, and his letters are spiky with complaint. 'All would be fine if Jacques wasn't especially odious.' Jacques and his brother are 'two perfect cretins' (Stein referred to 'the violence of his step-sons'). But the main focus of (mutual) antagonism was always the stepdaughter. 'Madeleine parades and imposes her self-importance, her stupidity, her bossiness.' 'She dances

the tango, fills the house with casual acquaintances, and criticises everything.' 'She spends her time doing her nails and watching everyone's suffering as if from on high.' Back in 1893, the painter Philippe-Charles Blache had teasingly addressed Vallotton in a letter as 'Monsieur le Mélancholique', and now the underlying melancholy of his temperament began to emerge. He was also 'hypersensitive and parsimonious' – which didn't make him natural step-parent material. Gabrielle, caught between emotional loyalties, often succumbed to illness. In his early letters she is frequently '*ma bonne Gab*', but this soon mutates into '*ma pauvre Gab*', and remains so thereafter. By 1911 Félix reports his state of 'permanent anguish' to his brother Paul: 'I have no-one in whom to confide, and the thoughtlessness of those around me, who only live for the immediate gratification of their appetites, is stupefying.' By 1918 he is writing in his diary: 'What has man done wrong that he is obliged to submit to this terrifying "associate" known as woman?' It is as if *The Lie* has become the truth. He expresses his horror of 'this false life, on the margins of real life, which I have endured for twenty years, and from which I suffer as cruelly as I did the first day'. While Vuillard could say, contentedly, 'I have never been anything more than a spectator', Vallotton complains that 'All my life I shall have been one who sees life through a window and doesn't live.'

There was only art left for him. In 1909, in a letter to his new patron Hedy Hahnloser (who lived with her husband Arthur at the Villa Flora in Winterthur), he writes:

I think that what is characteristic of my art is a desire for expression through form, silhouette, line and volume; colour is an additive, designed to emphasize what is important, while remaining subsidiary. I am not in any way an Impressionist, and while I much admire their art, I pride myself on having resisted

its strong influence. I have a taste for synthesis: subtleties of nuance are neither what I want, nor what I am good at.

This is a perceptive self-analysis, marking how distant he is, was, and continued to be, from his fellow-Nabis: by 1920 he was noting that he and Bonnard still got on very well 'despite being now at the opposite extremes of painting'. Vallotton was always a protestant painter: he believed in hard work, control and difficulty of execution; he hated artifice, virtuosity and 'good luck' in a painting. The critics largely agreed: he was a 'strong and sober' painter; his work emanated a 'stubborn sincerity'; it was 'concentrated, austere, coldly passionate, and devoid of grace'.

It is easy to see how such critics might turn against him if they chose. And, increasingly, they did. Valloton's last fifteen years, from 1910 to 1925, are marked, on a personal level, by increasing isolation and disenchantment; he becomes quarrelsome, also depressed – or 'neurasthenic', as it was then termed; his diary records the temptings of suicide. He is appalled by the war, and frustrated by his inaction: even the far-from-military Vuillard is helping the war effort, having been sent to guard bridges. He sounds more French than the French, in his loathing of the Germans; but is equally disgusted by the 'corruption' of French civilians, by their alcoholism and small-mindedness, by the sexual looseness of women whose husbands or lovers are at the front. The immediate post-war period brings no respite: there has been a decline in French spirit and values; every-where a moral abdication typified by 'the mass onanism of tango tea-parties'. He has few friends, and exists in a frozen stand-off with his family. His career is stalled; sometimes months go by without a single sale; his work comes back from the gallery to clutter his studio; his pictures get unloaded at auction in a way that damages his repu-tation. In 1916 the news that he had used photography in the making

of a picture (by now a painterly commonplace) made some Swiss collectors send back his pictures, fearing they would fall in value.

Beyond all this, he feels fashion turning against him. In 1911 he notes that 'Cubism is the latest thing, and those who have discovered it are too proud of themselves to bother with anything else'. By 1916 he is sounding almost paranoid:

> I have pictures on display in The Hague, in Christiana, Basel, and soon in Barcelona. Nothing comes of it. The Cubists, Futurists, Matissistes and so on are making a tremendous effort through their representatives, salesmen and brokers, throughout the whole of Europe and across the Americas. They are cannily preparing their post-war take-over.

He also finds himself falling into the wrong price bracket: it's easier to sell a 50,000-franc picture than a 500-franc one; collectors want either 'new artists at knockdown prices, or Renoirs for 50,000 francs – those at my level suffer'. Vallotton once wisely advised Hedy Hahnloser that 'A mediocre painting is *always* too expensive; a good picture can be expensive at its price; while a very good one is *never* too expensive.'

He painted and painted: he painted to keep sane, and therefore probably painted too much. He showed more and more nudes, which the critics increasingly disliked. Stubbornly, he carried on painting and showing more and more nudes. Other parts of his output were unfairly overlooked. He was an accomplished painter of still-lives – formidably good at red peppers – while his landscapes are a great wonder, and still for most people the surprise of any Vallotton show. In every decade he was painting sunsets – always sunsets, never sunrises. This would seem to chime with his temperament – except that they are bold, lush things, his sunsets, fiery explosions: *Sunset at Villerville* (1917),

The Pond (Honfleur) by Vallotton

almost hallucinatory in its swathes of orange, purple and black, is closer to Munch.

In his daytime landscapes he brought his own interpretation to the idealising tradition of Poussin and Rubens. Poussin eliminated accidents of nature, his imagination reordering everything to achieve the fitting high style. But Rubens surpassed even Poussin, in Vallotton's opinion: 'He is in my view the greatest landscape painter because he has a sense of universality. His landscapes are spectacles of nature rather than topographical incidents.' From these two masters Vallotton developed, from 1909, his notion of the *paysage composé*: the 'put-together landscape'. He would go out into the countryside, make sketches and notes, then return to his studio and assemble the picture using material from different sites: a new, technically non-existing nature, created for the first time on canvas. The results contain surviving elements of Nabism: the use of cut-out forms and strong colour contrast. There is a quiet wit too: so *The Pond* (1909) contains some areas rendered impressionistically and others painted with hard-edged realism, while a stretch of murky black water seems to mutate into a vast and sinister flatfish as you look at it. And though these late landscapes are often given named locations – *The Dordogne at Carrenac* or *Sandbanks on the Loire* – they somehow evade specificity. They are 'spectacles of nature', but there is something dissonant about them as well; in their own way, they are enigmatic narratives, like the *Intimités*.

And then, inevitably, there are the nudes. 'But have you *ever* seen a good nude by Vallotton?' Yes, a few, most of them early. *Étude de Fesses* (c.1884) is a bum-shot of extraordinary realism, as careful a rendition of human flesh as anything by Courbet or Correggio. *Nude in Interior* (c.1890) shows a sad-faced woman sitting on top of her discarded clothes on the studio divan: at a guess, she was an amateur model, and her uneasiness is vibrant. *Bathers on a Summer Evening*

(1893), in which women of various ages and body-shapes undress and take to the water, has an ethereally cross-cultural feel to it: part Japanesey stylisation, part Scandinavian myth, part revisiting of the old Fountain of Youth theme. When first shown at the Salon des Indépendants it caused a rumpus, and Douanier Rousseau, standing in front of it, said fraternally to its author, 'Well, now, Vallotton, let's walk together.' But Vallotton was always walking along his own path, and it led to increasingly large studies of the female nude. The first time I saw his nudes en masse they seemed to demonstrate all too thumpingly what might be called Vallotton's law: that the fewer clothes a woman has on in his paintings, the worse the result. There were charming early studies of Gabrielle in dressing-gown and long night-dress; another of a model beginning to take off her chemise; next a couple of iffy peek-a-boo studies of women with shoulder-straps lowered; and finally, the Full Félix.

Vallotton came to the nude through a study of Ingres, proving that great painters, like great writers – Milton, famously – can be perni-cious influences. (He even revisited several of Ingres's well-known subjects – *Le Bain Turc*, *La Source*, and *Roger and Angelica* – in so point-lessly, self-evidently inferior a fashion that you wonder he ever showed or sold them.) But Vallotton was, whatever else, a highly serious, indeed devout painter; sometimes witty, but never trivial; his weakness more likely to be an over-abundance of thought and control rather than laziness or sloppiness. So after that first shock I have attempted to like, or at least to see the point of, his nudes. They fall into two groups: the internal nude and the external nude; always with empty worlds around them. The subject of the unattended female nude, flatly lit in a modern room, generally exhibiting torpor and anomie, inevitably reminds us that it would subsequently be treated with more subtlety and complication by Hopper. But this is not the problem. It is, first, that most of these nudes are dismayingly inert; they might

as well have been sculpted from putty, for all the life and breath they have in them. They are far from erotic, because they seem bleached of thought and feeling. Further, they are often pictorially unconvincing: it is as if Vallotton has broadened the idea of the *paysage composé* to include the *nue composée*. So in *Reclining Nude on a Red Carpet* (1909) the painter seems to have put his wife's head on an Ingres neck and then attached both to a model's body: a baffling articulation. What works with a landscape fails with the human figure.

Then there are the exterior nudes: female bathers up to the knee and thigh in the sea; a chunky Europa hitching a ride in the shallows from a very farmyard bull; a modern Andromeda with a blonde bob tied by the wrists to a rock and responding to her predicament as if it is all terribly, terribly inconvenient; Perseus slaying a 'dragon' which all too exactly resembles the animal Vallotton copied, namely a stuffed crocodile. The very earnestness and high intention of these mythological and allegorical scenes – which get bigger and bigger – make you shake your head in disbelief at their outcome. And it is all the more frustrating because elsewhere Vallotton showed that he could appropriate and update myth brilliantly. *La Chaste Suzanne* (1922) is his version of Susannah and the Elders: the biblical bath becomes an enclosing pink banquette in a plush bar or nightclub, and the elders two sleek businessmen, light bouncing off their bald crania as they negotiate with their silver-hatted prey. It is intense and menacing, yet also enigmatic: the planned victim looks – to this eye, anyway – distinctly calculating and up to speed. In modern times, the painting suggests, it might well be Susannah who turns the tables and blackmails the elders.

At that Zurich show I ran away from the nudes and returned to *The Lie*, which held a final surprise for me, one now emphasised by those hulking zeppelins of female flesh. It was tiny – indeed, the smallest painting on display (thirty-three centimetres by twenty-four).

If I had been asked, in the years between seeing it first in Baltimore and seeing it again in Zurich, how large it was, I would probably have guessed about four times its actual area. It is strange how time and absence can do this to paintings that you admire and think you know well: a version of going back to the house where you were a child and realising how different its proportions actually were and still remain. With paintings, you tend to remember the small ones as bigger than they are and the big ones as smaller. I do not know why this should be the case, but am happy to leave it – appropriately enough, in Vallotton's case – as an enigma.

Braque: The Heart of Painting

They were friends, companions, painters-in-arms committed to what was, at the start of the twentieth century, the newest and most provoking form of art. Braque was just the younger, but there was little assumption of superiority by the other. They were co-adventurers, co-discoverers; they painted side by side, often the same subject, and their work was at times almost indistinguishable. The world was young, and their painting lives lay ahead of them.

You have to feel sorry for Othon Friesz, Braque's fellow-Le Havrean and loyal confederate in Fauvism, his proto-Picasso. While Braque moved on with his new Spanish friend to make the greatest breakthrough in Western art for several centuries, and Cubism relegated Fauvism to a jaunty memory, Friesz had to get on with the rest of his life and the rest of his career. Strangely, the first joint show the two painters ever had was a posthumous one, a century after they had stopped working together. The exhibition, in 2005 at the Musée de Lodève in the Languedoc, proved a display of unintentional cruelty. The most compelling Fauve pictures were all by Braque; but while this was just a stage in his development (though a fondly remembered one – fifty years later he was to buy back his own *The Little Bay at Ciotat*), it turned out to be what Friesz did best. Afterwards, he wandered his way through various styles, inclining more and more to the empty magniloquent gesture – a painter shouting not to be forgotten.

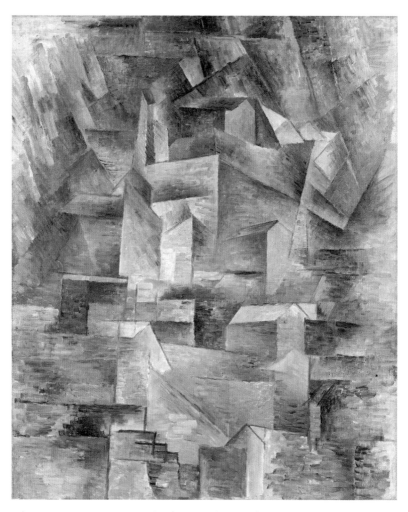

Les usines de Rio Tinto à l'Estaque by Braque

Fauvism was all about heat; and while the thrilling discoveries of the next ten years are about form and colour – about form asserting itself over colour or, rather, colour holding itself back in the service of form – the journey to analytic and then synthetic Cubism also plays out in terms of temperature. Fauvism is all pinks and mauves, with shouty blues and hilarious oranges: the sun is ferocious, whatever the sky in the picture may pretend. In the paintings Braque did next, at l'Estaque and La Roche-Guyon in 1908, you can feel the heat leaching out: here are rich browns and greens and greys. But colour was regarded as suspect by classical Cubism: it was 'anecdotal', it blurted, it carried too much information, it distracted from the pursuit of form. So it had to be whipped into line – literally: that old French battle between colour and line was now taking a new turn. By 1910–11 you could have any colour you liked, so long as it was grey, brown or beige.

Braque's great breakthrough was at l'Estaque rather than later: with paintings that absorb all Cézanne had taught, then go beyond, and culminate in his pictures of the Rio Tinto factories, which pitch us fully into Cubism. These are so astounding that we almost overlook the other sudden shift, of subject-matter: a Provençal 'landscape' can equally be made up of a sliding, dodging vista of factory roofs. And from here it all looks so inevitable: that Braque, returning from l'Estaque, would combine with Picasso to take the great discoveries forward. The two of them were, as Braque put it, 'like climbers roped together on a mountain'; and the words he scribbled on a visiting card he left with the Spaniard – 'anticipated memories' – sound like a confident prediction of lifelong association.

At the time, how much less certain it must have seemed: who could tell if Cubism – mockingly named by its detractors – would not turn out to be one more passing phase? These new painters were not like their immediate predecessors, who had tended to overthrow the

presiding pictorial conventions, develop their own way of seeing, and then more or less stick to it. The new gang were constantly, frenetically metamorphic, none more so than Picasso. Fauvism was like some hub airport with multiple destinations. A few years ago, the Courtauld Institute had a small Derain show of a dozen paintings he did in London in 1906. They rendered the city in more flatteringly – indeed, alarmingly – vivid colours than anyone had previously lent it. But while the first two were in a bold neo-Pointillist version of Fauvism, the other ten were in a quite different style, clumpier in form, solider in brushwork. Why should Cubism not also turn out to be a fleeting phase? How much would it prove to contain?

This was not just a question of style, but also of personnel. Who was on board, who had signed up merely for the trip around the bay, and who for the whole voyage? Also at l'Estaque in 1908 was Raoul Dufy, painting in just as radical a style as Braque (his *Arcades* are a thing of wonder, while his *Tileworks* and *Boats* have the hard-hatching of a Picasso nose). Whatever happened to Dufy that he ended up an artist of mere twirly decorativeness, whose paintings were no improvement on his postcards? And there were other ways in which Cubism's voyage might have ended. Braque was posted missing on the Somme in May 1915; when found, he was blind. What if the hand of the surgeon who trepanned him had slipped? What if, like his fellow-trepanee Apollinaire, he had survived the operation only to be carried off by the great influenza epidemic of 1918? Would Picasso, without the comradeship of Braque, the need to rivalise with him, to fight and overcome, have pursued the course he did?

Received art history tends to overlook such shiftingness, the hypotheticals that never occurred. We also easily forget that a great and serious artistic adventure may still contain a strong element of fun at its start: see the Bauhaus. Old artists grow solemn when feted by young critics, and may misremember the glee, the jokiness, the risk

and the doubt of their less-observed younger days. Cubism was a profound reinvention of how and what we see; it was, as Picasso told Françoise Gilot, 'a kind of laboratory experiment from which every pretension or individual vanity was excluded'; it was an eventually unsuccessful search for what Braque called 'the anonymous personality', whereby the painting would stand by and for itself, unsigned and self-free. It was all this, and all as high-minded as this; but it was also personal, playful, companionable. It was Braque teasing (and delighting) the dressy Picasso by buying him a hundred hats at an auction in Le Havre; it was Buffalo Bill and 'Pard', as Picasso signed himself; it was Braque as 'Wilbourg', Picasso's rendering of Wilbur Wright, whose flying contraption was an analogue (or the other way round) of Braque's pioneering – and lost – paper sculptures of 1911–12. It was judging pictures by whether they fell into the 'Louvre' category or the 'Dufayel' category (Dufayel being a department store which sold imitation Henri II sideboards). The latter was rather more of a term of praise than it might seem. 'They want art,' Picasso was to lament in later days. 'One has to know how to be vulgar.'

The joyful, improvisatory side of Cubism is more evident in Picasso's work than Braque's: in the visual puns, the jokey sculptures, the small beach pictures where the painter simply turns the framed canvas over and works on and in the back declivity with sand; also in self-presentation – Picasso at a restaurant table with bread-rolls for fingers, holding open studio, being endlessly photographed, playing the great artist, acting famous in the banal way the public understands. You might be tempted to conclude, as their careers developed, that Picasso overshadowed Braque as Braque had once overshadowed Friesz. You might even be tempted to feel sorry for Braque; but this would be a mistake. Picasso wanted to do everything and be everything. Braque knew he couldn't do everything, and didn't want to be everything. He recognised his technical limitations from early on: his

drawing was poor, his figure representation unsuccessful, his statuary 'lumpen'. Too much facility and the artist may fall in love with his own virtuosity; too little and a 'Wilbourg' won't get off the ground. And even when you can identify your own weaknesses, there is a choice to be made: the apparently sensible one of trying to eradicate them, and the more radical approach that Braque adopted, of ignoring them. 'Progress in art,' he wrote, 'does not consist in expanding one's limitations, but in knowing them better.' Put more simply: 'I don't do as I want, I do as I can.' In this, he resembled Redon, who also decided to make his weakness at drawing the human figure into a kind of strength.

In addition, Braque had a singular ability not to be distracted by the art he didn't need in order to make his own. His masters were Chardin and Corot; he admired Uccello; his favourite painter was Grünewald – and that was mainly it, as far as Western art went. He hated the *Mona Lisa* as many did, for its symbolic ascendancy. On a visit to Italy, he declared that he had 'had it up to here' with the Renaissance – though there does not seem to be much evidence of previous over-consumption. He disliked museums, preferring to sit outside and send Mme Braque in to see if there was anything worth attending to (which sounds like an instruction inviting the answer no). At times this seems to border on affectation: when the Tate put on a Braque–Rouault show in 1946, he chose to attend its closing – rather than its opening, or, indeed, any other – day.

He painted. That was what he did. He painted relief without perspective. He painted forms advancing towards the viewer rather than receding. He did not paint objects, he painted space and then furnished it. He was so close to the earth that for twenty years he did not paint the sky. He told the architect who designed his house in Varengeville not to use top-quality glass because he wanted the view through the closed window to be different from the view

through the open one. He avoided all symbols. He began in riotous colour, gradually decoupled colour from form, and then, slowly, from the 1920s on, put colour back together with form, but on his own terms; in the same way, he began with identifiable subject-matter, cubised it beyond recognisability, and then gradually made it identifiable again, but on his own terms. In a very long career, he had weaker periods, and his larger paintings tend to dilution rather than monumentality; but he never strayed from his principles, or stopped searching – in the 1950s he did a sequence of completely original, letter-box-shaped landscapes in suddenly rich colours. Picasso said that Braque was not 'domineering enough' to paint a portrait, a remark which perhaps says more about Picasso. He thought it would be ideal to reach a state where we no longer say anything when in front of a painting. He knew that a Braque fake was a fake because it was 'beautiful'. We might be astounded and awed by Picasso, we might submit and succumb to his art, as many did to his personality. But love him? Difficult. Braque is a painter, and a (largely hidden) personality for whom admiration and respect are immediate, and love not far behind.

In his life as in his art, he displayed the same unswervingness, the same elimination of the unwanted, the same commitment and certainty. When the Germans invaded France in 1940, Braque was fifty-eight. His service in the Second World War was as quietly heroic as in the First. The Germans were clever at flattering and suborning important cultural figures, and they had to be resisted with not just a moral sense but also a tactical intelligence. One winter's evening, two German officers arrived at Braque's studio, and wondered aloud how a great painter could work in such icy conditions. They would like to salute his genius by sending him two lorryloads of coal. Braque's answer was perfect. 'No, thank you,' he said. 'For if I accepted, I should no longer be able to speak well of you.'

In 1941 the invaders persuaded a group of French artists to visit the Fatherland. Some of their inducements, like that offer of fuel, were obviously tainted; others, like the promise to release French prisoners of war, deliberately put their invitees into a quandary. And here Othon Friesz re-enters the story. He agreed to go, as did Derain, Vlaminck, Van Dongen and Dunoyer de Segonzac. The photo taken of them on a platform of the Gare de l'Est – flanked by triumphant German officers – reeks of unease and bad faith. Braque's only public comment on the trip was properly conscious of the dilemma: 'Fortunately, my painting did not please. I wasn't invited. Otherwise, perhaps I would have gone, on account of the promised releases.' After the Liberation, Picasso, though not a French citizen, took the chair of a Front National des Arts, which sent the authorities a list of collaborationists, requesting their arrest and trial. In June 1946, twenty-three were sanctioned by a purifying tribunal, with Friesz, Vlaminck, Derain and Van Dongen receiving one-year bans. Braque distanced himself from the public taste for *épuration* (how, in any case, can you 'purify' with a one-year ban?), but his private sanction was more damning and more final. He broke with Friesz and Derain; and when he encountered Van Dongen in Deauville, not a word was ever exchanged.

The moral authority was the greater for not being publicly advertised. There was something about Braque's calmness, his silence, his artistic commitment which unwittingly showed up lesser men and women. This authority, finally, comes from the paintings themselves: the sense of form, of harmony, of colour-balance – the seriousness of truth to nature, and truth to art – has a moral underpinning. And Braque became, over the years, a living reproof to vanity, pomposity, charlatanry. Gertrude Stein, who thought only Spaniards could be Cubists – and who later offered to translate Pétain's speeches – wrote a 'word-portrait' of Braque in her finest mode of clotted twaddle.

(Perhaps it was meant to be Cubist prose. If so, a bad idea – brush-strokes may slip representationalism, but words do so at their peril.) Cocteau, who was himself lucky to escape *épuration*, patronised Braque for having 'the perfect taste of a poor milliner' – the remark of a gaudy snob. A similar snobbery is implicit in Le Corbusier's Purist manifesto: he and his co-propounder Amédée Ozenfant loftily dismiss 'simple paintings by good painter-decorators smitten with form and colour'. What more desirable description of a painter, you might think, than as one 'smitten with form and colour'? And then there is our own Bruce Chatwin, who as a twenty-year-old courier from Sotheby's was allowed into Braque's presence when a well-known collector wanted a drawing authenticated. Each time Chatwin recycled the anecdote, his own participation swelled gloriously.

These are revealing side-encounters, which confirm the painter as the moral equivalent of magnetic north (true north too, for that matter). But the main encounter was always with Picasso. The Spaniard liked to say that he took Braque to the station in Avignon in 1914 and never saw him again. This was no more than an exasperated denial of an obvious truth: that 'anticipated memories' was an accurate prediction, and that the two of them – roped together on the mountain – would remain in one another's thoughts and studios until death. At times it is an astonishment that two great artists, so aesthetically indistinguishable at the high moment of Cubism, could have had such radically different temperaments, beliefs, politics, personal habits and social tactics. When reading about Picasso's ways with his fellow-mortals, you sometimes wonder if 'fellow-mortals' is even an appropriate term: he combined the relentlessness of a Wunderkind with the wilfulness and vanity of a god. He was like one of those old denizens of Olympus whose abrupt interventions in human affairs are purely selfish and delightedly manipulative. The fact that you were a friend or lover merely upped the ante. As Françoise

Gilot observed, 'his lowest tricks were reserved for those he liked best'. Braque was one of the few – Gilot herself being another – who managed successfully to resist Picasso. Silence and withdrawal were Braque's main tactics, which of course exasperated Picasso the more. One of the great undocumented exchanges came when Picasso spent a week in 1944 trying to persuade Braque to join the Communist Party. Braque denied him, as he also denied a second approach from none other than Simone Signoret (I feel a three-hander play coming on).

Braque was like some hilltop castle that Picasso was constantly besieging. He invests it, bombards it, mines it, assaults it – and each time the smoke clears, the castle is as solid as ever. Thwarted, he declares the site of no strategic interest anyway. Braque, he says, merely has 'charm'; he has gone back to 'French painting', becoming 'the Vuillard of Cubism'. He tells him his pictures are 'well hung'. Braque replies that Picasso's ceramics are 'well cooked'. It is often the laconic, rather than the voluble, who win verbal battles. Picasso's words frequently arise from not getting his own way over something unconnected with art; either that, or as a means of cheerleading the Picassoites. Braque's words seem the more pondered, more to do with art, and therefore more deadly. Words like 'talent' and 'virtuoso' have an extra edge in his mouth. His replies culminate in the famous observation: 'Picasso used to be a great painter. Now he is merely a genius.' That's to say, the public's idea of a genius, someone protean and industrially productive, whose private life is also a publicised circus.

They were not the first or last 'pardners' to fall out, and to give the maliciously indifferent an afternoon of pleasure. But unlike some other fallings-out (that of Truffaut and Godard, for instance, which was rancorously terminal), Picasso and Braque's was complicated and continuing rather than ever final. And though Picasso might

seem the more powerful, and was certainly the more famous, it is he who comes across as the supplicant, the more needy, in their dealings. It was Picasso who complained of being neglected and insufficiently visited; Picasso who took his new girlfriends to Braque for approval. And in their working lives it was Picasso who learned how to grind colour from Braque, and how to make his *papiers collés* stick; Picasso who was led to new challenges by Braque's work (the *Studios* of 1949–56 provoking the *Las Meninas* variations); Picasso who suggested in the mid-1950s that the two of them go back to collaborating as they had done half a lifetime previously – another invitation Braque declined.

René Char called them Picasso and anti-Picasso; but the more you look at them, the more they turn into Braque and anti-Braque. Braque slow, silent, autonomous, magisterial; anti-Braque mercurial, noisy, voluminous, virtuosic. Braque pursuing his own, known, 'limited' path; anti-Braque furiously metamorphic. Braque rural, domestic and uxorious; anti-Braque cosmopolitan, voracious and Dionysiac. It is not an either/or, more an and/also: there are different ways of being a genius, whether that word is loaded or not. Yet it is also salutary to flip the traditional order of expression and write, as Alex Danchev does in his wonderful biography of Braque, that Picasso's 'Braque period' was 'the most concentrated and fruitful of his whole career'.

There is a danger in attributing sanctity to Braque. Jean Paulhan wrote that he was 'reflective but violent'. He was hurtful to Juan Gris, refusing to be hung in the same room; he once beat up his ex-dealer at Hôtel Drouot – admittedly, on grounds that seem reasonable. While decrying Picasso's 'Duchess' period, his ball-going and fancy costumes, Braque was, in his soberer way, a pretty dressy fellow: on his rare trips to London, he headed not for the National Gallery but for the house of Mr Lobb the bootmaker. He had a taste for fast and expensive cars, both driving them and being driven: like Picasso, he had a

uniformed chauffeur. He enjoyed his food, though occasionally a puritanism kicked in: on a tour of three-star Paris restaurants with the painter Umberto Stragiotti, he quite spoiled it for his companion by wolfing down his food far too quickly. Before taking his first transatlantic telephone call, Braque combed his hair. An odd reaction – was this vanity or modesty? (And perhaps not so odd: I once watched a *Sunday Times* arts journalist leap to his feet when the telephone on his desk turned out to have Lord Snowdon at the other end of it.)

These are passing, and humanising, distractions. What struck many people who met Braque was the completeness, the integration of his personality, and the further integration of that personality with his art. Françoise Gilot said: 'All of Braque was always there.' Miró said he was 'a model of everything that is skill, serenity and reflection'. For the young John Richardson, visiting the painter's studio for the first time, 'I felt I had arrived at the very heart of painting.' This, finally – and firstly – is where his authority comes from. There is never a danger that Braque's life might overshadow his work; indeed, such a life is most lived when making that very work. There is little gossip to be had around Braque's existence, because he provoked and provided little (he came back from the First World War with only one 'war story'). Georges and Marcelle Braque 'were completely faithful to one another for over fifty years'. Duncan Grant could so little understand such coupledom that he decided it must derive from a shared passion for the sea. When Mariette Lachaud joined the household in 1930 at the age of sixteen (her mother was the Braques' cook), you might think her future course would be a cliché. But as Alex Danchev points out, she was 'as chaste as she was devoted', graduating from 'studio assistant to ministering angel and photographic documentarist – never to mistress'.

This is, in fact, more biographically interesting than the usual tales and trails of artistic bed-hopping. My wife, before she met me, long

Georges Braque, artist, and his wife Marcelle, Paris, 27th January, 1959
by Richard Avedon

held in her head two chief images of conjugality: Etruscan marital tomb-statues, and the Avedon portrait of the Braques in old age – he seated, smiling, she resting against his shoulder. (It is an interesting coincidence that the ceiling Braque painted in the Louvre – the only such commission he ever accepted – was for the Etruscan room.) Marcelle Braque was even more discreet than her husband, and left few traces; she was apparently 'a real woman of the people'; also cultured, religious and shrewd. She once warned Nicolas de Staël, 'Watch out – you staved off poverty all right, but do you have the strength to stave off riches?' We are told that she sewed Modigliani's shroud.

'The only thing that matters in art is what cannot be explained,' Braque wrote. And: 'How is one to talk about colour? . . . Those who have eyes know just how irrelevant words are to what they see.' Further: 'To define a thing is to substitute the definition for the thing.' In the same way, to write a biography is to substitute the written life for the lived life, an awkward business at best, but possible as long as Braquean moral truth is to hand. The painter approached death as he had life: 'always there', in Gilot's words. Towards the end, he called for his palette. The colours present on it were later listed by the critic Jean Grenier: raw umber, burnt umber, raw sienna, burnt sienna, yellow ochre, lamp black, vine black, bone black, ultramarine, orange-yellow and antimony yellow. Braque died 'without suffering, calmly, his gaze fixed until the last moment on the trees in the garden, the highest branches of which were visible from the great windows of his studio'.

Magritte: Bird into Egg

Magritte could not possibly have had a better describer, and therefore defender, than David Sylvester (1924–2001), who wrote about the artist over four decades, and spent just as long putting together the Catalogue Raisonné. He flourished in an era when television arts programes often contained serious aesthetic argument (and when presenters were even allowed to smoke on camera). He was also widely acknowledged as the best exhibition-hanger of his time, and in 1992, at London's Hayward Gallery, he presented Magritte's work in physical space as wisely and deftly as he had in printed text. This was the most brilliantly hung show I have ever seen. Sylvester made a bright virtue of the Hayward's bizarre and rebarbative expanses: that miserable concrete backdrop, those odd corridors, pokey side-spaces and sudden pinched staircase were transformed into something like a monster version of Magritte's brain. You wandered through bewildering, dingy passages of grey matter, to be confronted at every turn with star-bursts of bright ideas.

Sylvester's writing about Magritte was just as exemplary: careful and shrewd, extraordinarily sensitive to artistic cross-reference, scornful of jargon and theory, thoroughly at ease with the life and able to add to it from his own personal encounters. He also gracefully avoided the serious danger awaiting anyone who has spent so much time pondering the same artist: that of being too certain. I remember going round a Mantegna exhibition at the Royal Academy, and running

into a group of art students being hand-held by a junior lecturer. They were standing in front of *Portrait of a Man* (supposedly Carlo de' Medici), which the explainer compared to Freud's portrait of Bacon, adding confidently, 'Of course, Mantegna's aim here wasn't realism.' To which the only reply might have been, 'Talked to him lately, have you, mate?' Sylvester, on the other hand, knew enough to know that you can't always know. Teasing out the delicate and confused relationship between the suicide by water of Magritte's mother, the manner in which it was reported to him, the manner in which he reported it to others, the effect it might have had, and the consequent emergence into his art of female figures, shrouded and naked, Sylvester rightly prefaced his remarks with 'perhaps'. Not once, but constantly: there is one paragraph where six consecutive propositions are preceded by six successive perhapses. Pound complained to Eliot that the first draft of *The Waste Land* was 'too damned perhapsy'. Sylvester showed the merit – too rare in art criticism – of perhapsiness.

The poet, Surrealist and civil servant Louis Scutenaire claimed that his friend Magritte had 'strangled the eloquence of painting'. Another way of putting it would be to say that he reacted to the history of art like a landscape gardener appalled, and weighed down, by his predecessors' lofty attempts to counterfeit nature, to persuade it to their own ends while cherishing each hillock and dale, and who therefore decides to apply maximum order: nothing but gravel, box hedges and geraniums on an entirely horizontal surface under artifical lighting. Magritte's art is one of control and exclusion: he uses a blandly frontal viewpoint; symmetricality and parallel receding planes; a deliberately reduced set of image-objects, either ordinary in themselves (curtains, birds, fire) or worked up into ordinariness by repetition (the bilboquet, the jingle bells); flatness of paint; and a detached way of representing things, so that, for instance, the blue of the sky is always parodically bright. He rejects the fantastic and the free-associative in favour of

the rigorous, the argued, the systematic. It is witty, seductive self-conscious art, put together with what Sylvester called 'a suavity of representation', and topped off with ponderedly provocative titles. How could you be young and fail to love Magritte?

This manner of painting – concentrated, restrictive, iconic – is designed to produce monumental images: monumental regardless of the size of the canvas. It knows exactly what it is doing, which renders it beside the point to complain, say, that when you are suddenly presented with the same images in gouache, you find them warmer, nicer, kinder: the coldness and flatness are central to Magrittiness. Similarly, when the painter tells his fellow-Surrealist Paul Nouge in November 1928 that his aim is to produce 'pictures in which the eye must "think" in a completely different way from the usual one', it is no good observing that 'making the eye think' seems to preclude 'making the heart move'. Of course it does: Magritte's most moving work was probably the series of post-Cubist nudes he did in 1922–3.

But this system, this ruthless system, produced a number of works which we may as well call by that meaningless term 'great': images by which the spectator is unnerved, disoriented, lost; works in which, as Magritte wrote of de Chirico, 'the spectator might recognize his own isolation and hear the silence of the world'. Paintings like The Hunters at the Edge of Night, which encloses and provokes fear in its pure state; or the thunderous The Titanic Days (which Sylvester fascinatingly relates to the Temple of Zeus at Olympia), where the most terrifying touch is a tiny one, the cut-out in the assailant's jacket-cuff at the join of the woman's thighs – this is how inextricably the man occupies the woman's body-space; or the monumental image-confection On the Threshold of Liberty; or the cleverly sensual The Eternally Obvious (1930), a vertical set of five separately framed sections of a female nude, which Sylvester adroitly installed at the Hayward in a little room of its own, like some Flemish polyptych

in a hidden side-chapel. Pictures like these are the high justification of the method. There is no point in wishing it otherwise, in wanting artists to be different from the selves that they have spent a long time finding; no point saying, Oh, if only he'd gone in for more texture, or really done collage, been less clever, painted with more 'heart', or whatever. The result would not only have been less Magrittean, but more of a mess; there are too many artists around already with no individuality worth expressing for us to complain when an artist 'over-expresses' his or her individuality. And while we're about it, let's do away with Magritte's claim of 1925 that by deliberately using a banal style of painting and by dealing in ready-made things, he was refusing to indulge, artistically, in 'the minor predilections of an individual'. Maybe he thought so at the time, but when an artist chooses to be 'objective' rather than 'subjective', the determined manner of choosing can result in just as dense and pungent a subjectivity. No body of work in twentieth-century art is as individual and imitable as Magritte's; none depends so much on the consistent reuse of trademark images.

Explaining his creative process in the lecture 'La Ligne de Vie', Magritte famously described how he woke up one night and in a 'splendid misapprehension' imagined that his wife Georgette's pet canary had been replaced in its cage by an egg. Hence (though 'hence' is always brutal shorthand) the doctrine of 'elective affinities', the 'new and astonishing poetic secret', the shift from the Surrealist method of opposing completely unrelated objects to the Magrittean one of opposing subtly (sometimes not so subtly) related ones. Or, as Magritte put it:

> We are familiar with the image of a bird in a cage; interest is heightened if the bird is replaced by a fish or a shoe; but although these images may be intriguing, they are unfortunately accidental, arbitrary. It is possible to find a new image, which will

Les Affinités Electives by Magritte

withstand examination through its definitive, accurate character: this is the image which shows an egg in the cage.

So we have *Les Affinités Electives* of 1933. The painting focuses on the business end of a standing bird-cage, its supports given a bilbo-quetish turn; inside the support is a hanging wire cage; filling the cage almost completely is a whopping, unlayable egg. The picture is predominantly grey, with a bright sheen of white on the egg, perhaps indicating the future it encloses. Now, we can comment on the unset-tling size of this egg; we can reflect that egg and cage are both in their different ways, as Nouge put it, 'images of confinement'; we might add that the bilboquets add an extra layer of confinement (as do the grey surround and the actual picture frame itself). It is certainly an unsettling image, both suave and gloomy. But does it 'withstand examination'? When all is said and done, the primary and final thing about *Les Affinités Electives* is that, instead of a bird in a cage, Magritte has painted an egg in a cage. Which is hardly a startling conceptual leap. It should also remind us that our brilliant night-time aperçus often turn out, in morning's unflattering light, to be less distinguished than they earlier felt.

A similar case is the self-portrait *La Clairvoyance* (1936). Here a recognisable Magritte sits at the easel, palette in hand; he gazes to his left at an egg sitting on a brown-clothed table, while with his right hand he finishes painting a bird, its wings outstretched, rising in triumph against a beige background. It is a neat and perky image, delightful on first viewing. But though we may make something of the fact that the painter is looking at the object rather than the canvas he is working on, as an image of artistic transformation *La Clairvoyance* doesn't take us very far. The artist can turn an egg into a bird; well, nature does that every day, in battery farms around the world. Ah, but the artist only has to *look* at the egg to transfigure it. Again, no

La Clairvoyance by Magritte

very big deal: I know someone who can't drive past a field of sheep without muttering 'Dinner' and imagining a plate of lamb chops, and he claims to be merely hungry rather than Magrittean. The trouble with being an 'ideas' painter rather than, say, a bourgeois aesthetician of the kind despised by Magritte is that any less-than-brilliant idea on canvas looks more exposed than does a less-than-brilliant 'aesthetic' sketch.

When the ideas-factory is simply churning out production, Magritte brings to mind Dr Johnson's complaint about *Gulliver's Travels*: 'When once you have thought of big men and little men, it is very easy to do the rest.' But, away from his more programmatic concerns, Magritte is also a fine and skittish comic painter, with good jokes and wheezes. He is playfully adept at the 'cottage industry' – as Sylvester terms it – of the Surrealist object, with his jolly masks and painted wine-bottles (the 'rare old vintage Picasso' is a stylish pun on the joint snobberies of oenophilia and art-collecting). The titles of his paintings – indeed, the whole title-giving process, with Surrealist chums sucking their teeth and pronouncing – can seem over-careful, if not pompous; while his 'Uses of Speech' series (such as *This is Not a Pipe*), his plan for 'finding new words for objects', seems misconceived, or at least rather flimsy. The main objection is that it's a literary rather than a painterly project: what gives us the brief surprise is the name given, rather than the representation of the object misnamed. So we tend to react with, Oh, so he's calling a bowler hat *La Neige*, rather than, Oh, so *that's* what snow really looks like, or might be made to look like. But our reaction may be confused by the ubiquity with which Magritte's images have been commodified. 'This is not a Something' has long been a headline-writer's and adman's trope. Recently, I received the first volumes of the Penguin retranslation of the Maigret novels, by Magritte's fellow-Belgian Georges Simenon. The front cover of the publicity booklet has a drawing of a Magrittean–Maigretian

pipe, the name of Simenon and, underneath, the catchline 'I am not Maigret'. As for those painted wine-bottles: they have for decades now been the logo of a London wine-merchant.[1]

Then there is the wartime period of Impressionism, or what Sylvester calls 'sunlit Surrealism'. Magritte left several explanations of his gaudy Renoirism. He said that if darkness and panic were what you wanted, the Surrealists might as well fold their tents once the Nazis' real-life version came along; he said that 'against the general pessimism, I uphold the quest for joy and pleasure'; and finally (in a letter to Éluard of 1941) that he wanted 'to exploit the "bright side" of life. By this I mean all the traditional para-phernalia of charming things, women, flowers, birds, trees, the atmosphere of happiness, etc.' It's hard not to find the first part of this disingenuous: let's paint menace and fear and disorientation until the real thing comes along, and then retreat into how the world isn't. As for the call, from wartime Brussels, in favour of the 'bright side', this pre-echo of the *Life of Brian* crucifixion song is no more convincing a response to one's circumstances. Perhaps the Impressionist phase could be an example of artistic male meno-pause, induced by the extreme control of Magritte's working methods. If you are famous for not getting any paint on your clothes, perhaps the midlife temptation for looser splosh seems headily powerful. More broadly, don't painters, like other artists, often come to resent what it is they do best? Boudin got fed up with being praised for his small beach scenes with grouped figures. If Magritte's post-war Fauve or *vache* period was, as Sylvester maintains, an Up Yours to the Paris art market, perhaps his

[1] And since the firm's owner is also part-owner of Crystal Palace Football Club, fans on the terrace at Selhurst Park can look down and see Magritte wine-bottles deco-rating the roofs of the home and away dugouts. It is a small dislocation you can't help feeling the painter would have approved.

Impressionist period was an Up Yours to himself. He was of a sarcastic, ironic temperament, and such natures are inclined to punish or mock themselves.

Sylvester is appreciative of both these periods, and rightly points out that if they offer what seem to be rogue variations of style (which were hated by Magritte's associates and friends), they do not represent an abandonment of 'his general *attitude* to style. That attitude was essentially an opposition to style for art's sake and to style as an ego trip for the mandarin artist.' All painters should have the luck to find so lucid an appraiser of their work as David Sylvester. The final phrase of his 1992 monograph perfectly describes the effect that the most powerful Magrittes still have on us: they induce 'the sort of awe felt in the presence of an eclipse'.

Oldenburg: Good Soft Fun

Time has had some gentle revenges on Claes Oldenburg since he first came to prominence; nothing too savage, of course, just a few fond tweaks. The rebel whose 1961 manifesto valiantly proclaimed an art 'that does something other than sit on its ass in a museum' now has sedentary retrospectives and five-city museum tours. 'I am for an art you can sit upon,' he continued, yet any nostalgic exhibition-goers treating his soft beanbaggy sculptures like true 1960s beanbags would soon find themselves in trouble with the warders. Back then, he further demanded 'an art which is put on and taken off like pants . . . which is eaten, like a piece of pie, or abandoned with great contempt, like a piece of shit' – a yearning for demystification and disposability which now butts against such stern conservatorial warnings as: 'Please do not touch the artworks in this exhibition. Many of them are extremely fragile.'

Of course, it's mildly unfair to take any artist's *profession de foi* and compare it with the actual art produced. Manifestos are more about the past, about what is objected to and reacted against, rather than a set of reliable promises about future work. Most of that 1961 statement should be treated as a kind of loose Ginsbergy outpouring. It would be a harsh and unpoetic critic who compared Oldenburg's asserton that 'I am for an art which helps old ladies across the street' with the official statistics of old ladies helped across the street by the subsequent *oeuvre*. No, we should read such

Proposed Colossal Monument for Central Park North, N.Y.C. - Teddy Bear
by Oldenburg

statements as loosely as they are written: Oldenburg is 'for' art, and he is 'for' helping old ladies across the street. Who would jib at either of these two predilections?

More long-lasting, and more misguiding, is his grander assertion from the same time that his art was to be 'political-erotical-mystical'. Marcuse once claimed that if any of Oldenburg's fantasy monuments were actually realised, it would be 'a bloodless means to achieve revolutionary change', and a sure sign that 'this society has come to an end'. Well, a few dozen playful colossi have now been erected (sponsored by German banks and other such revolutionary bodies) and society remains considerably unchanged. In truth, Oldenburg's work is about as political as a hot dog, and as mystical as a Hoover. As for 'erotical': the human form, and human relations, are entirely lacking from almost all his pieces. There is a critical line, massaged by the artist himself, asserting that the very absence of the human body proves that the sculptures are really full of seething eroticism (big hard prongy things, soft squishy other things with holes in them); but this is just sales talk. If you look at the 'erotic fantasy drawings' Oldenburg showed in 1975, they are far more fantastical than erotic. A familiar trope was the large-breasted woman with a monster three-foot cock plugged into her mouth: in other words, an 'impossible object' of the kind he has devoted most of his life to creating in three-dimensional form.

So let's replace 'political-erotical-mystical' with, say, 'demotic-plastic-cheerful'. Less grand, of course; but then the worst one can do to Pop Art is not to dismiss it, but to freight it with exorbitant intention. Take, for instance, Oldenburg's well-known proposed monument for Central Park: a monster teddy bear sitting on its ass. It's a pleasant stroke to place a nursery item provocatively into the middle of the world's least innocent city. But this isn't enough for the artist, who claims the image as 'an incarnation of white conscience; as such,

it fixes white New York with an accusing glance from Harlem . . . I chose the toy with the "amputated" effect of teddy paws – handlessness signifies society's frustrating lack of tools.' Need one point out that the monument would only convey anything like this message to Manhattanites if it was written in big letters on a plaque beneath the bear? And has anything read more like an example of *ex-post-factum* artistic intent?

Oldenburg may have begun as a bohemian, a Sixties rebel, an organiser of happenings; but his transition to museum artist and public sculptor could not have been swifter or more required. To look back at photographs of performance art (note the hip audiences reacting with well-mannered and unthreatened amusement), or to sit through the hippyish home-movie hi-jinks of *Birth of the Flag* or the sub-sub-Buñuel Surrealism of *Photodeath* is to be dismayed at the production values (part of the point, no doubt), but mainly to be bored stupid by the derivativeness of the imagination. This side of Oldenburg lingered, though he knew from the start it was doomed. 'If only I could forget the idea of art entirely,' he mused in 1961. 'I don't really think you can win. Duchamp is ultimately labelled art too . . . Possibly art is doomed to be bourgeois.'

Oldenburg's art is fundamentally democratic – and democracy is one of the most bourgeois notions of all. With Oldenburg, you don't have to know much about art to know what you like about it. In its early manifestations, it created its own found objects and transmuted street rubbish, offered up the transient, the discardable, the ready-made: the influences were Duchamp as theorist and Dubuffet as practitioner. There was a quick-bite consumability back then, and an inherent one-off jokiness: it is wryly typical that the zestful yet approximate finish of his early food sculptures is the result of their being iced with genuine cake-decorating tools.

Gradually, the art becomes sleeker, more obviously out to please, with the finish a large part of its primary appeal (and what could be

Giant Soft Fan by Oldenburg

more bourgeois, more shop-window, than that?). Yet what the art is up to – making the soft hard, the hard soft, making the normal-sized big, vast or colossal – remains democratically easy to follow. Our visual expectations and sensuous knowledge are knowingly teased: the bitten ice-lollies made in the plush fur of hot-water-bottle covers; the sleek cherry-wood plug and its floppy vinyl sister; the steel-and-lead baseball mitt with the wooden ball. The chosen medium and manner of display are often genuinely witty. Thus *Freighter and Sailboat* (soft and downsized) are pegged to a clothes-line, as if to drain them of the element they thrive in; while *Giant Soft Drum Kit* offers every element of a drum kit except the very tautness that makes a drum a drum.

When Oldenburg settles for mere enlargement, the results are comparatively dull: a double-sized *Vacuum Cleaner* (even if it is, or could be construed as, making a socio-economic point about the monstrous nature of housework) still remains a double-sized vacuum cleaner. His art works better when it raises some visual paradox or enigma (shoestring potatoes spilling from a bag much too small to have held them); best of all when the shape of the objects is so collapsed by softness as to suggest a different item or environment altogether. A pay telephone flops into a golf-bag, the handset like a pair of club-head covers; a Manhattan subway map becomes a fetishist's costume; the *Soft Juicit* looks like a boy in school uniform being flushed down a toilet. Especially rich in their deconstruction are the giant fans, which come in cream canvas and black S&M vinyl; each resembles a collapsing piece of prehistorical animal life, or some vast insect mutated by atomic radiation in a Fifties film (a possible source), with the plug-in lead a drooling antenna.

Even when the eye is being pushed and challenged like this, we never lose our visual way; and a bourgeois exhibition label is always at hand to let us know what is really what. X may look like Y but we

know it's really X. And after a while you begin to feel the limitations of this X-ness. Why this – a soft ladder, hammer, saw and bucket – rather than anything else? And why not a soft abstract? Do we need the titles because without 'getting' the metamorphosis in a crossword-clue way there is no pleasure, no point? Or is it that abstraction would be too elitist, too anti-democratic for this art?

When it comes to the monumental sculptures, often long-conceived yet recently constructed, they couldn't be more democratic: cheery, colourful and instantly identifiable. All we have to do is crank up our Lilliputian marvelment. They exult in their ordinariness, and also transcend it: here is a clothespin that will never get lost, a trowel stuck in the ground that will never (while grants continue) get rusty. We gaze at them with benign if subdued awe. At the Parc de la Villette in northern Paris children scamper among the various parts of some giant's abandoned, half-buried bicycle, using its saddle as a slide. At a time when it's far from clear what function public sculpture should have, when municipal elders and war heroes are in disrepute, and the Philadelphia *Clothespin*'s rival is Rocky (not Stallone: Rocky), Oldenburg's work may at least help concentrate the argument. And one local sub-section of that argument cannot help asking whether the monumentality, the unvaryingness, the permanence of Oldenburg's sculpture doesn't cut against the essential good-humoured fleetingness of his art. Perhaps we could better exploit its vibrant one-offness by making it temporary, relocatable. Why not make a vast, easily transportable teddy bear and set it down in all its symbolic pawlessness in Central Park (where we might quickly see if whites take it as the incarnation of their conscience), but then let it reappear across the land – rising out of some prairie, marooned on a freeway median, floating near the Statue of Liberty? Or would this be a dangerous step towards the suggestion that many of the sculptures might be better

off not being built, since the idea and the preliminary drawings are often stronger than the final image can possibly be?

Most Pop Art is art in a loose, trivial or jesting way. It is about hanging around art, trying on its clothes, telling us not to be over-impressed by it. Warhol, for instance, is an artist rather as Fergie is a Royal. In a small way, each is self-evidently what they claim to be; in a larger way, they hardly register on the dial. Fergie has had a lot of fun, and made a lot of money, out of being a Royal; ditto Warhol and art. Only a snobbish churl, or a tax-payer, would object; while only a reader of *Hello!* would take their claims too seriously. Many rich people like collecting Warhol, just as many rich people like collecting a Royal (indeed, you could propose a rule: the higher the proportion of rich people who collect an artist, the less interesting the art). Most Pop Art is about having fun, extending the subject-matter of art, and extending the materials you can make it from. This isn't especially new: there are, indeed, few new ideas in art, only new applications. Still, both Oldenburg and Warhol are made to look tough and confrontational when set beside the machine-tooled whimsicalities of their immediate descendant, Jeff Koons. In a recent interview, Koons announced that 'Art shouldn't demand anything of anybody.' Job done!

Oldenburg, for all his ups and downs (and his later museum objects do seem very unsparkling), has remained a true Pop Artist. And if his art has shown an increasing tendency to sit on its ass, at least the same can't be said for its appreciators. Little sedentariness is called for when we confront one of his objects: we bag the *jeu d'esprit*, check out the materials and the transformations, approve the slick finish and move on. Oh, and did you see the *Cheeseburger*? Wasn't that fun? And the baseball mitt? And the collapsing toilet? Yes, yes, yes, we saw them all. We remember them all too. And that's an achievement. Does this art touch the heart in the slightest? Are we, in any way, moved? Well,

we are moved to smile, to chuckle, to puzzle, to smile again – and that's not shameful.

What would it be like to live with an Oldenburg, though, to have to see the same one every day? It's hard to imagine, but I got a slight handle on it when I once went to dinner at the house of the Baltimore film-maker John Waters, who, as it happens, is an admirer of Oldenburg. (The latter's *Bedroom Ensemble* would make a perfect set for a scene in Waters's *Hairspray*, and the suave, ironic campness of that film – which manages to look both rough-hewn and sophisticated at the same time – is a sort of cinematic equivalent of Oldenburg's work.) Waters collects fake food: every spare surface is covered with fried eggs, sliced roast beef, cheese and pickle on rye, whirlingly inert pasta, and so on. The cineaste also likes his fake food really tacky and garish: the produce of Oldenburg's deli might, you feel, be a bit too classy, too hand-crafted, for him. But there is a parallel effect. Oh, you would say, each morning as you ran into your Oldenburg, it's a cheeseburger but you can't eat it! It's a Hoover but you can't clean with it! Still, what larks! You would find yourself living your life with italics and exclamation marks. This is an art that gooses you, that gives you a visual gargle, that cheers you up and speeds you on with the day. Practical art, in that sense. It may not get an old lady across the street, but it will help her climb the stairs with more of a spring to her step.

So Does It Become Art?

The star item of the 1997 'Sensation' show in London was Ron Mueck's *Dead Dad*. People clustered round this small, naked image as it lay on the gallery floor, drawn by its high finish and hyperrealist exactitude, proof of an eye both tender and pitiless. The reduction in scale of the figure also concentrated its power. Is that what death does – shrink us all like this? Or is it that death itself is not so grand, and the thing itself is being shrunk? *Dead Dad* had the silence and strength of a work of art that keeps its secrets; the more so when surrounded by the usual cabal of shouty, upfront, show-us-the-money Young British Artists.

Almost exactly a century previously, the French doctor-sculptor Paul Richer (1849–1933) made a cast of a dead body. The figure is of a naked, thin, prematurely aged woman, whose frame has been distorted with suffering. The title, or rather label, states that she died from 'rheumatism of the joints', but her subtitle – *la Vénus ataxique* – tells us more. Ataxia is the outward manifestation of tabes, or tertiary syphilis of the nervous system. Tabes causes some of the most extreme pain known to medicine, and this is a body (or a copy of a body) which has known endless torment. The left arm is turned almost inside out on its joint, the right foot has swivelled through ninety degrees and the left knee is grotesquely distended. It may well be an example of 'Charcot's knee', a classic ataxic development. This would make sense, as Richer was director of life-casting, or 'principal

illustrator of nervous pathologies', at the Salpêtrière Hospital in Paris, where the great neurologist J.-M. Charcot had presided.

This wasted, racked, almost breastless figure, painted back into realistic nakedness, inevitably recalls wooden sculptures of the cruci-fied Christ – especially those of the more violent, northern European kind. The writer Alphonse Daudet, who endured tertiary syphilis at exactly the same time as the *Vénus ataxique* (she died in 1895, he in 1897), compared his suffering – accurately, unblasphemously – to that of Christ on the Cross: 'Crucifixion. That's what it was like the other night. The torment of the Cross: violent wrenching of the hands, feet, knees; nerves stretched and pulled to breaking-point.' Eugène Carrière did a portrait of Daudet in 1893. Edmond de Goncourt viewed it, and wrote in his diary: 'Daudet on the Cross, Daudet at Golgotha.'

Dead Dad was made to be exhibited and sold as a work of art; sculptures of the dead Christ were designed to evoke pity, awe and obedience; the Ataxic Venus was an instructional tool for teachers and students of nervous diseases. She was made with great skill by a copying process; then she was decorated and retouched, given hair and a plausible skin colour; the sculptural marks of Richer's tools can still be seen in her wax flesh. In 2001 she was on display in an art palace, the Musée d'Orsay, in a six-room show of nineteenth-century life-casts, or *moulages sur nature*. Can we, should we, must we now call her art?

This was a question provoked, not noisily, but gently and obsti-nately, by a show that wisely made no claims for its contents other than their intrinsic interest – which in any case was broad and strange enough. There were casts made for every purpose except that of being put forward as works of art. There were death-masks and memorials, writers' hands and dancers' feet, heads of Maoris and Icelanders (and even an Englishman), athletic torsos, war-torn faces, syphilitic noses, erotic female curves, leprous buttocks, monkeys'

Dead Dad by Mueck

Vénus ataxique by Richer

heads, the hand of a giant, flayed dogs and perky mushrooms, red peppers and watermelons. Medicine, anthropology, phrenology, botany, architecture, sculpture and sheer brute human curiosity were all served. But the craft of moulding in the nineteenth century knew its place; it was subsidiary, supportive. So why might it start asserting itself as something it was hardly intended to be a century and more ago?

Art changes over time; what *is* art changes too. Objects intended for devotional, ritualistic or recreational use are recategorised by late-comers from another civilisation who no longer respond to these original purposes. Where would *New Yorker* cartooning be without Lascaux gags in which one bison-painter makes anachronistically 'artistic' remarks to another? What also happens is that techniques and crafts judged non-artistic at the time are reassessed. In the nine-teenth century life-casting was to sculpture what photography was to painting, and each was viewed by the senior art form as a cheating short-cut. Their virtues – of speed and unwavering realism – also implied their limitations: they left little or no room for the imagina-tion. In 1821 a certain Dr Antommarchi had taken a death-mask of Napoleon on St Helena; over the next few years, copies made without his permission began to circulate. In 1834 Antommarchi sued, and his counsel submitted that 'without attributing to moulding the same importance as that of sculpture and painting', it was legally the case that 'the Emperor's death-mask was a genuine work of art'. The defence argued that the moulder was 'a mere plagiarist of Nature and Death' and that 'life-casting was a purely manual business'. The court agreed with this argument and found against Antommarchi: he owned no rights in the image he had created – in other words, he was specifically held not to be an artist. For many, life-casting was an insult to the sculptor's creative gesture. Rodin said: 'It happens fast and it doesn't make art.' Others feared that the whole canon of aesthetics

The Head of an Englishman

might be blown off course: if too much Nature was allowed in, it would lead Art away from its proper pursuit of the Ideal.

Gauguin, at the end of the century, worried about future developments in photography: if ever the process went into colour, why should any painter continue to labour away at a likeness with a brush made of squirrel-tail? And yet, painting was to prove surprisingly robust. Photography changed it, of course, just as the novel had to reassess narrative after the arrival of the cinema. But the gap between the senior and junior arts was always narrower than the diehards implied. Painters have always used technical back-up – studio assistants to do the boring bits, cameras lucida and obscura; while apparently lesser crafts involve great skill, thought, preparation, choice and – depending how we define it – imagination. Life-casting was complex, technical work, as Benjamin Robert Haydon discovered when he poured 250 litres of plaster over his black model Wilson and nearly killed him.

Time changes our view in another way too. Each new art movement implies a reassessment of what has gone before; what is done now alters what was done previously. In some cases this is merely self-serving, with the new art using the old to justify itself: look how all of that points to all of this, aren't we clever to be the culmination of everything that has gone before? But usually it is a matter of re-alerting the sensibility, reminding us not to take things for granted; every so often we need the aesthetic equivalent of a cataract operation. There were many items in that show at the Musée d'Orsay – innocent bit-players in the last half of the nineteenth century – which nowadays would sit happily in a commercial or public gallery. There was a white plaster cast of Balzac's dressing-gown, weirdly standing up by itself, as if the novelist had momentarily slipped out of it and just left it there, defying gravity. Many curators would doubtless put in for the stunning cast of the hand of a giant from Barnum's circus

The Hand of a Giant from Barnum's Circus

(French, anonymous, *c*.1889, 'wax, cloth, wood, glass, 53 x 34 x 19.5 cm'). The initial impact is on the eye, in the contradiction – which Mueck constantly exploits – between unexpected size and extreme verisimilitude. Next, the human element kicks in: you note that the nails are dirt-encrusted and the paddy fingertips extend far beyond them (was the giant an anxious gnawer, or does giantism mean that the flesh simply outgrows the nails?). Then you take in the element of choice, arrangement, art if you like – the neat, pleated, buttoned sleeve-end that gives the work balance and variation of texture. This is just a moulded hand, yet the part stands utterly for the whole; and as an item on public display, it reminds us slyly, poignantly, of the full-size original, who in his time was just as much a victim of gawping. We are not such a long way from Degas's *La Petite Danseuse* (which, after all, one critic said should be in the Dupuytren pathology museum); though we are nearer to contemporary art that lazily gets called cutting-edge.

Ah, but is it art? That old, tediously repeated question whenever bricks are laid, beds disarranged, or lights go on and off. The artist, defensively, responds: 'It's art because I am an artist and therefore whatever I do is art.' The gallerist talks aesthetic code, which is either parroted or mocked by the usual rogues and rascals of the press. We should always agree with the artist, whatever we think of the work. Art isn't, can't be, a temple from which the incompetent, the charlatan, the chancer and the publicity-chaser should be excluded; art is more like a refugee camp where most are queueing for water with a plastic jerry-can in their hand. What we *can* say, though, as we face another interminable video-loop of a tiny stretch of the artist's own unremarkable life, or a collaged wall of banal photographs, is: 'Yes, of course it's art, of course you're an artist, and your intentions are serious, I'm sure. It's just that this is very low-level stuff: try giving it more thought, originality, craft, imagination – interest, in a word.'

The great short-story writer John Cheever once said that the first canon of aesthetics is interest.

Most art is, of course, bad art; a large percentage of art nowadays is personal; and bad personal art is the worst of all. The judge of a poetry competition once told me of his experience of wading through thousands upon thousands of amateur poems: 'It felt', he said, 'as if most of them had just cut off a chunk of themselves, a hand or a foot, wrapped it up and sent it in.' We shouldn't doubt that it was poetry, just as, say, Tracey Emin's work is art. And here we should applaud the poet Craig Raine for introducing the term 'homeopathic' to describe work whose artistic content is so dilute that it cannot have any more aesthetic effect than a placebo.

Barthes proclaimed the death of the author, the liberation of the text from authorial intention, and the consequent empowerment of the reader; though he announced this, needless to say, in a text written with a particular intention in order to communicate something very specific to a reader who was expected not to misinterpret it. But what doesn't work for literature works much better for art. Pictures do escape their creators' intentions; over time the 'reader' does grow more powerful. Few of us can look at a medieval altarpiece as its painter 'intended', let alone an African sculpture or those serene Cycladic figurines which served as grave-goods. We believe too little, and aesthetically know too much; so we re-create, we find new categories of pleasure in the work. Equally, the lack of artistic intention in Paul Richer and other forgotten craftsmen who brushed oil onto flesh, who moulded, cast, decorated and primped a century and more ago is no longer relevant. What counts is the surviving object and our living response to it. The tests are simple: does it interest the eye, excite the brain, spur the mind to reflection and move the heart; further, is an apparent level of skill involved? Much currently fashionable art bothers only the eye and briefly the brain, but it fails to engage

the mind and the heart. It may, to use the old dichotomy, be beautiful, but it is rarely true to any significant depth. (On this subject, by the way, we should follow not Keats but Larkin: 'I have always believed that beauty is beauty, truth truth, that is not all ye know on earth nor all ye need to know.') One of the constant pleasures of art is its ability to come at us from an unexpected angle and stop us short in wonder. The Ataxic Venus doesn't make Ron Mueck's *Dead Dad* any the less intense and moving an image; but she does offer herself as a companion, precursor and, yes, rival.

Freud: The Episodicist

Rembrandt's *The Painter in His Studio* (*c.*1629) is a small picture with a blazing message. The viewpoint is that of one seated on the bare floor in the corner of an attic-studio with crumbling plaster walls. On the right, in shadow, is the doorway. In the centre, with its back to us, is an enormous easel with a picture propped on it. On the left, barely half the height of the easel, stands the painter, brush and mahl-stick in hand, dressed in his painting robe and hat. He is in shadow, but we can roughly make out his moon-face as he stares at his picture. The light-source, out of shot, is to the left of him and above. It falls almost entirely on the floorboards, turning them corn-coloured, and also on the left-hand edge of the painting on the easel, giving it a glittering vertical line. But because we can't see where the light is coming from, the image switches round in our head: it is as if the painting is blazing out over the floor (but not onto the mannikin-painter). So we are to understand: it is the art which illuminates, which gives the artist both his being and his significance, rather than the other way round.

Lucian Freud made the same point once with a brilliant aside. Any words that might come out of his mouth concerning his art, he remarked, would be as relevant to that art as the noise a tennis player produces when playing a shot. He wrote one article for *Encounter* at the very start of his career in 1954, and at the very end added a few sentences to it for the *Tatler* in 2004. (His view of art

Artist in his Studio by Rembrandt

had not changed in the fifty-year interval.) Otherwise he kept textual silence. He issued no manifestos and gave no press interviews until his final decade. All this through a period when artists became fashionable subjects for colour supplements, and the easel-painter seemed *vieux jeu* compared to the collager, silk-screener, installer, conceptualist, video-maker, performer, neon-signer and stone-arranger. There was much art-babble, and newcomers were expected to provide credos of fluent obscurity.

Flaubert once said, in reply to a journalistic enquiry about his life, 'I have no biography.' The art is everything; its creator nothing. Freud, who used to read aloud to his girlfriends from Flaubert's letters, and who portrayed the writer Francis Wyndham with a battered but recognisable copy of the first volume of the Harvard/Belknap edition in his fist, would have agreed. But having 'no biography' is impossible; the nearest you can get is to have no published biography in your own lifetime. Freud, more than any other artist of his stature, came as close to that as possible. In the 1980s, an unauthorised biographer started delving, only to find heavies at his door, advising him to desist. A decade later, Freud eventually authorised a biography by the critic William Feaver, and cooperated on it; but when he read the typescript and realised what biography entailed, he paid Feaver off. He lived furtively, moving between addresses, never filling up a form (and hence never voting), rarely giving out his telephone number. Those close to him knew that silence and secrecy were the price of knowing him.

On Capri they show you the sheer cliff from which those who displeased the Emperor Tiberius were reportedly flung (though the Caprese, who call him by the softer name of Timberio, insist that the death-toll was much exaggerated by muck-rakers like Suetonius). The court of Freud was similarly absolutist in its punishments: if you displeased him – by bad time-keeping, unprofessionalism, or disobedience to his will – you were tossed over the cliff. My friend Howard

Hodgkin once knew Freud well, until the day Freud arrived at his studio unannounced. 'Not now, Lucian,' Hodgkin said to him quietly, 'I'm working.' This was altogether the wrong greeting. Freud went away displeased – 'And I never saw him again.' In the painting that shows Francis Wyndham flaubertising in the foreground, the background originally held the figure of the model Jerry Hall breastfeeding her baby. She sat thus for several months, until one day she called in sick. When, a couple of days later, she was still unfit to pose, the enraged Freud painted over her face and inserted that of his long-time assistant David Dawson. But the baby had not caused offence, so was not painted out, with the result that a naked and strangely breasted Dawson is now seen feeding the child. Freud's American dealer gloomily assumed the picture would be unsellable; it was bought by the first American client he showed it to.

The novelist Penelope Fitzgerald thought the world divided into 'exterminators' and 'exterminatees'. Certainly it divides into controllers and controllees. I met Freud a few times and was struck by the fact that he never smiled, neither on meeting, nor at any point in the conversation when any other, 'normal' person might smile: it was classic controller's behaviour, designed to unsettle. A typical controllee is someone who is love-dependent; Freud was that once, and swore never to be so again. He was always a controller, and sometimes an exterminator. Martin Gayford's and Geordie Greig's accounts[1] of Freud's behaviour reminded me at times of two unlikely novelists: Kingsley Amis and Georges Simenon. When Amis's second wife and fellow-novelist, Elizabeth Jane Howard, saw him at eleven o'clock on a morning he was due to lunch at Buckingham Palace, standing in the garden punishing an enormous whisky, she asked anxiously, 'Bunny, do you have to have a drink?' He replied (and it was a reply that would

[1] *Man with a Blue Scarf* by Martin Gayford (2010); *Breakfast with Lucian* by Geordie Greig (2013)

have fitted a vast number of other exchanges), 'Look, I'm Kingsley Amis, you see, and I drink whenever I like.' As for Simenon, he practised two things obsessively: his art and fucking. In a winning moment of self-analysis, he once observed, 'I am not completely crazy, but I am a psychopath.' Freud confessed his 'megalomania' to Martin Gayford, adding that there was a bit of his mind 'that believes, just possibly, my things are the best by anyone, ever'. Amis, Simenon and Freud all had controlling, interfering mothers, which may or may not be relevant.

Freud always lived a high–low life: dukes and duchesses and royalty and posh girlfriends on the one hand, gangsters and bookies on the other. The middle classes were generally scorned or ignored. He also had high–low manners: unfazed and relaxed in royal circles, a stickler for good manners from his children, but also indelibly rude and aggressive. He did whatever he liked, whenever he liked, and expected others to go along with it. His driving made Mr Toad look like a nervous learner. He would assault people without warning or, often, excuse. As a refugee child, he used to hit his English schoolfellows because he didn't understand their language; as an octogenarian, he was still getting into fist-fights in supermarkets. He once assaulted Francis Bacon's lover because the lover had beaten up Bacon – which was quite the wrong response: Bacon was furious because he was a masochist and *liked* being beaten up. Freud would write 'poison postcards', vilely offensive letters, and threaten to have people duffed up. When Anthony d'Offay closed a show of his two days early, an envelope of shit arrived through d'Offay's letter box.

In one version of the philosophy of the self, we all operate at some point on a line between the twin poles of episodicism and narrativism. The distinction is existential, not moral. Episodicists feel and see little connection between the different, unfolding parts of their life, have a more fragmentary sense of self, and tend not

to believe in the concept of free will. Narrativists feel and see constant connectivity, an enduring self, and acknowledge free will as the instrument that forges their self and their connectedness. Narrativists feel responsibility for their actions and guilt over their failures; episodicists think that one thing happens, and then another thing happens. Freud in his personal life was as pure an example of an episodicist as you are likely to get. He always acted on impulse; he described himself as 'egotistical . . . but . . . not in the least introspective'. Asked if he felt guilt about being an entirely absent father to his large number of children, he replied, 'None at all.' When Freud's son Ali, who was angered by his father's massive absence, later apologised in case his own behaviour had caused his father anxiety, Freud replied: 'That's nice of you to say, but it doesn't work like that. There is no such thing as free will – people just have to do what they have to do.' He was a reader of Nietzsche, who thought us all 'pieces of fate'. His episodicism applied to such varied matters as the weather (his favourite being Irish, which comes in many unpredictable forms each day) and grief ('I hate mourning and all that kind of thing – I've never done it'). He thought the idea of an afterlife 'utterly ghastly' – perhaps because such a contrivance might prove narrativism. Not surprisingly, narrativists tend to find episodicists selfish and irresponsible; while episodicists tend to find narrativists boring and bourgeois. Happily (or confusingly), in most of us these tendencies overlap.

Though each new painting may be seen as a furiously concentrated episode, every artist can – and must – also be a narrativist, must see how one brushstroke is connected to the next, and each has a consequence; how past is connected to present, and present to future, and how there is an unfolding story in any painting, which is largely the result of the application of free will. And also that, beyond this, there is a wider narrative: of self-instruction, of real or imagined progress,

of an artistic career. Martin Gayford's *Man with a Blue Scarf* is a narrative of a single episode: his seven-month sitting for the picture of his title. Structured like a journal, with each entry amounting to a kind of brushstroke, it is one of the best books about art, and the making of art, that I have ever read. While Freud studies Gayford, Gayford studies Freud; as the portrait builds on the easel, so it does in the text. Gayford wittily describes the actual process of posing as 'somewhere between transcendental meditation and a visit to the barber's'. But he has fallen into the chair of the most demanding hair-cutter. Invited to make himself comfortable, he sits with his right leg crossed over his left, and the artistic process begins. After an hour or so, a break is called, there is already a charcoal outline of Gayford's head on the canvas, and Freud flops down on one of the famous piles of rags that litter his studio. When Gayford returns to his chair he asks if he is allowed to cross left leg over right. Absolutely not, replies Freud, because it would subtly alter the angle of the head. And you would certainly have to take his word for that. Gayford, whose portrait was begun in November, also found himself lumbered with his heavy tweed jacket and scarf as the sittings dragged on into the following summer. Freud never used professional models, but demanded professional obedience from his amateurs. Everything was on his terms, even when the sitter was a fellow-painter. David Hockney calculated that he sat for Freud for 'more than a hundred hours over four months'; in reciprocation, Freud gave Hockney two afternoons.

Gayford provides an intense account of an intense process, of how art is made by a mixture of instinct and control, eye and brain, of nerves, doubt and constant correction. He describes Freud's way of muttering and chuntering away as he works ('Yes, perhaps – a bit', 'Quite!', 'No-o, I don't think so', 'A bit more yellow'), his sighing and pausing, irritation at a mistake and triumphant waving of the brush at the conclusion of a successful stroke. Gayford is also funny and

honest about what a sitter goes through – the excitement, the shameful vanities (he worries about his ear-hair) and the discomfort and boredom. A large side-reward is the pleasure and value – the more so for an art critic – of Freud's high-quality table-talk and easel-talk. There is good gossip about his life and times, and Freud talks freely about his ambitions and procedures. Also about painters he admires (Titian, Rembrandt, Velázquez, Ingres, Matisse, Gwen John) and those he doesn't: Leonardo da Vinci ('Someone should write a book about what a bad painter Leonardo da Vinci was'), Raphael and Picasso. He prefers Chardin to Vermeer, and dismisses Rossetti so violently as to induce pity. He is not just 'the worst of the Pre-Raphaelites' (Burne-Jones breathes a sigh of relief), but 'the nearest painting can get to bad breath'.

Freud was always a painter of the Great Indoors. Even his horses are painted at home in their stables; and though he curated a thrilling Constable show in Paris in 2003, the greenery he depicted himself lived either in pots or was visible from a studio window. His subject-matter was 'entirely autobiographical'. Verdi once said that 'To copy the truth can be a good thing, but to invent the truth is better, much better.' Freud didn't invent; nor did he do allegory; he was never generalising or generic; he painted the here and now. He thought of himself as a biologist – just as he thought of his grandfather Sigmund as an eminent zoologist, rather than a psychoanalyst. He disliked 'art that looks too much like art', paintings that were suave, or 'rhymed', or sought to flatter either the subject or the viewer, or displayed 'false feeling'. He 'never wanted beautiful colours' in his work, and cultivated an 'aggressive anti-sentimentality'. When there is more than one figure in a picture, each is separate, isolated: whether one is reading Flaubert and the other is breastfeeding, or whether both are naked on a bed together. There is only contiguity, never interaction. He greatly admired Chardin's *The Schoolmistress* – which most would see as one

of the tenderest (and most beautifully coloured) images of human interaction; Freud liked it mainly because the schoolmistress had the best-painted ear in the history of art. He admired 'jokiness' in a painter, finding it in Goya, Ingres and Courbet; though his own attempts at jokiness rarely come off. For all his intelligence, when Freud has an 'idea' in a painting, it is usually a bad and clunky one. The naked woman with two halves of a hard-boiled egg in the foreground (woman – womb – eggs; woman – breasts – nipples – yolks) is crass and juvenile. *Painter and Model* shows a clothed Celia Paul with her brush pointing at the model's penis, while her naked right foot squeezes paint out of a tube on the floor. This makes visual double-entendres in James Bond movies look sophisticated.

Early on, he painted with a Memling-like precision, each hair and eyelash clearly delineated, with a light palette and a (comparatively) gentle eye. Then, switching from sable- to hog-hair, his brushwork grew broader, his tones dunner and greener, his canvases larger; some of his sitters grew larger too, culminating in the enormous Leigh Bowery and the benefits supervisor Sue Tilley (making her the most famous fat woman since Two-Ton Tessie O'Shea). Freud liked to emphasise his own incorrigibility, his instinct to do the opposite of what he was told to do; and several times in interviews he ascribed this major stylistic switch to being praised for the drawing which was the basis of his painting. And so, imperious in his perversity, he decided to stop drawing and to paint more loosely. This explanation seems hardly credible, given his admiration for great draughtsmen like Ingres and Rembrandt. Further, no artist as serious as Freud, however contrarian he might like to appear, would allow himself to be stylistically controlled by (even favourable) criticism. But the explanation draws attention away from the truer reason – which he also admitted: the influence of Francis Bacon. Freud lived his life instinctively, but painted with utter control; Bacon lived in the same way,

Hotel Bedroom by Freud
Detail showing Caroline Blackwood

but seemed to outdo Freud by also painting instinctively, and at speed, with no preliminary drawing, occasionally finishing a picture in a morning. Some found Freud's stylistic switch alarming, or worse than that: Kenneth Clark, an early admirer, wrote to Freud suggesting that he was deliberately suppressing what made his work remarkable. 'I never saw him again,' Freud tells Gayford. Another one off the Tiberian cliff.

This looser brushwork did not lead to any greater speed of work ('The trouble with Lucian,' Bacon once cuttingly remarked, 'is that he's so *careful*'). But it changed the way he portrayed flesh. From now on, even when he painted the young and smooth-skinned, he highlighted the flesh's vulnerability, 'its potential to sag and wither', as Gayford puts it. Some thought he'd been doing that all along. Caroline Blackwood, writing about Freud's portraits in the *New York Review of Books* in 1993, described them as 'prophecies' rather than 'snapshots of the sitter as physically captured in a precise historical moment'. She added that his paintings of her had left her 'dismayed', while 'others were mystified why he needed to paint a girl, who at that point still looked childish, so distressingly old'. Blackwood had much cause for resentment against her former husband (not least that he had slept with her teenage daughter), but this accusation seems misplaced. If we look at the Blackwood portraits now, it is more her anxiety and fragility that strike us, rather than any premature ageing. Gayford thinks that Freud's second style is all about mortality. In the self-portraits, he writes, Freud 'seizes almost gleefully on signs of ageing and time'; and his 'attitude to other sitters is in this way the same as his attitude to himself'. Perhaps; but I wonder if it isn't more a question of style and brushwork than of a not-very-subtle message about mortality. This was the method Freud developed in his quest to express the sitter's nature and essence, whether he was painting the naked young or the fully clothed octogenarian Queen of England.

The Painter Surprised by a Naked Admirer (detail) by Freud

As for Freud's many self-portraits, it is less their gleefully depicted decay that is striking than their self-celebration, their implicit stance of artist-as-hero. The worst is *The Painter Surprised by a Naked Admirer*, another of Freud's 'ideas' pictures. It shows a naked model on a bare studio floor clinging to Freud's ankle and thigh, as if to prevent him getting to his easel. Its intention may be jokey, but the result is somehow both arch and vain. And perhaps it also doesn't work because it is a rare attempt at showing interaction rather than contiguity.

Blackwood is right that her ex-husband's portrait style is not flattering – nor was it intended to be. Even so, it comes as a shock, after a long looking at Freud's paintings, to turn to the photographs of many of Freud's sitters (and standers and liers) by Bruce Bernard and David Dawson in *Freud at Work* (2006). How sleek and erotic the human body really is, you think, and what a very nice colour too. Doesn't the benefits supervisor look good, and isn't Our Queen wonderful for her age – it's remarkable how few wrinkles she's got, considering. But then, photography has always been a flattering art – just as portrait-painting used to be. In the old days (and in some quarters still) there was an unwritten contract between painter and sitter, because the sitter was the paymaster. Nowadays the sitter only pays if he or she buys the picture; and in any case, Freud would ignore any such unwritten contract, even if he believed it existed.

Artists can be wrong about their own art: Gayford tells us, for instance, that Freud's aim 'is to make his pictures as unalike as possible, as if they had been done by other artists'. This must be some kind of necessary delusion, perhaps designed to ensure that his attention and ambition did not flag. But mostly, artists know more of what they are up to than we do. Freud's aim was never to serve or copy nature, but to 'intensify' it until it had such force that it replaced the original. So a 'good likeness' is irrelevant to a 'good picture'. His idea about portraiture, he once told Lawrence Gowing, 'came from dissatisfaction

with portraits that resembled people. I would wish my portraits to be *of* the people, not *like* them . . . As far as I am concerned, the paint *is* the person.' One sitter (who preferred to remain anonymous) told me that Freud approached him with the words, 'I'd be interested in painting *from* you.' He said to Gayford of his portrait: 'You are here to help it' – as if the sitter were a kind of useful idiot, present while the artist attains his larger aim.

This can get precious, or unnecessarily complicated. Presumably, what the painter wants is for the viewer, when confronted with a portrait of a sitter familiar to him or her, to say, 'Yes, that's him/her, *only more so.*' The 'intensification' will then have been achieved. But 'likeness' hasn't been, and can't be, abandoned – after all, what is Freud's famously intense scrutiny for, if not to see more clearly than others do? Would we ever react to a picture by saying, 'Oh, that's terrific – it looks nothing like him/her, in fact it looks like someone else, but funnily enough it's like an intenser version of them'? I think not. The question also gets muddled up with another: how far the portrait displays the sitter's character, how far it acts as a moral likeness. Gayford rightly points out that we respond to a Van Eyck or a Titian or an ancient Egyptian statue 'in ignorance of the sitter's personality'. (Also in ignorance of whether or not it is a good 'likeness'.) But our reading of that Van Eyck or Titian will not be personality-free: we do not see it merely as an arrangement of paint. Part of the encounter will be about working out what this painted imitation or substitution tells us about the long-dead original. When we look at a very great portrait – say, Ingres's *Louis-François Bertin* – we take its likeness for granted and (leaving aside our purely aesthetic musings) respond as if Monsieur Bertin were alive and breathing in front of us. In that sense, the paint *is* the person.

Martin Gayford's book is about an artist who also happened to be a man; Geordie Greig's book is about a man who also happened to

be an artist. Greig's Wikipedia entry reminds us that 'members of his father's family have been royal courtiers for three generations'. Having edited the *Tatler* and the *Evening Standard*, he is now, as editor of *The Mail on Sunday*, at the court of Rothermere. But more important to him, I would guess, were his years at the much more exclusive court of Freud. He spent many patient years applying for membership – collecting the friendships of other artists on his way to the main prize – before playing a cunning trick which gained him entry. He served at the court of Freud for the last ten years of the painter's life and, as he tells us, gained Freud's 'confidence and trust'. He did so to the extent that the back-flap photo of *Breakfast with Lucian* shows the painter halfway towards smiling – a rare achievement, since Freud had long ago perfected the granitic scowl whenever a lens was raised in his direction. Greig's book is more substantial than it first appears – not just breakfast, but coffee and a light lunch too. When dinner – the full biography – arrives, its author will have reason to be grateful to Greig, who gained access to Freud's early (and by now nonagenarian) girlfriends, to sitters, lovers, children and others who felt released into testimony by Freud's death. Whether Freud himself would have felt his 'confidence and trust' had been misplaced is another matter. Greig's book will certainly do Freud's personal reputation harm. But it will also, I think, harm the way we look at some of his paintings, and perhaps harm the paintings themselves – at least until a different generation of viewers comes along.

At one point, Greig suggests (quite plausibly, to my mind) that Freud's nudes might be related to those of Stanley Spencer; but Freud slaps him down, swatting at 'Spencer's sentimentality and inability to observe'. Had I been in Greig's position, I might have offered Egon Schiele as a Viennese ancestor, for the gynaecological poses, the loose brushwork and the colouring (see, for instance, *Self-Portrait with Raised Bare Shoulder*). But I would have been slapped down in my

turn: Freud regarded Klimt and Schiele as shilling shockers who were full of false feeling. I doubt many would accuse Freud of false feeling, or question the sincerity of his constant reassertion of the artist's role as truth-teller. But there is more to it than this. As Amis put it: 'Should poets bicycle-pump the human heart / Or squash it flat?' Neither, one presumes, is the answer. The accusation against Freud would be that he is a heart-squasher, and nowhere more than in the female nudes which are the most contentious part of his output. They are proudly, truth-tellingly vulvic, literally in your face. His women lie splayed for inspection: Celia Paul, by her own admission 'a very, very self-conscious woman', found sitting (or rather, lying) for Freud felt 'quite clinical, almost as though I was on a surgical bed'. Freud's men, on the whole, keep their clothes on, and lead with their faces; Freud's women, on the whole, (are made to) take their clothes off, and lead with their pudenda. His animals, which are allowed to keep their genitalia hidden, come out best of all – but then Freud did say he had 'a connection to horses, all animals, almost beyond humans'.

There are two questions here. The first is technical, or physiological. There are many differences between people's genitalia, but these differences are not expressive; they lead nowhere. That is why portraitists usually give more attention to the face – 'the heart's great canvas', in Lorrie Moore's phrase – which is expressive, and does lead somewhere: to a sense of the person's presence, and essence, even if it is a changeable essence. The second question is interpretative, and here autobiography, if it is not kept out, may percolate and stain. There is the male gaze in art; and then, beyond that, there is the Freudian gaze. His pictures of naked women are not in the least pornographic; nor are they even erotic. It would be a very disturbed schoolboy who successfully masturbated to a book of Freud nudes. They make Courbet's *The Origin of the World* look suave. The question is the way

in which they are autobiographical – given that all Freud's work is
– and here biography comes in.

We have known for many years, anecdotally, about Freud and
women. That there were many of them; that he married twice;
that his children were literally countless: he acknowledged fourteen,
but may have had twice that number (he regarded any form of
birth control as 'terribly squalid'). On the whole, his women were
posh; and, on the whole, teenagers when he met them. He was
always a star – compelling, mysterious, famous, intense, vital. One
girlfriend told Greig, 'He was like life itself.' Another said, 'When
he was not there it was as if the light got dim. In the same way,
he made everyone who was with him feel more illuminated and
somehow more alive and interesting.' So far, perhaps, so good: the
dangerously magnetic artist, into whose force-field women are drawn,
is a centuries-old trope. And there are even moments when Freud's
insistence on living life entirely on his own terms, with others fitting
in accordingly, has its comic side. Here is a story which clearly
means something to him, as he tells it to both Gayford and Greig
with little variation:

> For example, I like spinach served without oil or butter. Even
> so, I can imagine that if a woman I was in love with cooked
> spinach with oil, I would like it like that. I would also enjoy the
> slight heroism of liking it although I didn't usually enjoy it served
> in that way.

If this was Freud's idea of the heroic compromise a man makes when
in love with a woman, it's not surprising that London's society host-
esses did not consider him son-in-law material.

But Freud, who never put any limit on things, was more than just
a charming womaniser. He was priapic, no sooner acquiring a woman

than he was after another, while expecting the first to remain available. Caroline Blackwood, his second wife, found him 'too dark, controlling and incorrigibly unfaithful' – not that he acknowledged 'fidelity' as a concept in the first place. If this was hurtful, tough; the women could just get on with it. He was also sexually sadistic: two of his ex-girlfriends separately describe him twisting and hitting their breasts. But Greig's most destructive witness for the prosecution is Victor Chandler, a public-school-educated bookie, thereby folding into one person Freud's beloved high–low divide. He 'adored' Freud, but also tells the two worst stories about him. In the first, he and Freud – who is already drunk – went for dinner at the River Café. In front of them as they arrived were two north-London Jewish couples. 'Lucian could be very anti-Semitic,' Chandler recalled, 'which in itself was strange.' He took exception to the women's scent and shouted at them, 'I hate perfume. Women should smell of one thing: cunt. In fact, they should invent a perfume called cunt.'

On another occasion, Freud and Chandler talked about women:

The conversation we had about that was that he needed sex to stay alive. It was his attitude to living, to need the release. I think he needed to dominate women in certain ways. He talked about everything. One night we had a long conversation about anal sex. He said unless you've had anal sex with a girl she hasn't really submitted to you.

So what's this? Just a bit of tittle-tattle, as if from the pages of *The Mail on Sunday*, leaked to damage the reputation of a great artist? More than that, I think. However leery we might be of biography affecting our interpretation of pictures, once we know these two stories, we can't unknow them, and they seem to change – or, for some, confirm – the way the female nudes are to be read. Some men,

and many women, are, and always have been, made uneasy, indeed queasy, by them. They seem cold and ruthless, paintings more of flesh than of women. And when the eye moves from the splayed limbs to the face, what expressions do Freud's women have? Even in the early, pre-hoghair portraits, the women seem anxious; later, they seemed at best inert, passive and exsanguinated, at worst fraught and panicked. It is hard not to ask oneself: Is this the face and body of a woman who has first been buggered into submission and then painted into submission? Asked why he disliked Raphael so much, Freud said that while he had done some marvellous things, 'I think it's his personality I hate.'

It is sometimes said of compulsive womanisers that they get off with women because they can't get on with them. (I first came across this crack in a biography of the womanising Ian Fleming, who knew and cordially loathed Freud – who loathed him back.) François Mauriac, in his great novel of literary envy, *Ce qui était perdu*, puts it more subtly and tellingly: 'The more women a man knows, the more rudimentary becomes the idea he forms of women in general.' This was written in 1930, but is not irrelevant today. Though Freud painted very slowly, he painted all day and night, and ended up with a large corpus. Inevitably he repeated himself, never more so than in the way he posed women. Though he usually paid no heed to his fan-mail, he one day received a letter from a (black) woman solicitor asking why he had never painted any black people. And so he answered the letter, took up the challenge and he painted her. No prizes for guessing the pose: naked, thighs open for our inspection, contorted head in the distance. It is a feeble picture. He called it *Naked Solicitor*.

Biography infects other pictures as well, or rather, adjusts our previous reading of them. I had always imagined, for instance, that the paintings of Freud's aged mother in her paisley dress were gentle,

tender works, similar in spirit to those Hockney painted of his aged parents. Biography corrects this interpretation. From an early age, Freud found his mother's interest in him repellent (she would do dreadful things like bring food round to him when he was poor), and throughout his life he kept her at a distance. When his father died, she took an overdose; she had her stomach pumped, but major damage had already been done, and she was reduced to a shell of herself. Only then – when, as you might say, life had buggered her into submission – did he begin to paint her. And as he put it, she had become 'a good model' because she had stopped being interested in him. Freud's cousin Carola Zentner found it 'terribly morbid' that he was 'painting somebody who is no longer the person they were . . . because basically she was still alive physically but she wasn't really alive any longer mentally'. Does this matter? Artists are ruthless, they take their subject-matter where they find it, and so on. I think that in this context it does matter, because these pictures present themselves as loving portraits of Dear Old Mum, and therefore exemplify what Freud abhorred: false feeling.

Perhaps, in time, all this will cease to matter. Art tends, sooner or later, to float free of biography. What one generation finds harsh, squalid, unartistic, cold, the next finds a truthful, even beautiful vision of life and how it should be represented – or rather, intensified. Two or three generations ago, Stanley Spencer's nudes shocked many. This little man posing himself naked beside voluminous women – indeed, wives – whose breasts obeyed the law of gravity. Now such pictures seem, yes, gentle, tender works, and a true depiction of love and lust's playfulness. Will Freud come to be seen as the greatest portraitist of the twentieth century? Will his nudes seem to future generations as Spencer's do to us now? Or will Kenneth Clark's regret at Freud's early change of style appear vindicated? For myself, I think his tiny portrait of Francis Bacon greater than his monumental studies of

Two Japanese Wrestlers by a Sink by Freud

Leigh Bowery. I also wish he had painted more sinks, and more pot-plants, and more leaves, and more trees. More waste ground, more streets. Artists are what they are, what they can and must be. Even so, I wish he'd got out a bit more.

Hodgkin: Words for H.H.

Henry James said: 'Painters have a great distrust of those who write about pictures.' Flaubert said: 'Explaining one artistic form by means of another is a monstrosity. You won't find a single good painting in all the museums of the world which needs a commentary. The more text there is in the gallery guide, the worse the picture.' Degas believed that 'words are not necessary: you say *humph, hé, ha,* and everything has been said.' Matisse said: 'Artists should have their tongues cut out.'

Henry James, nevertheless, wrote a great many public words about painting. Flaubert wrote a great many private words, in letters and journals. He knew French art collections as well as Stendhal did, and European ones better than either the Goncourts or Baudelaire. One striking thing about his art notes is that they are almost entirely devoid of what we think of as judgements. Or rather, he notes and describes the pictures he likes, and the noting is the judgement.

Howard Hodgkin is a writer's painter. More than any other contemporary British artist, he has attracted the attention of those used to telling stories, to describing, imagining, explaining. His pictures often have titles which seem to imply a narrative. And yet here is the paradox: there is rarely a narrative visible in, or extractable from, his pictures. Sometimes he is teasing us. And writers like to be teased. Just as they like to envy other art forms.

Writers' envy of other forms is usually to do with greater directness. Music is the form most envied, being both the most abstract and the most direct: from soul to soul without the trudging intervention of words. Dramatists must envy opera composers because of the way opera cuts to the chase: you can have the equivalent of a fifth-act climax in Act One, and then another, and another, every act – every scene, if you want. Painters are envied because their art combines the means of expression and the expression itself in the same act and place; contained, and the more powerful for its containment. Writers rarely consider if there might be reverse-envy as well: that a painter whose picture is given a five-second glance by some window-shopping gallery-goer might well envy the sheer time a reader is willing to spend with a writer. Redon declared literature 'the greatest art'.

H.H.'s paintings are not narratives. Mostly, they are memories. But it is not a case of emotion recollected in tranquillity. Rather, it is emotion recollected in intensity. In that sense, his pictures are operatic.

Flaubert loved imitating people. One of his favourite impressions was of a very minor Rouennais painter called Melotte, whose particular mannerism was to describe an arabesque with his hands – like a double S – whenever he used the totemic word 'artistique'.

Edinburgh, September 2002: words unheard. H.H.'s blue-walled seventieth-birthday show at the Scottish Gallery of Modern Art. Downstairs there is a twenty-minute film of the artist speaking about his own work, while upstairs the exhibition is laid out in two sections. Between these two sections is a high open stairwell which channels the artist's voice upwards. The voice pursues you as you cross the stairwell, and leaks into the galleries. But because of the amplification and the echo, you cannot understand what is being said. H.H.'s voice is not just

disembodied but disworded; all that remains is its tonality. After a while, this begins to feel apt.

Flaubert's novels, especially *Madame Bovary*, were often compared to the work of Realist painters like Courbet. In fact, the novelist had a particular dislike of Courbet: for being doctrinaire, for painting with a theory attached; and for his insistence on explaining his work, supplementing his images with words. Also because: 'He did not have the sacred fear of form.' Art is made from the tension of love and fear.

Royal Academy, September 2002. The RA offers its space for a few weeks to a range of commercial galleries. Most choose to showcase their youngest talents, and a visual cacophony inevitably results. But at least some of the stifling orthodoxies of recent decades seem to be breaking down. Some young artists have even tried painting – with a brush, or something like, on a flat surface, or something like, with paint, or something like; though many of them, perhaps insecure, have helpfully decorated their mute painted areas with explanatory words. I run into the critic Andrew Graham-Dixon and we discuss this hesitant revival. But wouldn't you think, I suggest, that some of these youngsters might have noticed that this form of art has been practised before – indeed, over quite a number of centuries? Graham-Dixon chuckles at my naivety: 'Oh, the past hasn't got anything to teach *them*.'

At the heart of the Academy is an octagonal space, whose walls are painted the same brilliant dark blue as at the Edinburgh show. On them hang eight small paintings by H.H., a still, grave, blazing centre amid the surrounding racket. A writer friend described her reaction: 'They just came off the wall at me and said, "This is what art is meant to be."'

At the Academy, I say to H.H.: 'You've used exactly the same blue as in Edinburgh.' He replies: 'It's not *exactly* the same blue.'

Over the years I have known him, he has often said how isolated he feels, being a painter in these times and these isles. Others, like Lucian Freud, have also described going against the swim and fashion of things – though Freud clearly enjoyed that feeling more. The only major British painter who doesn't appear to have expressed resentment against the marginalisation of painting is the perenially sunny (and perennially popular) David Hockney. But how temporary that side-lining now seems. And when the future looks back at the second half of the twentieth century in Britain, it will surely see it as a period dominated by painters: Bacon, Freud, Hockney, Hodgkin, Riley (and Caulfield, Auerbach, Hitchens, Aitchison, Uglow . . .).

Travelling with H.H. The four of us – H.H., his partner Antony, my wife Pat and I – went to Morocco together, to India, and, for several years running, to small Italian cities with good art museums. I would be the organiser, Antony the translator, H.H. the artist-in-residence, Pat the muse: roles only taken semi-seriously. I was also the diarist:

Taranto, April 1989. H.H. spots a black hand-towel in the window of an old-fashioned haberdashery. The four of us go in. The assistant produces a black hand-towel. 'No,' says Howard, 'It's not as black as the one in the window.' The assistant pulls out another, which is similarly rejected, and then another, and then another. This is Italy, and trade is slow, so everything is very good-natured; the assistant does not show the slightest impatience. The same does not apply to me. H.H. has now rejected seven or eight, for God's sake, and is now asking the fellow to get the original towel out of the window. The assistant contorts

Alpine Snow by Hodgkin

himself to do so. When he lays the item down on the counter, I instantly see what I would not have seen in anyone else's presence: the towel is indeed very, very slightly blacker than all the others. A sale is concluded.

Wall-colours against which H.H. has displayed his pictures: white, duck-egg blue, dove-grey, green, gold, ultramarine.

Blue. Bologna, November 2002. We are crossing an arcaded piazza in search of dinner. We pass a small decorators' shop, its brushes and rollers, paint-trays and cans of emulsion a brief parody of an artist's studio. H.H. says, 'I've discovered a new colour. Cobalt blue.' As he describes its purity and intensity, his eyes are those of a voluptuary.

H.H. is sometimes described as a colourist. It's what they call Bonnard when they want to patronise him. (Remember Delacroix complaining that the term was 'more of an obstacle than a recommendation', and Le Corbusier rebuking Braque for being 'smitten with form and colour'.) It's puzzling to those outside the art world why this should be a term of semi-disparagement. Perhaps it would be, if colour were merely finish, gloss, appeal – decorating – rather than being, as it is, the very core of painting. I grow less puzzled when I find a literary comparison. To be called a 'colourist' is rather like being called a 'stylist'. For some critics, 'writing well' is the sign of a bad writer. The Harvard Professor of the Practice of Literary Criticism primly dismissed a novel by the great John Updike with these words: 'Of course Updike writes well; one is severe with a novel as bad as this because of those powers. But Updike . . . doesn't write well enough to be pardoned.' In Auden's poem it is Time that 'pardons' Paul Claudel, 'pardons him for writing well'. Here the Professor has supplanted Time itself as the dispenser or withholder of pardons.

After Degas by Hodgkin

H.H.'s painterly origins are usually located in Intimism, especially Vuillard. This is true, and admitted in his homage *After Vuillard*. But Intimism is warm, whereas Hodgkin is hot, often scorched: even a picture called *Alpine Snow* burns. So consider the other painters to whom he has also painted homages: Corot, Degas, Ellsworth Kelly, Matisse, Morandi, Samuel Palmer, Albert Pinkham Ryder, Seurat. There is also an oval Braque, *Cartes et dés* (1914), full of punched Hodgkinian dots, which feels like a precursor.

Flaubert refused to allow his novels to be illustrated. Such 'inept precision' interfered with the book's intended effect. The purpose of art, he said, was first to make you see – *faire voir* – and then to set you dreaming – *faire rêver*.

It's not just what you paint, it's also what you don't paint (the grained wood that shows through), what you paint over, what gets covered up, what exists temporarily to help you get to somewhere else. Flaubert, answering a series of questions from Taine about the artistic imagination, explained that his internal picturing of a scene would often contain details which he kept to himself. For instance, the fact that Homais, the *pharmacien* in *Madame Bovary*, was 'lightly marked with smallpox'. But he hadn't told the reader this. At some future time, H.H.'s work will be scientifically examined for preliminary marks, underdrawing, underpainting, first thoughts. This will be interesting, but won't help much.

Flaubert as colourist. He told the Goncourts that when he wrote a novel, the plot was less important to him than the desire to render a colour, a shade. Thus for him, *Salammbô* was a kind of purple; while with *Madame Bovary*, 'All I wanted to do was render a grey colour, the mouldy colour of a woodlouse's existence.' So a painter may do the reverse of this, and render emotional states and complexities

normally conveyed at novel length by means of colour, tone, density, focus, framing, swirl, intensity, rapture.

Flaubert and H.H. have this in common: a dislike of being photographed, a habitation not far from Rouen, and a close attention to palm trees. In Egypt, Flaubert took notes on a flamboyant sunset: bands of vermilion in the sky, pale green lakes melting into the blue of the sky, low mountains turning pink. In the foreground are palm trees 'spraying out like fountains'. He goes on: 'Imagine a forest in which the palm trees are as white as ostrich feathers.' He also observes nature being transformed by the evening light into a stage set. At this moment it becomes 'another nature', and a palm tree stops looking like its live self and instead resembles . . . 'a painted palm tree'. Art as second nature.

Flaubert loved the 'stupendous' and 'impossible' colours of the tomb-painters; also the way in which the walls of tombs were 'painted from top to bottom' – a phrase he later appropriates to describe how he would like his own prose to be. The pictorial representations of Egypt he had seen back in France had failed to prepare him for either the light or the colours of the real place. Painters were clearly paralysed by timidity and tradition, afraid to render the true colours of the Red Sea's surface for fear of being accused of exaggeration. 'Painters are imbeciles,' he concluded.

I have always declined to interview or profile H.H. Partly because I know him too well, partly because I do not know how to put his pictures into words. Once, German *Vogue* invited us to record a conversation ranging over art, literature and wider cultural topics. It took place in my back garden. A moderator presided over our exchange, and a photographer recorded the occasion. The moderator

seemed to have rather too many ideas about what we might say to one another. The photographs survived; the conversation was junked by the magazine.

H.H. has always been a difficult interviewee, not least because he doesn't want to talk about his own pictures, let alone 'explain' them. In later years, his refusal to play the game has become extreme. Interviewers have received monosyllabic answers and long pauses; there was a famous onstage disaster with Simon Schama at a literary festival. I remember a radio programme in which the diligent questioner grew more and more frustrated with H.H.'s seeming obstructiveness, and was reduced to offering his own hypotheses about the work, its origins and processes. One particular attempt to put ideas into his mouth was killed off by H.H. with the courteous words, 'But that presupposes that I know what I'm doing.'

Trust the art, not the artist; trust the tale, not the teller. The art remembers, the artist forgets. Flaubert, when he wrote to Taine about *Madame Bovary*, forgot that he had indeed informed the reader that Homais was 'lightly marked with smallpox'.

Flaubert hated the picturesque, especially as popularised by early nineteenth-century travel writing; in particular, he loathed the immensely popular illustrated *Voyages pittoresques* published by Nodier and Taylor. H.H. hates guidebooks of any colour – green, blue, red – let alone the notion of attractions being awarded stars. 'What does your guidebook say?' is a question to which there is only a losing answer. 'And why have we been brought here?' he will politely demand as he gazes round a church he finds devoid of any interest. I will indicate the supposedly impressive statuary on the cardinal's tomb in the second chapel on the north aisle. He will dismiss it with a glance,

Lovers by Hodgkin

instead pointing out a strange, weather-worn lozenge of medieval marble unknown to any guidebook. He is always right. Even so, I like to maintain that the green burst at the bottom right-centre of his painting *When Did We Go To Morocco?* shows me hiding behind a Michelin Green Guide; this despite there being no Green Guide to Morocco when we went there.

Flaubert was haunted by bad art, bad words, linguistic cliché. A memory from a vast provincial Italian art gallery – Parma, perhaps – which some modern designer-architect had attempted to enliven with bright wooden ramps and walkways. Pat and I are sauntering dutifully through some early rooms of indifferent and parochial painting when H.H., who has despatched the museum in ten minutes flat, comes whizzing back towards us. His attitude is one of fierce rebuke. Stop wasting your time on this crap, save your visual energy for the two or three half-decent pictures in fifteen rooms further on. He herds us towards quality.

Delhi, February 1992, the opening of H.H.'s mural on the facade of the British Council building. An officer of the Council, embarrassingly searching for the right words, eventually gestures to the local workmen who are finishing the job and asks diplomatically, 'I hope they're doing what you want?' Later, at the launch party, an Indian woman says to H.H., 'I have revised my opinion of British art on the basis of your mural.' He bursts into tears.

When travelling, H.H. and I have a running joke. From time to time, sitting in a bar, looking across a piazza, relaxing in a restaurant, he will say, with a delivery poised between self-satire and true content-ment, 'I feel a picture coming on.' I ritually reply, 'I feel a novel coming on.' He means it more than I do (well, I never mean it), and I often

wonder what is going on in his head at these moments, as he sits, chin out, eyes half-closed, preparing his future memories. Maxime Du Camp, travelling with Flaubert in Egypt, took furious notes all the time, and later pretended to be exasperated that the novelist 'looked at nothing, and remembered everything'. H.H. looks intently all the time, but when he says he feels a picture coming on, he seems to be looking differently; the moment is digestive, ruminant. And I know he will remember everything – that's to say, everything he will need.

I have been looking at H.H.'s work for three decades now, and it is one of the recurring delights of my life when his paintings, like a gang of international acquaintances, reassemble for a different show in a different city in a different country. When I stand again in front of a familiar picture after a few years, I often find myself murmuring internally, 'Yes, of course', or, 'Good', or, 'That's right', or sometimes, 'Now I'm beginning to see.' As these banal words of greeting imply, my continuing friendship with his pictures, and my increasing absorption of and in them, rarely translates into coherent comment. Of course, I can talk about titles and speculate about a picture's origin, about its resemblance to or difference from another picture; I can describe what I see in front of me like a novelist writing travel notes. These paintings speak to my eye, my heart and my mind – but not to that part of my mind which articulates. Mostly, I address them in that ideal Braquean silence. They resist words – at least, words which can convey what happens inside me when I look at them. I do not think this matters, except socially. All that matters is that what happens, happens; and repeats itself, and asks to be repeated again and again, down the years.

So that's enough words.

Acknowledgements

This book owes its existence to the encouragement of my friend and Danish publisher Claus Clausen. When he first suggested bringing out a collection of my art essays, I thought he was joking; when he repeated the offer, I thought he was still just being polite. He convinced me otherwise, and twelve of these pieces appeared as *Som jeg ser det* (Tiderne Skifter, 2011).

All the essays collected here – apart from the one on Géricault – were the result of commissions, and I thank all the editors who trusted my eye. I am especially grateful to Karen Wright, who ran seven of them in *Modern Painters*. I was not the only novelist or poet to benefit from her generous interpretation of who might be equipped to write about art.

Pat Kavanagh saw most of these pictures with me, and is at my side in the text.

ACKNOWLEDGEMENTS

Original versions of these pieces appeared as follows:

1 Géricault: *A History of the World in 10½ Chapters* (1989)
2 Delacroix: *Times Literary Supplement*, 7th May 2010
3 Courbet: *New York Review of Books*, 22nd October 1992
4 Manet: a) *Guardian*, 16th April 2011
 b) *New York Review of Books*, 22nd April 1993
5 Fantin-Latour: *London Review of Books*, 11th April 2013
6 Cézanne: *Times Literary Supplement*, 21st/28th December 2012
7 Degas: *Modern Painters*, Autumn 1996
8 Redon: *Modern Painters*, Winter 1994
9 Bonnard: *Modern Painters*, Summer 1998
10 Vuillard: *Modern Painters*, Autumn 2003
11 Vallotton: *Guardian*, 3rd November 2007
12 Braque: *London Review of Books*, 15th December 2005
13 Magritte: *Modern Painters*, Autumn 1992
14 Oldenburg: *Modern Painters*, Winter 1995
15 Life-Casts: *Modern Painters*, Winter 2001
16 Freud: *London Review of Books*, 5th December 2013
17 Hodgkin: *Writers on Howard Hodgkin*, Irish Museum of Modern Art/Tate Publishing (2006)

List of illustrations

274

Leonard Lauder, President.
© 1965 Claes Oldenburg

p. 221 *Giant Soft Fan*, 1966–7, vinyl filled with polyurethane foam, canvas, wood, metal, plastic fan, approximately: 120 x 58 ⅞ x 61 ⅞ in. (305 x 149 x 157.1 cm); cord and plug, length: 290 in. (736.6 cm), by Claes Oldenburg. The Museum of Modern Art, New York, The Sidney and Harriet Janis Collection, 1967. Photo: 2014, Digital Image, The Museum of Modern Art, New York/Scala Florence. © 1966–7 Claes Oldenburg

p. 228 *Dead Dad*, 1996–7, mixed media, 20 x 38 x 102 cm/7 ⅞ x 15 x 40 ⅛ in., by Ron Mueck. Stefan T. Edlis Collection. Image courtesy of the Saatchi Gallery, London © Ron Mueck, 2015

p. 229 *Vénus ataxique*, 1895, by Paul Richer. Musée de l'Assistance Publique-Hôpitaux de Paris, France © F. Marin/AP-HP

p. 231 *The Head of an Englishman*, 1840?, anonymous. Muséum National d'Histoire Naturelle, Paris, France © MNHN – Daniel Ponsard

p. 233 *The Hand of a Giant from Barnum's Circus*, c.1889, anonymous. Musée Fragonard, École national vétérinaire d'Alfort, Maisons-Alfort, France

p. 238 *Artist in his Studio*, c.1628, oil on panel, 24.8 x 31.7 cm (9 ¾ x 12 ½ in.) by Rembrandt Harmensz. van Rijn. Museum of Fine Arts, Boston, Massachusetts, USA/Zoe Oliver Sherman Collection/Given in memory of Lillie Oliver Poor. Photo: Bridgeman Images

p. 246 Detail from *Hotel Bedroom*, 1954, by Lucian Freud. Beaverbrook Art Gallery, Fredericton, NB, Canada © The Lucian Freud Archive. Photo: Bridgeman Images (In full below)

p. 248 Detail from *The Painter Surprised by a Naked Admirer*, 2004–5, by Lucian Freud. Private Collection/© The Lucian Freud Archive. Photo: Bridgeman Images (In full below)

p. 257 *Two Japanese Wrestlers by a Sink*, 1983–7, by Lucian Freud. The Art Institute of Chicago, IL/© The Lucian Freud Archive. Photo: Bridgeman Images

p. 263 *Alpine Snow*, 1997, oil on wood, 13 ¼ x 15 ½ in. (33.6 x 39.4 cm) by Howard Hodgkin. © Howard Hodgkin. Courtesy Gagosian Gallery

p. 265 *After Degas*, 1993, oil on wood, 26 x 30 in. (66 x 76 cm) by Howard Hodgkin. © Howard Hodgkin. Courtesy Gagosian Gallery

p. 269 *Lovers*, 1984–92, oil on board, 67 ½ x 72 ⅞ in. (171.5 x 185.4 cm) by Howard Hodgkin. © Howard Hodgkin. Courtesy Gagosian Gallery